East Coast / West Coast and Beyond

COLIN CAMPBELL COOPER · AMERICAN IMPRESSIONIST

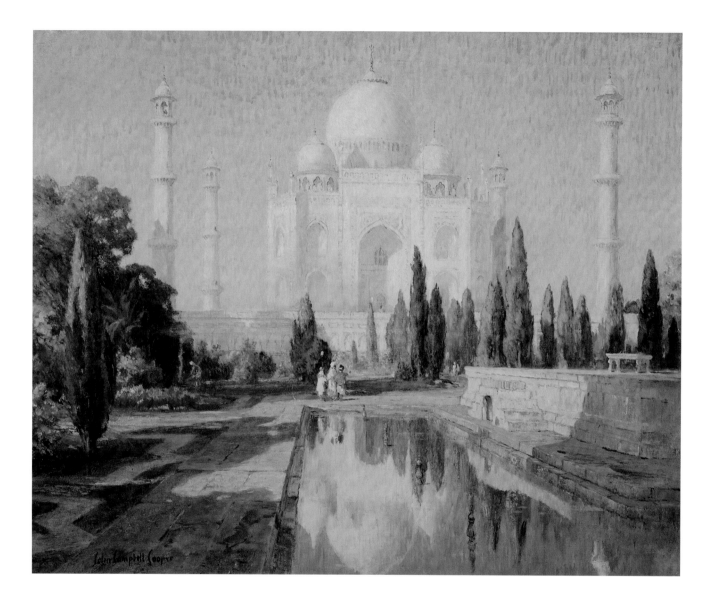

East Coast / West Coast and Beyond

COLIN CAMPBELL COOPER · AMERICAN IMPRESSIONIST

William H. Gerdts

Deborah Epstein Solon

LAGUNA ART MUSEUM | THE IRVINE MUSEUM

IN ASSOCIATION WITH HUDSON HILLS PRESS

NEW YORK AND MANCHESTER

East Coast/West Coast and Beyond, Colin Campbell Cooper, American Impressionist is published on the occasion of the exhibition of the same name organized by Laguna Art Museum, Laguna Beach, CA, on view at the Heckscher Museum of Art, Huntington, NY, November 11, 2006 through January 28, 2007 and at the Laguna Art Museum, February 23 through June 3, 2007.

Published in the United States by Hudson Hills Press LLC, 74-2 Union Street, Manchester, Vermont 05254.
Distributed in the United States, its territories and possessions, and Canada by National Book Network, Inc.
Distributed in the United Kingdom, Eire, and Europe by Windsor Books International.

Co-Directors: Leslie van Breen and Randall Perkins
Founding Publisher: Paul Anbinder
Publication Coordinator and Editor: Terry Ann R. Neff, t. a. neff associates, inc., Tucson, Arizona
Designer: Christopher Kuntze
Indexer: Karla Knight
Proofreader: Margot Page
Production Manager: David Skolkin/Skolkin + Chickey, Santa Fe, New Mexico

Color separations by Pre Tech Color, Wilder, Vermont
Printed and bound by CS Graphics Pte., Ltd., Singapore

LIBRARY OF CONGRESS CATALOGING-IN-PUBLICATION DATA

Gerdts, William H.

 East Coast, West Coast, and beyond : Colin Campbell Cooper, American impressionist / William H. Gerdts and Deborah Epstein Solon. — 1st ed.

 p. cm.

 Catalog of an exhibition at the Heckscher Museum of Art, Huntington, N.Y., Nov. 11, 2006–Jan. 28, 2007 and at the Laguna Art Museum, Laguna Beach, Calif., Feb. 23–June 3, 2007.

 Includes bibliographical references and index.

 ISBN-13: 978-1-55595-269-3 (alk. paper)

 ISBN-10: 1-55595-269-0 (alk. paper)

 1. Cooper, Colin Campbell, Jr.—Exhibitions. I. Solon, Deborah Epstein. II. Cooper, Colin Campbell, Jr. III. Heckscher Museum of Art. IV. Laguna Art Museum (Laguna Beach, Calif.) V. Title.

 ND237.C679A4 2006

 759.13—dc22 2006016371

Front cover: Colin Campbell Cooper, *Chatham Square Station, New York City*, 1919 (detail, cat. no. 52)
Back cover: Colin Campbell Cooper, *Panama-Pacific Exposition*, c. 1916 (cat. no. 44)
Page 2: Colin Campbell Cooper, *Taj Mahal Afternoon*, c. 1913 (cat. no. 27)
Page 6: Colin Campbell Cooper, *Half Dome, Yosemite*, 1916 (cat. no. 37)

Contents

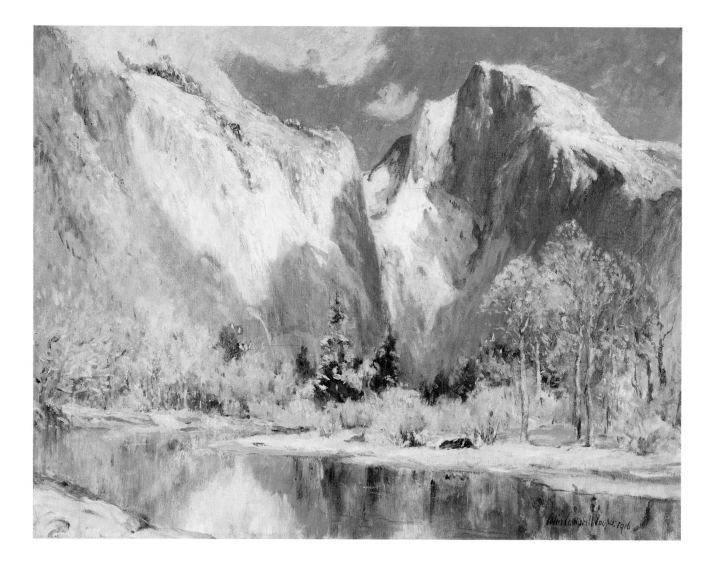

Foreword

Few studies of the artistic output of early twentieth-century American artists focus equally on both East and West Coast subject matter. Rare art-historical moments such as this provide us with the unusual and fascinating opportunity to compare two fairly distinct bodies of work within one artist's oeuvre. Colin Campbell Cooper's optimistic paintings of New York's financial district beginning at the turn of the twentieth century literally helped to identify a new facet of the American landscape: the modern urban center with its spirit of promise and progress. By the time Cooper had moved to Santa Barbara in 1921, he had already begun to turn away from such images of towering architectural newness toward an older, more traditional, and, perhaps, natural vision of America. This would be exemplified in Cooper's paintings of the California missions, completed while the artist was visiting the state for the San Francisco and San Diego expositions in 1915 and 1916. One wonders whether the trip to California in some measure inspired this new artistic direction or if it was merely part of a larger national movement in art motivated by America's entry into World War I.

East Coast / West Coast and Beyond: Colin Campbell Cooper, American Impressionist takes a broad view of Cooper's work, and is, in many ways, a true retrospective. It exemplifies the artist's virtuosity with various subjects over several decades, including European architectural monuments, the Taj Mahal, figural works, even Yosemite landscapes. Together, the works form a picture of an ambitious, peripatetic, and worldly artist, who garnered much critical acclaim with paintings that are technically remarkable as well as sensitive "Impressionist" interpretations of atmosphere and light.

Although *East Coast / West Coast and Beyond* is the first monograph exhibition that Deborah Epstein Solon has completed for Laguna Art Museum, it is the third exhibition project that she has organized for the museum. Previous collaborations include *In and Out of California: Travels of American Impressionists* (2002) and *Colonies of American Impressionism: Cos Cob, Old Lyme, Shinnecock, and Laguna Beach* (1999). Laguna Art Museum is an originator and organizer of a number of other exhibitions and publications dealing with California Impressionism, including *William Wendt, 1865–1946* (Nancy Dustin Wall Moure, 1977), *Early Artists in Laguna Beach: The Impressionists* (Janet Blake Dominik, 1986), and *California Light, 1900–1930* (Patricia Trenton and William H. Gerdts, 1990). These exhibitions have made important contributions to American art history in addition to being seminal to the understanding of California art.

In delving into Colin Campbell Cooper's history, Dr. Solon has unearthed source material that has led to a much clearer understanding of the artist's life, especially the lesser known California years. Her examination of this original material has brought forward Cooper's participation in and importance to the Santa Barbara art scene in the 1920s and 1930s. Cooper was central to the region's burgeoning cultural activities in numerous ways: writing plays, producing art and theater criticism, and pursuing an active painting career.

William H. Gerdts's comprehensive essay on Cooper's contribution to art on the East Coast is informed by his consummate knowledge of the history of architecture in New York's financial district. It is this subject matter, Dr. Gerdts rightfully argues, that is Cooper's most significant contribution to American art.

As always, many generous people have contributed to making this project a reality. Deborah Solon and William Gerdts have done an outstanding job of curating the exhibition

as well as writing critical essays for the catalogue. Dr. Solon was also instrumental in helping to raise funds for the exhibition and was of great support to the museum's former Development Director Ann Camp and present Development Director Kelly E. Cornell. Terry Ann R. Neff, who has edited all three of Dr. Solon's exhibition catalogues for Laguna Art Museum, has once again very professionally handled not only the editing of the essays but assisted with negotiations with the copublisher of the book, Hudson Hills Press.

The Laguna Art Museum is extremely grateful to The Irvine Museum and The Joan Irvine Smith & Athalie R. Clarke Foundation for their financial support of this exhibition catalogue. In addition, this is the first time that The Irvine Museum is partnering with Laguna Art Museum in the distribution of one of its exhibition catalogues. Through a unique program that The Irvine Museum has developed with the California state school system, every public school library in California will receive a copy of *East Coast/West Coast and Beyond: Colin Campbell Cooper, American Impressionist*. Joan Irvine Smith and her son, James Irvine Swinden, have been extremely supportive of this exhibition and a great inspiration to work with.

I also wish to warmly thank Tom and Barbara Stiles for their significant financial underwriting of the exhibition. Mr. Stiles, formerly the Vice President of the Board of Trustees of Laguna Art Museum, was also very helpful with negotiations with representatives of The Irvine Museum. Jean Stern, Director of The Irvine Museum, was equally receptive and helpful in coordinating the exhibition catalogue for distribution to the California school library system.

Generous financial support for this project has also come from many longtime friends of the museum: Laguna Art Museum's Historical Art Council, Burlington Resources Foundation, Paul and Kathleen Bagley, Mark and Donna Salzberg, Thomas Gianetto and Edenhurst Gallery, Frank Goss, Jason Schoen, Lawrence Shar, Earl and Elma Payton, Greg and Sharon Roberts, Whitney and Susan Ganz, William A. Karges, George Stern, DeWitt McCall, William Selman, and Ray and Beverly Redfern.

Tyler Stallings, Chief Curator of Laguna Art Museum, has done a remarkable job of coordinating this project and traveling the exhibition to the Heckscher Museum in Huntington, New York. Janet Blake, Curator of Collections and Registrar, has done a tremendous job of organizing lenders, shipping, insurance, and overseeing the valuable paintings in this exhibition. Tim Schwab, Chief Preparator, has very ably handed the works in the exhibition and contributed to a wonderful installation. Stuart Byer, Marketing and Public Relations Manager, has garnered exceptional press for the exhibition. Peter Salomon, Business Manager, has kept meticulous track of the complicated finances surrounding the show. Mike Stice, Laguna Art Museum's Chief of Operations, has done a fine job of ensuring the safety of the exhibition and the visitors who come to see it.

Finally, I would like to thank the Trustees of the Laguna Art Museum for their essential ongoing support of the museum and their particular interest in this important exhibition.

Bolton Colburn, Director

Acknowledgments

The history of Colin Campbell Cooper has been infinitely enriched by the cooperation of Jennifer Dahlke, Cooper's great grandniece, who graciously provided access to the Coopers' papers, diaries, letters, newspaper articles, and unpublished manuscripts. Drs. Gerdts and Solon are grateful to Ms. Dahlke and her family for their commitment to this project. Dr. Gerdts would also like to acknowledge the assistance and inspiration he received from the late Sherrill Seeley Henderson, the artist's grandniece, and Dr. Joy Sperling of Denison University, who provided him with copies of a trove of Cooper manuscript materials, including the artist's account book, letters, newspaper clippings, and other pertinent material. The authors would like to offer special thanks to Frederick D. Hill and Lawrence Shar for their financial support in making possible both essential loans and the full publication of this catalogue. Crucial information, as well as encouragement, was offered by Marshall Norman Price, former Assistant Curator of the Santa Barbara Museum of Art and presently Assistant Curator at the National Academy of Design in New York. Likewise, Bruce Weber, Director of Exhibitions and Research at the Berry-Hill Galleries in New York, was extremely helpful and supportive, as was Carol Lowrey, Curator of the National Arts Club, New York, and Lee Vedder, Luce Curatorial Fellow in American Art, The New-York Historical Society. Christopher Gray of the Office for Metropolitan History in New York was of assistance in identifying New York buildings. Marjorie B. Searl, Chief Curator of the Memorial Art Gallery, University of Rochester, Rochester, New York, is an authority on the work of Cooper's artist-wife, Emma Lampert Cooper, and provided the authors with much useful material. Agnes de Rijk of Laren, Holland, assisted with details concerning Cooper's activities in the Netherlands. Ray Redfern graciously provided information on Cooper that was skillfully compiled by researchers Phil and Marian Kovinick.

A good many individuals—scholars, collectors, and dealers—shared their knowledge of the whereabouts and histories of Cooper's paintings, and are partly responsible for their presence in this exhibition and/or their reproduction in this catalogue. These include Warren Adelson, Martha Fleischmann, Lillian Brenwasser, Debra Force, Howard Godel, Michael Owen, and Ira Spanierman, all in New York City; Erwin and Margaret Zeuscher, Plandome, New York; Abby Taylor of Greenwich, Connecticut; Gloria Rexford Martin of Santa Barbara, California; Michael Redmon, Director of Research and Publications, Santa Barbara Historical Society; Boris Wanio of Allentown, Pennsylvania; Robert Metzger, formerly Director of the Reading Public Museum, Reading, Pennsylvania; David and Martine Altman of Rochester; Jonathan Stuhlman, Curator of American Art, Norton Museum of Art, West Palm Beach, Florida; Tyler Mongerson of Chicago; Gary Breitweiser and Frank Goss of Santa Barbara; George Stern of Los Angeles; and Jessie Dunn-Gilbert, The North Point Gallery, San Francisco.

The staff of the Laguna Art Museum, including Director Bolton Colburn, Chief Curator Tyler Stallings, Curator of Collections and Registrar Janet Blake, and Ann Camp, former Development Director, all dedicated their time and effort to ensure the success of this project. Anne Cohen DePietro, formerly Chief Curator at the Heckscher Museum, was

instrumental in securing the museum as an East Coast venue. We are grateful for the major financial underwriting from the Joan Irvine Smith & Athalie R. Clarke Foundation, which continues to reaffirm its ongoing dedication to scholarship in this field. Additionally, many private individuals generously contributed to the underwriting of the publication. We are indebted to editor Terry Ann R. Neff and to Hudson Hills Press for the publication of this catalogue. Finally, we acknowledge the lenders to the exhibition, both private and institutional, who have demonstrated great support and interest in this undertaking.

William H. Gerdts
Deborah Epstein Solon

East Coast / West Coast and Beyond

COLIN CAMPBELL COOPER · AMERICAN IMPRESSIONIST

1

Nude Male Study, c. 1880s
Oil on canvas
23½ x 14½ inches
Collection of Michael and Deborah McCormick
Photograph courtesy of Sullivan Goss–An American Gallery

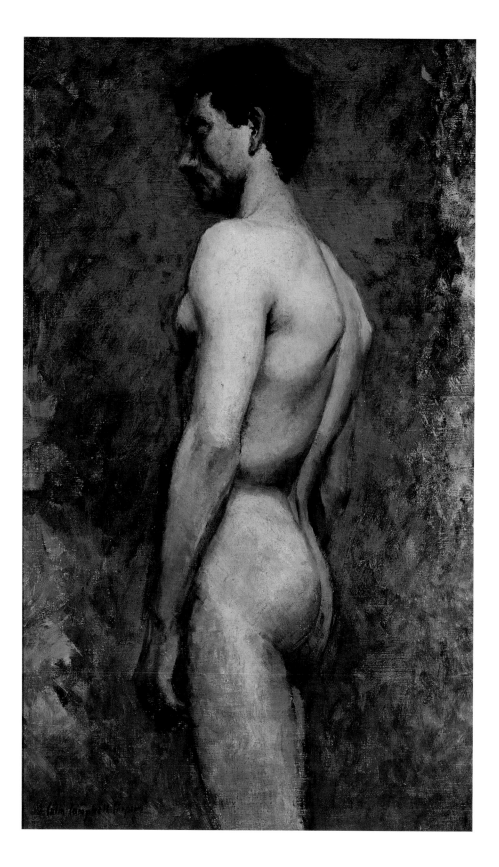

Cooper in New York and Beyond

William H. Gerdts

The artistic reputation of Colin Campbell Cooper (fig. 1)[1] has escalated in recent decades, and somewhat exceptionally in two quite separate fields of endeavor.[2] In the American East, he has become known as one of the most able and formidable of the painters of the "skyscraper city" New York, while in California he is recognized as the Dean of Santa Barbara painters, though his range of subject matter extended beyond the confines of his adopted city. One factor that unites both aspects of his widely divergent art—and as we shall see there are a good many more facets to his artistry than these two prominent phases—is his utilization of many of the strategies of the Impressionist movement, which reached the height of its prominence in America during Cooper's career. Another is his continued concern with the representation of architecture and/or scenes in which architectural structure determines the vitality of his conception and composition. Cooper had mastered figure painting, as is evidenced both in his relatively rare pictures devoted to that theme and his introduction of smaller staffage in his urban street scenes. He was an excellent landscape painter, an achievement that comes through in some of his earliest known works and surfaces again in many of his California subjects. Landscape is necessarily less a significant issue in his pictures of majestic architectural structures, whether medieval cathedrals or modern skyscrapers.

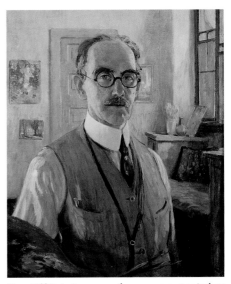

Fig. 1. *Self-Portrait*, c. 1922; oil on canvas; 30 × 25 inches; National Academy Museum, New York (268-p)

During his long career, and particularly in the first three decades of the twentieth century, Cooper was a well-known and respected painter. His work was exhibited widely throughout the country and published in numerous articles and scores of exhibition catalogues, some pairing his pictures with those of his first wife, the Rochester-born artist Emma Lampert Cooper, herself a painter of exceptional ability. After his death, however, Cooper's art fell into obscurity. This was due, in part, to a lack of interest in the kind of architectural subjects for which he had achieved his greatest distinction, and also to the general disdain in which art historians, museum staff, and collectors held the aesthetics of American Impressionism. What is somewhat surprising, however, is that beginning in the 1960s, when interest in Impressionism began its rise, Cooper's work continued to be ignored. One reason for this may be because Impressionism in America, during both its decades of disdain and its reappraisal, was primarily associated with lovely, colorful, sunlit landscapes and paintings of beautiful young women and tousle-haired children, neither of which were to be found in Cooper's repertoire. The one exception here is the painting of Childe Hassam (1859–1935), the painter with whose art Cooper's is, today, most closely linked and compared. Still, for the most part, Hassam's city scenes, dating primarily from the 1890s, depict a more intimate, less majestic celebration of the changing New York skyline, except for his famous *Flag* series (1916–19), whose nationalistic overtones at a time when the country was embroiled in World War I won for these pictures tremendous acclaim. Otherwise, Hassam was only seldom the painter of the "skyscraper city." Rather, this was to become one of Cooper's greatest achievement, and is only now gaining its due recognition.

Colin Campbell Cooper was born on March 8, 1856, in Philadelphia, to Dr. Colin Campbell Cooper and his wife, the former Emily Williams, the fifth of nine children. His great-grandfather, Thomas Cooper, had emigrated from Londonderry, Ireland, while on his mother's side, a Williams forebear had come to colonial America from Weymouth, England. His mother, an amateur watercolorist, most likely encouraged her son's interest in the arts,

while the artist recalled that his father, a great lover of literature and music, also encouraged his artistic bent.[3] This predilection surely received stimulation by the enormous art display shown at the Philadelphia Centennial Exposition of 1876 when Cooper was eighteen years old. Ironically, given the direction his mature art was to take, the two paintings in the fine arts display that especially impressed him were by French artists: Georges Becker, *Rizpah Protecting the Brides of Her Sons from the Birds of Prey*, and especially L. Emile Adan, *Scene from the Inquisition* (both unlocated).[4] The following year, Cooper was in business with his brother John at 5581 Germantown Avenue, though no specific occupation was given; two years later, they were identified as working in the publishing business. However, his inclination toward the arts was apparent in 1878 when he joined the Philadelphia Sketch Club, and in 1879, when he first began to exhibit oils and watercolors with the Philadelphia Society of Artists. That same year, too, Cooper became a student of Thomas Eakins at the Pennsylvania Academy of the Fine Arts. Eakins was, at times, discouraging to Cooper, who in turn felt that Eakins was too severe in his demand for construction and made too little of the importance of movement and vitality, resulting in rather static drawings among his students; nevertheless, Cooper always considered Eakins a great artist. He studied with Eakins for three years, and in 1881 set up a separate studio at 1514 Chestnut Street, where he remained until he went abroad in 1886. Cooper may also have been one of the earliest painters to work in Taos, New Mexico. In 1881, he made his second trip to Colorado, with a commission to make a picture of the Red Canyon near Colorado Springs, and was induced there to take the Denver and Rio Grande Railroad to the town of Embuda, and then traveled on horseback to Taos. Cooper exhibited a Taos picture at the Pennsylvania Academy in 1882.[5] During the 1880s, Cooper displayed his abilities in additional arenas, taking on illustration jobs[6] and also publishing short stories.[7] In the early 1880s, Cooper and one of his older brothers undertook to edit and publish a small illustrated monthly, *The Germantown Social*, for which Cooper provided most of the illustrations. The project lasted but a short time; however, it established his contact with the future great graphic artist Joseph Pennell, who provided some of the etchings for the monthly and became a lifelong friend.[8] Pennell was ultimately to undertake in the graphic arts subjects of the modern urban world for which Cooper achieved his fame in oils and watercolor, and critics frequently paired the two artists, recognizing their diverse mediums.[9] Literature, in fact, remained an abiding passion of Cooper's; he wrote numerous articles and treatises, some published, some left in manuscript form; later, in Santa Barbara, he wrote plays that were performed locally, in Pasadena, and at the Community Theatre in Santa Fe, New Mexico.

In 1886, Cooper took one of the Red Star steamers to Europe, landing in Antwerp, and worked in Holland, making sketches and studies along the dikes at Monnickendam, Volendam, and Maarken. On his return, Cooper became part of a design firm with George F. Stephens in Philadelphia, joined the following year by Jesse Godley and by Walter J. Cunningham by 1889. At this time, however, Cooper returned to Europe to continue his artistic education in Paris, enrolling in the Académie Julian and studying with William Bouguereau, Jules-Joseph Lefebvre, and Lucien Doucet, and also at the academies Delacluse and Viti. Testimony to Cooper's proficiency in figure painting can be seen in his "académie," *Nude Male Study* (cat. no. 1). Though here Cooper may not have been completely successful—he

2

The Brittany Coastline, 1890
Oil on canvas
20¼ x 29 inches
Courtesy of The Greenwich Gallery

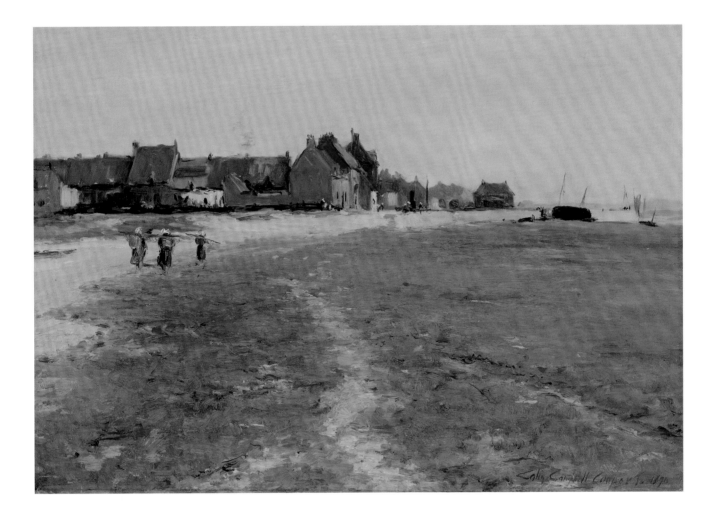

3

The Pageant at Bruges, 1896
Oil on canvas
16 x 20 inches
Payton Family Collection

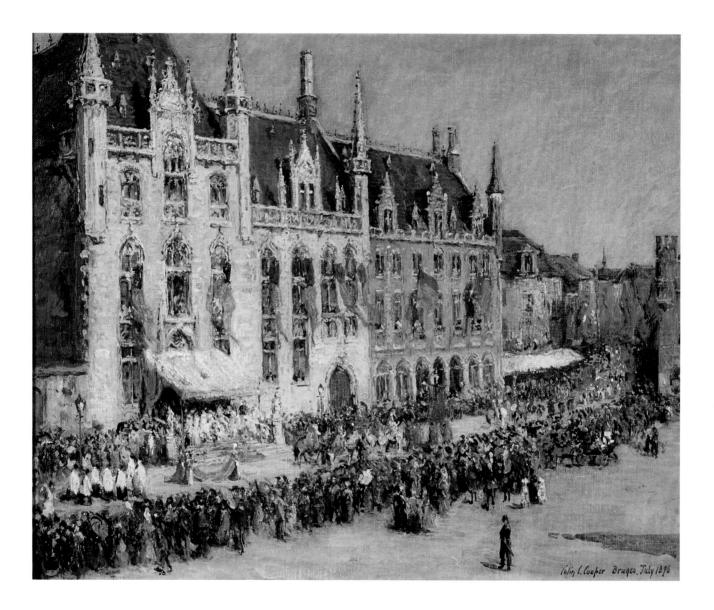

seems to have overemphasized the pectoral and backbone structure, presumably to demon-
strate his anatomical mastery—he has obviously been able to transcribe with power and
grace the human form well foreshortened. Sometime during the summer of 1890, Cooper
joined the decades-long procession of American art students to Brittany in search of pictur-
esque subject matter among the peasant villages of this still most traditional area of France,
where he painted *The Brittany Coastline* (cat. no. 2). There are no distinctive architectural ele-
ments such as a village church with which to identify the specific locale here, though he had
painted and exhibited a number of views of Concarneau at the Pennsylvania Academy of
the Fine Arts in 1897. Here Cooper has created a fascinating panorama, with the wide swathe
of green grass, empty except for the three peasant women walking along the path at the left,
leading up to the horizontal row of small houses with multicolored roofs, with just a
glimpse of ships and water in the upper right. This rare, pure landscape by Cooper suggests
his facility in a genre he was otherwise pretty much to abandon.

Cooper spent at least part of the winter in Spain, copying at the Prado in Madrid and vis-
iting in a little village near Seville.[10] Probably deriving from this trip, Cooper exhibited for
the first time in the Paris Salon in 1890, a figure painting, *Une Andalouse* (unlocated), but he
appears to have remained in France only a year, for he was residing back in Germantown
later in 1890 and then in Mt. Airy in 1892 with a studio in Philadelphia. In 1891, Cooper may
have visited Nantucket and spent the summer in Spain and Algiers, judging by his exhibition
record in the spring of 1892, and the next two summers may have worked in the growing
artists' colony in Mystic and Noanck, Connecticut.[11] Two years later, he took a position as
instructor of watercolor at the Drexel Institute in Philadelphia, where he remained until
1898. In 1895, Cooper won his first award: a bronze medal at the Cotton States and Interna-
tional Exposition held in Atlanta for his painting *The Taj Mahal, Agra* (unlocated), although
no trip at this time to India is documented. Unfortunately, a fire at the Haseltine Galleries in
Philadelphia in 1896 consumed many of Cooper's paintings, so that relatively few of his early
works are known today.

As with many artists who had returned to America after European study, often accepting
teaching positions at home, Cooper spent his summers abroad. During his Drexel years, his
primary destinations were in Holland, in the artists' colony of Laren, outside of Amsterdam,
and especially in southern Holland. Dordrect, in particular, was the subject of a number of
his paintings during the later 1890s, such as his *Dordrecht Harbor* (cat. no. 4). In these works,
Cooper first came into his own as a painter of monumental architecture, with the "Grote
Kerk." The great church, set in its city environment, rises above and dominates the pictur-
esque buildings in front of it; the small bridge over a canal at the right and the harbor with
boats and myriad diminutive figures all contribute to the majesty of the building, silhouetted
against a glorious blue sky. By choosing so vertical a format, Cooper heightened this
majesty.[12] That Cooper considered *Dordrecht Harbor* one of his major works at the time is
established by his exhibition of the picture in the Paris Salon in 1901. Another small but
majestic work featuring subjects from Cooper's sojourn in the Low Countries is *The Pageant
at Bruges* (cat. no. 3), in which the ostensible subject of the celebration of the Procession of
the Holy Blood on Ascension Day is dwarfed by the Gothic architecture of the City Hall
on the Grand Place. Shown at the Society of American Artists in New York in the spring of
1897, the painting began to establish a national reputation for Cooper as a painter of

medieval architectural monuments—a subject that fascinated him throughout his lifetime.

Among the many American artists who worked in Dordrecht in the late nineteenth century were Henry Ward Ranger, Charles Adams Platt, Jerome Elwell, Francis Hopkinson Smith, Dwight Tryon, Charles Gruppe, John Twachtman, and the expatriates Frank Myers Boggs, George Boughton, and James McNeill Whistler.[13] Cooper, however, appears to be more consistently associated with Dordrecht than any of his American compatriots.[14] American women artists were there also, including Emma Lampert from Rochester, New York, whom Cooper met in Dordrecht and shortly thereafter married in Rochester on June 9, 1897. Lampert had been visiting and working in Holland since 1891, taking classes there and bringing back Dutch goods to use for "set-ups" for Dutch subjects, and inviting Dutch painters to exhibit in her native town.[15] In 1898, Cooper and his new wife went abroad, spending almost a year in the art colony in Laren and residing abroad until 1902.

Fig. 2. *Woman with a Large Hat*, 1904; oil on canvas; 17½ × 19½ inches; Collection of Gail Feingarten Oppenheimer; Photograph courtesy of Feingarten Galleries, Beverly Hills, California

Cooper's exhibition record offers a map of his travels, even when paintings are unlocated. Thus, he appears to have traveled to Italy in 1897, based on a watercolor, *The Port of Genoa, Italy* (unlocated), which he exhibited at the New York Water Color Club in November of that year. His chief destination, however, as with so many other late nineteenth-century American painters, was Venice, for he exhibited Venetian scenes in 1898 in Philadelphia, New York, Boston, Chicago, and St. Louis. Although he was back in Dordrecht that year, he spent a good deal of time painting in Amsterdam, and in 1899 was active in Ecouen, France, another town outside of Paris that attracted a good many American painters. While some of Cooper's foreign views may have been street scenes and panoramas, others appear from their titles to have concentrated rather specifically upon architecture, sometimes just groups of old houses but more often upon architectural monuments such as the *Cathedral at Chartres*, the *Ca d'Oro* in Venice, and *The Rathaus, Rothenburg, Bavaria* (all unlocated).[16] In 1900, Cooper appears to have decided to explore new pictorial territory, painting figural depictions and portraits of young women. His under life-size *Portrait of a Lady in a Green Dress* (cat. no. 5) may be one of these. This lovely rendering of a young woman seen in profile from below—not at all idealized but beautifully sympathetic, and exhibiting Cooper's mastery of the human form—represents another artistic path seldom taken until much later in his career. The subject may be a hired model, but the painting is more likely a portrait; in January 1902, Cooper exhibited *Portrait of Miss H* and *Portrait of Miss Dillaye* (both unlocated) at the annual exhibition of the Pennsylvania Academy of the Fine Arts; the former had previously been exhibited in the Paris Salon in 1901. "Miss H" cannot be identified, but "Miss Dillaye" is almost surely Blanche Dillaye, a prominent Philadelphia watercolor painter and a pioneer woman etcher who had been a classmate of Cooper's at the Pennsylvania Academy and became a regular exhibitor there. Such portrait likenesses remained in Cooper's repertoire, for another beautiful and sympathetic rendering of an extremely attractive young woman, *Woman with a Large Hat* (fig. 2), is dated 1904. At this time, Cooper was, in fact, lauded not only for his architectural subjects but also for his portraiture. One writer in 1903, while acknowledging his growing fame in the rendering of architectural subjects, noted that Cooper "holds no insignificant position among the American portrait painters. He paints a likeness; discovers the soul of his sitter and gives you an expression of the same in the features." The writer was especially struck by the now unlocated *Portrait of Miss H.*[17]

4

Dordrecht Harbor, c. 1898
Oil on canvas
43 x 32 inches
Payton Family Collection

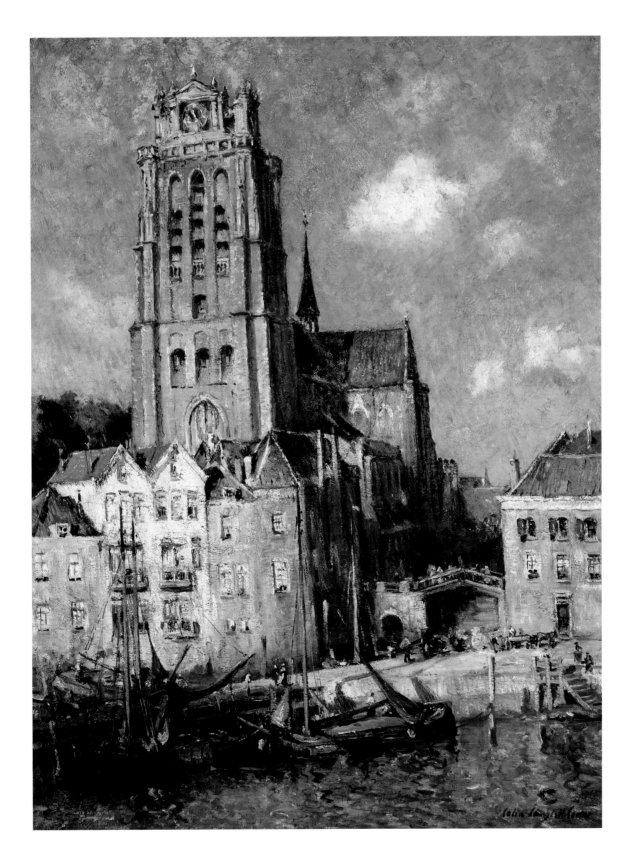

5

Portrait of a Lady in a Green Dress, c. 1900

Oil on canvas

18 x 21 inches

Collection of Michael and Deborah McCormick

Photograph courtesy of Sullivan Goss–An American Gallery

An inveterate traveler, Cooper continued to paint some of the great monuments of European architecture, especially of the Gothic era. One of his greatest achievements is his *Wells Cathedral* (cat. no. 6), probably painted in 1902 when he spent the summer in England. The artist delighted in the intricate stone work and warm coloration of the giant structure, and emphasized its geometric blockiness. Cooper seems to have decided to focus on great English cathedrals that year, for in January 1903, he exhibited a series at the Pennsylvania Academy that included not only *Wells Cathedral: West Front* but also *Ely Cathedral: West Front* and *Lincoln Cathedral: Interior* (both unlocated). He would later exhibit paintings of the west front of Lincoln Cathedral and pictures of Winchester Cathedral as well. Likewise, the great Gothic churches of France remained an important aspect of his repertoire, not only those at Chartres, but St. Ouen in Rouen, Rheims Cathedral, the Church of St. Wolfram at Abbeville, and Beauvais Cathedral. His earliest known rendering of Beauvais Cathedral was a watercolor shown at the New York Water Color Club in 1907, but an oil rendering of the church appeared at the Annual Exhibition of American Art held at the Cincinnati Art Museum in May 1912, and at the Corcoran Gallery of Art in Washington, D. C., in December. Cooper's rendition of Beauvais Cathedral (or, less likely, alternative versions) subsequently appeared in a series of major shows, including the Panama-Pacific International Exposition held in San Francisco in 1915, one of a group of paintings for which he earned a gold medal for oil painting. In 1926, *Beauvais Cathedral* appeared in the Sesqui-Centennial International Exposition held in Philadelphia, in this case very possibly the present example (cat. no. 67), also dated 1926, which itself may either be a second version of the subject or a reworking of the original picture.[18] A magnificent view from below, the great Gothic church radiates sunlight from its façade, dwarfing the small figures on the steps and in front of the church, and even the medieval turreted buildings to the left. Certainly, compared to the much earlier *Wells Cathedral*, the painting shows a greater freedom of handling, looser brushwork, and a far brighter palette, which coincides with the aesthetics of Cooper's later, Santa Barbara paintings, but it may also reflect the distinction between the weather conditions under which Cooper addressed the two great structures and also, more generally, the climates of England and France. Nor was Cooper quite finished with Beauvais Cathedral. A decade later, in 1936, now long resident in Santa Barbara, he exhibited *Beauvais Cathedral (Night)* (date and location unknown) in the summer exhibition of the local Faulkner Memorial Art Gallery.

But it was at the very beginning of the twentieth century that Cooper began to investigate the theme with which his art and reputation became forever associated: the buildings, streets, skylines, and general appearance of the modern, twentieth-century American city— the "skyscraper city" so identified with New York, though Cooper's repertoire was hardly limited to that metropolis. Cooper identified the year 1902 as the start of his fascination with this theme; returning from abroad in December, he was immediately impressed by the soaring skyline of the modern city, and within a year critics were already writing of his "Skyscraper Series."[19] Still, it is possible that contemporary architecture in general and New York street scenes in particular had already attracted his attention, for in the Tennessee Centennial & International Exposition held in Nashville beginning in May 1897, he exhibited *The Times Building (Illinois)* and *Fifth Avenue and Fifty-ninth Street, New York* (both unlocated).[20]

While the great Plaza Hotel, the distinguishing feature of the plaza at Fifth Avenue and Fifty-ninth Street, had not yet been built, in 1897 the plaza was dominated by three great hotel structures: the earlier Plaza apartment-hotel, and the Savoy and New Netherlands hotels, both built in 1892, the latter the tallest hotel in the world at the time. New York was, of course, growing upward in the 1890s, as indicated by a series of usually glowing articles describing this growth.[21] When Cooper returned in 1902, no fewer than sixty-six skyscrapers had risen above lower Manhattan—most within a few blocks of one another around Wall Street, where real estate prices now spiraled, making this land the most valuable property on earth.[22] And the city itself was necessarily conscious of its physical transformation. The culminating celebration of the transformed city, not only the skyscrapers themselves but the life of the metropolis where the great tall buildings stood as the defining icon, was the 1909 book by John C. Van Dyke, *The New New York,* a summation of the changes in the city that Cooper's art mirrors more faithfully than that of any other painter.[23] Actually, though, the concept had been voiced in a whole series of articles that preceded the book, even down to the title.[24]

In one sense, Cooper's turn to contemporary urban scenes, centering around the growth of the great skyscrapers—especially but not only in New York—can be seen as a logical outcome of his interest in great Gothic cathedrals, the "skyscrapers" of the Middle Ages. And while one might raise the distinction between structures created for the glory of God and those that celebrated Mammon, it should be recalled that in 1913, when the Woolworth Building was constructed on lower Broadway—the subject of one of Cooper's most glorious New York scenes—it was christened "The Cathedral of Commerce."[25] Though many of Cooper's paintings depicting New York do focus on outstanding architectural structures, he took a striking variety of approaches to the metropolis, from panoramic views of the city's skyline, to a survey of the shoreline of Manhattan, to the wealth of bustling urban activity. In this last category, one might identify a correspondence to the urban concerns of the contemporary New York painters of "The Ashcan School"—John Sloan, Everett Shinn, George Bellows, and others—but the distinctions are far too great to include Cooper among them. For one, Cooper's urban scenes are almost unfailingly optimistic, glorifying progress in both the new technology and the new vitality of the cities; his images of towering buildings were far more likely to encourage patronage than tenements and back alleys. For another, while figures at times play a significant albeit secondary role, architecture and allied structures of transportation—the ferry, the elevated railroad—dominate a good number of his city scenes. And Cooper's aesthetic, increasingly, absorbed the rich colorism and bright light of Impressionism, itself underscoring the confidence in progress that is usually absent in Ashcan School painting.

Though Cooper and his wife continued to travel frequently in Europe and the artist never forsook foreign subject matter, 1225 Sansom Street, Philadelphia, remained his home base until 1904, when he moved into the studio building at 58 West Fifty-seventh Street in New York. This would be his neighborhood until he moved to California in 1921. In 1908, he moved a few blocks to the Gainsborough Studios at 222 Central Park South, and became treasurer of the building. He maintained this address through 1924, three years after he had settled in Santa Barbara. During these several crucial decades, then, New York was Cooper's

6

Wells Cathedral, c. 1902
Oil on canvas
25 x 31 inches
Courtesy of Berry-Hill Galleries

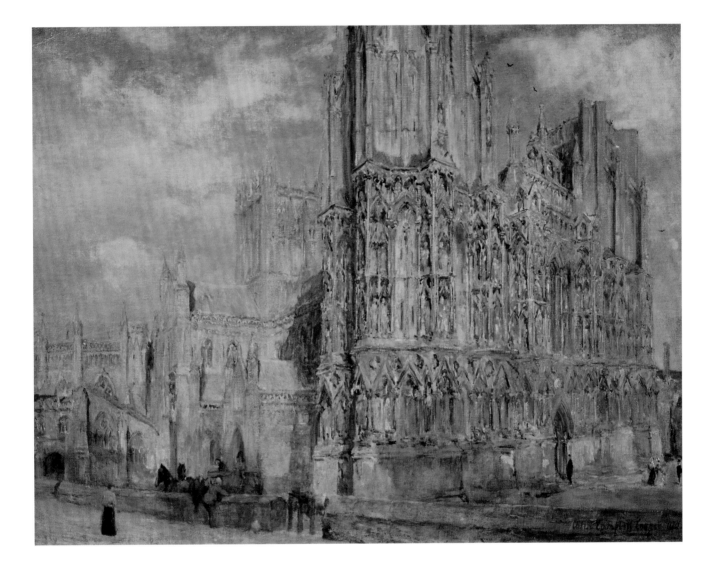

7

Cliffs of Manhattan, 1903
Oil canvas
36 x 48 inches
Collection of the City of Santa Barbara
Photograph courtesy of Scott McClaine

home base, and it was here that he gained the reputation as "the first artist to discover the artistic possibilities, the canyon like beauty, of streets of modern sky-scrapers,"[26] but he drew his subject matter from other major urban centers as well. In the first public exposure of his contemporary architectural interests, in fact, were a series of watercolors shown with the American Water Color Society in April 1903, all entitled *Sky Scrapers*, two of which were identified as Philadelphia and only one a view of Broad Street, New York. Cooper was a very able practitioner of watercolor, using it extensively and exhibiting his watercolors as often as his oils. Judging from his exhibition record and account book, it appears that he sometimes "tried out" a subject in the smaller and perhaps more tentative medium of watercolor before moving on to create large oils of the same subject. Alternatively, his general tendency was to make small gouache studies on canvas or paper very similar to the "finished product," or larger, careful charcoal or pencil drawings, though the final oils are studio productions. But it should be emphasized that his preliminary watercolors were usually finished—and exhibited—works in their own right, often exhibited earlier, sometimes by many years, than the oil paintings from which they ultimately derived.

Fig. 3. *On the Rhine*, 1905; oil on canvas; 24 × 32 inches; New Britain Museum of Art, New Britain, Connecticut, J. B. Talcott Fund (1916.1); Photograph courtesy of James Kopp

Cooper seems also to have carefully calculated the range of architectural subjects that would gain him recognition, especially when exhibited at the country's more prestigious venues. Thus, in 1904, at his old turf, the Pennsylvania Academy of the Fine Arts, he exhibited three oil paintings, one each of Philadelphia, Chicago, and New York. The Chicago picture, *Skyscrapers: Randolph Street, Chicago* (fig. 9) would be his most often-reproduced Chicago picture (including in the academy's exhibition catalogue), while his Philadelphia painting, *Broad Street Station, Philadelphia* (cat. no. 11) won the Jennie Sesnan Medal. Cooper obviously sought skyscrapers in his home city as well as in New York, but Philadelphia could not compete in that realm. Here, the red brick towers of the façade of the railroad station at the left are in brilliant sunlight, while opposite is the facade of Philadelphia's City Hall, its crowning statue of William Penn casting its shadow on the street below.[27] Cooper was also to enshrine the train station in *Broad Street Railroad Station*, more accurately known as *Glass Train Shed, Broad Street Station, Philadelphia* (cat. no. 23), in which the modern industrial subject is isolated against the distant backdrop of the city skyline with Philadelphia City Hall rising in the center, centering on the giant, steel-enclosed glass maw from which issue forth steaming railroad trains.[28] The station had been built in 1881, but the train shed covering the tracks was completed in 1892, atop a retaining wall known locally as the "Chinese Wall" (and visible in Cooper's picture), obstructing traffic with its low underpasses. It extended almost half a mile and divided Philadelphia across the middle along Market Street.

Likewise in 1904, at the Louisiana Purchase International Exposition held in St. Louis, Cooper showed a watercolor, *Broad Street, New York*, along with both the previous Philadelphia and Chicago oils, and one titled *Pennsylvania Avenue, Washington, D. C.* (unlocated). Nor had Cooper by any means given up Old World subjects. Even while turning to soaring modern architecture, he was creating picturesque European views such as *On the Rhine* (fig. 3). Nevertheless, critics were quick to perceive and acclaim the change in the direction of Cooper's architectural subjects. In 1904, Charles Caffin noted that "Colin Campbell Cooper has turned from the study of old architecture abroad to the painting of street scenes in American cities with a very marked advance, both in reality of representation and pictorial

quality."[29] Added to their modernity was their distinctly nationalistic appeal. Two years later, Willis E. Howe wrote of Cooper:

> He settled in New York and quickly discovered that Manhattan Island had as much of the striking and the picturesque as the Old World towns among which he had been roaming. What is more, the monster buildings he saw around him, a distinctive New World product, offered an undreamt of field of opportunities. . . . They had not the flavor of antiquity, but they had . . . the suggestion of sublimity, the spirit of progress and promise, the manifestation of a merging, restless, all-attempting, all-achieving life essentially American.[30]

Still, once Cooper had moved to New York, many aspects of its urban life dominated his easel. While the majority of these were views along the avenues, streets, and "canyons," dominated by the new skyscraper buildings, he did, in fact, create a wide panoply of images, a number of which present a broad sweep of lower New York. One of the first of these was *The Wall Street Ferry Slip (The Ferries, New York)* (cat. no. 17), which he exhibited at the Worcester Art Museum, Massachusetts, in 1904, and copywrited three years later as *The Ferry Slip*. Here, a packed ferry is crossing the Hudson River to its terminus, surrounded by other low-lying buildings, all painted in brownish tones, with the great new towers of the modern city rising behind them, dwarfing even the distinct profile of the spire of Trinity Church at the head of Broad Street on Broadway. White smoke from the foreground vessels mixed with industrial smoke and the great cumulus clouds define the city as an apparition which the low-slung ferry is approaching. Exhibited in the Paris Salon in 1906, this was probably one of Cooper's first paintings to glorify the "new" New York in an international forum.

The Wall Street Ferry Slip is Cooper's earliest and most dynamic view of the New York waterfront and skyline but hardly the only one. Not surprisingly, however, later, similar views tend to be more staid, lacking the sense of discovery embodied in the early masterwork. In Cooper's *Hudson River Waterfront* (cat. no. 55), the artist has assembled the great towers that dominated lower New York—the Singer Building at the right and the Woolworth Building at the left, more a series of variegated blocks of rising towers, and in the foreground, the small ferries and tugs now compete with ocean-going liners along the placid Hudson. In his *New York from Brooklyn* (cat. no. 58), Cooper has moved to the other side of Manhattan, and even further away from the tall buildings where only the Woolworth Building is easily recognizable, and the picture emphasizes more the docks and river traffic on the Brooklyn side.

Nor are all of Cooper's most vibrant New York scenes dominated by skyscraper constructions. The tall buildings of City Hall Park, at the entrance to the Brooklyn Bridge, would seem to dominate Cooper's *The Rush Hour, New York City* (originally *The Brooklyn Bridge Entrance. N.Y.* (cat. no. 15),[31] but these loom as slightly menacing forms in the background, while the true subject of the picture is the rush of working people onto the trolleys and down into the subways. In his later *South Ferry, New York* (cat. no. 49), the brightly illuminated, multicolored old buildings at the right overlook the activity of both pedestrian and equestrian figures, and modernity is represented more by the elevated railroad than the tall, pale, distant skyscrapers, in this case, the pyramid-topped Banker's Trust Building (1912) at

8

Mountains of Manhattan, c. 1903
Oil on canvas
42 x 68 inches
Collection of the City of Santa Barbara
Photograph courtesy of Scott McClaine

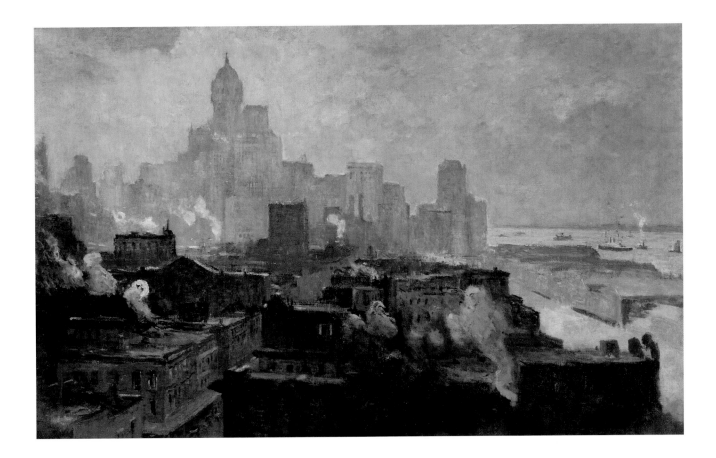

9

Broad Street Cañon, New York, 1904
Oil on canvas
56 x 39 inches
Leonard N. Stern School of Business, New York University

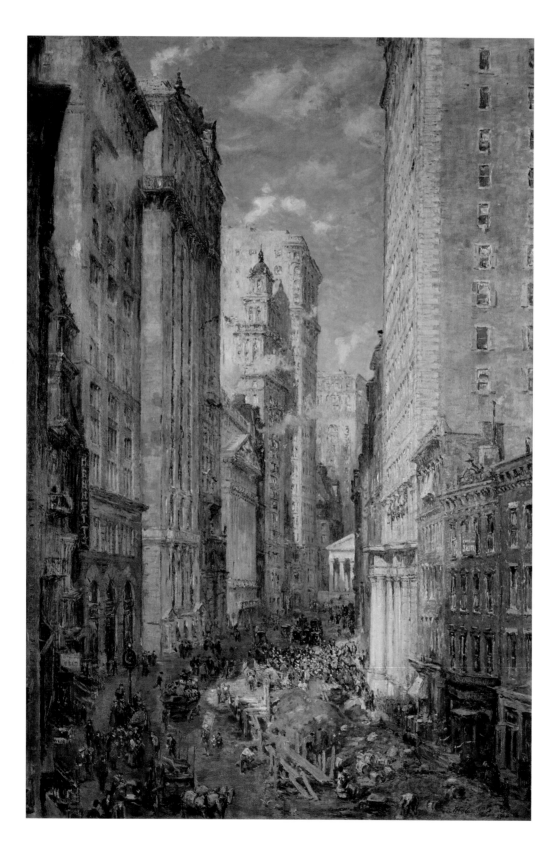

14–16 Wall Street on the right, and the Equitable Building (1912–15) at 120 Broadway, on the left. In fact, between the foreground scene and the skyscraper background is the older, massive, fortresslike red brick United States Army Building at 30 Whitehall Street (1886).[32]

What is certainly one of Cooper's last great paintings of modern New York is his *Chatham Square Station, New York City* (cat. no. 52) of 1919. Here, the viewer (and the artist) is on a level with the rounding elevated railroad tracks of the Third Avenue Elevated Railroad at Chatham Square, at the north end of Park Row, which at the time was a major transportation hub: Mott Street, The Bowery, Division Street, and East Broadway all converged here, along with both the Second and Third Avenue elevated lines.[33] As a train comes speeding into the station in Cooper's painting, the dynamics of the curve are echoed in the shadows of the tracks falling upon the pavement below. Dozens of commuters of all ages and dress wait on the platform, while horse-drawn and motorized vehicles, pedestrians, and even a marching naval band enliven the ground scene. The diversity of the area is emphasized not only in the variety of architectural styles of the old buildings surrounding the tracks, but also in the range of merchandizing on the left, including "Simpson's Loans" and "Rome Movies." An American flag flies proudly from the tallest building at the left, while in the background are distinct Wall Street skyscrapers, such as the Singer Building, and at the right, near to hand, is the gigantic Municipal Building (1914). As vital as the painting of Chatham Square is, the extant drawing and gouache (cat. no. 53) also fully embodies Cooper's conception of the dynamism of lower New York City.

Moving into the interior of the great city, one of Cooper's sweeping New York views, *Cliffs of Manhattan* (cat. no. 7), was exhibited at the New York University Settlement Exhibition in 1905.[34] In this view from Lower Manhattan, Cooper captured the jaggedness of the skyline of soaring buildings interspersed with low-lying ones. The isolated tall structure in the center is probably the Lorsch Building, while to the left is the Sheldon Building at John and Nassau streets, and farther left is the two-turreted skyscraper of 1899, the Park Row (or Syndicate) Building. The broken outline confirms Henry James's impression of New York a few years later: "New York may indeed be jagged, in her long leanness, where she lies looking at the sky in the manner of some colossal hair-comb turned upward and so deprived of half its teeth that the others, at their uneven intervals, count doubly as sharp spikes."[35] James was only one of a number of writers in the early twentieth century to deplore skyscraper construction, though even he recognized some degree of beauty in them, noting their "felicity of carrying out the fairness of tone, of taking the sun and the shade in the manner of towers of marble."[36] A particularly panoramic example of Cooper's New York views is his *Mountains of Manhattan* (cat. no. 8), a fascinating counterpoint of older midtown structures in gloomy russets and browns against the pale violet backdrop of the new New York. White puffs of smoke issue from the buildings in the foreground, but the skyscrapers in the distance rise serenely toward the heavens, dominated by the distinctive tower of the domed, forty-seven-story Singer Building (1908). This was the tallest building in the world, though for only a year, when it was surpassed in height by the Metropolitan Life Tower (1909), which in turn was exceeded four years later by the Woolworth Building.[37] The names of these buildings themselves identify the displacement in American aesthetic interest, from the majestic landscape painting of the nineteenth century to the urban glorification of the twen-

tieth. The terminology remained, however, with cliffs, mountains, and canyons now discovered in the urban panorama. And both subjects are seen from on high, the viewer situated above the old New York, but on a level where so many art patrons were now spending much of their corporate and even personal lives.

The debate about the aesthetic merits of the skyscraper is beyond the scope of the present essay; needless to say, the crowding and giganticism of the new structural form had both its partisans and its adversaries, among the latter the well-known architectural critic Montgomery Schuyler.[38] Early on, critics recognized Cooper's unique pictorial solution to the representation of the skyscraper; when some of his first skyscraper pictures were exhibited at the Pennsylvania Academy annual in 1904, a writer for the *Washington Post* noted that they were "well-painted, artistic, and amazing. The unpaintable painted at last."[39] In 1909, Cooper himself authored a two-part "how-to" article on the paintings of skyscrapers. Using five New York skyscraper paintings, one of the bridge at Parthenay, France, and two diagrams, he described his own methodology. In addition to his discussion of technical issues of canvas versus paper, opaque versus transparent watercolor, and various kinds of brushes, Cooper considered perspective. He described relinquishing a concern with the ordinary rules of perspective toward a horizon line, and replacing it with a cardboard in which an oblong hole had been cut, relative to the verticality of skyscraper construction, and holding it at a greater or less distance from the eye to bind the composition of the picture. From then on, within the "box," the student was advised to pinpoint certain structures and to draw lines between them to determine the perspective angles in relationship to one another. Cooper's second article addressed color in a more traditional manner, but with a concern about the color of light rather than the color of "things," and with shadows effected through complementary colors, including building overhangs, and with a consideration of a gray day, in which the light would be a cool gray, and its shadows a complementary warm gray.[40]

The majority of Cooper's paintings of "The New New York" center around the streets off Lower Broadway, the canyons between the skyscrapers, and a concentration on groups of the new high-rise structures that gave the city its distinction. This began early on; indeed, the painting that could be said to have "made" Cooper's reputation, as he himself was to confirm, was his painting *Broad Street Cañon, New York* (cat. no. 9). This is, indeed, the "new" New York, a view down Broad Street toward Wall Street, with construction underway in the foreground and masses of figures on the Curb Exchange—those traders who had no place inside the Stock Exchange itself. Featured at the left is the newly erected, pedimented Stock Exchange, built just the previous year, surrounded by the twenty-one-story Commercial Cable Building and the ornate nineteen-story Gillender Building (both 1897). These are contrasted with the "old" New York—the 1842 Sub-Treasury building (1842) at the rear, and the Mills Building (1883), seen only in the shadows on the right. Presumably, Cooper utilized his usual procedure of first producing a watercolor of the subject the previous year, *Broad Street, New York*, shown in St. Louis earlier in 1904, after winning the William T. Evans Prize in April 1903 at the American Water Color Society Annual.[41] In this case, Cooper also prepared a series of oil studies varying in degree of size and finish before completing the monumental version. The artist also executed variants of the picture, such as *The Financial District* (cat. no. 18), with the artist moving slightly closer down Broad Street. This work is far more

10

Flat Iron Building, 1904
Casein on canvas
40 x 20 inches
Dallas Museum of Art, Dallas Art Association Purchase

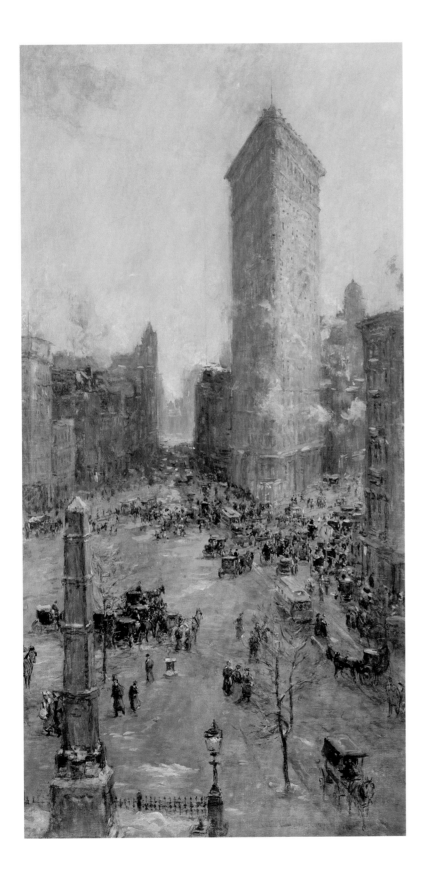

11

Broad Street Station, Philadelphia, 1905
Oil on canvas
45 x 33 inches
Courtesy of Payne Gallery of Moravian College
Bethlehem, Pennsylvania

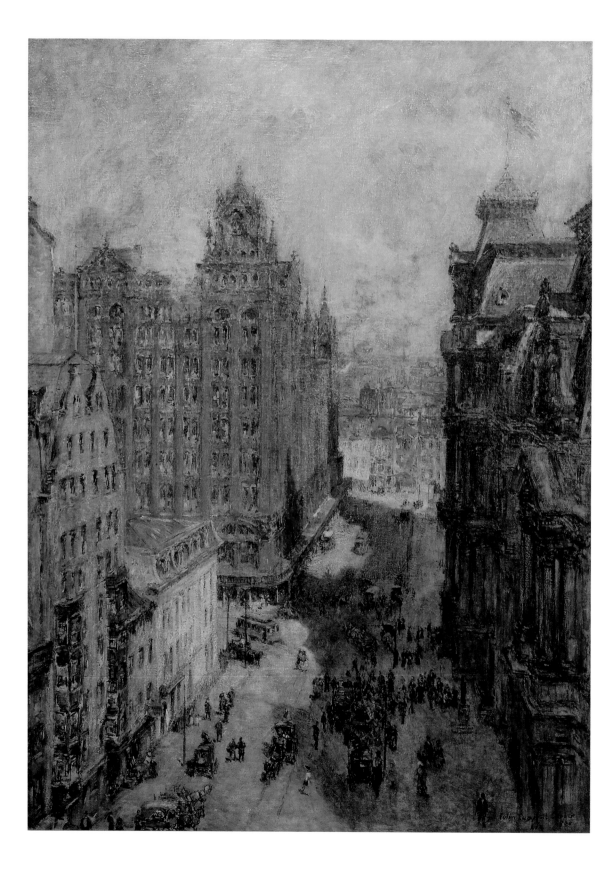

broadly handled, with swirling, stormy skies, and a complete shift of the light source, so that the Stock Exchange and its surrounding buildings are in shade, and those on the south side of the street receive brilliant sunlight. This view became an icon of New York as the world's modern, financial capital, replicated in an etching by Joseph Pennell in 1904, and reproduced with minor variations by Childe Hassam three years later as *Lower Manhattan (Broad and Wall Street)* (Herbert F. Johnson Museum of Art, Cornell University, Ithaca, New York), and was the subject of numerous watercolors several decades later by John Marin.

Cooper himself was enthralled by the vista down Broad Street. He wrote:

> Broad Street above Beaver Street I consider one of the grandest things ever concocted by man. Nothing anywhere else approaches it. It has a very handsome skyline, a perfect balance. It was one of the very first things I painted after arriving in New York.... One of the points that strikes me about this view up Broad Street is the dramatic contrast between the old, low type buildings put up in the 50s—both brick buildings and those of the type occupied by J. P. Morgan & Co. [the Drexel Building]—and the great skyscrapers. My pictures are built on these contrasts.[42]

After much celebration, the painting was acquired in 1906 by the Cincinnati Art Museum from its annual exhibition of work by American artists, and the image became known to many through a facsimile edition of 250 impressions;[43] it was deaccessioned by the museum through the Coleman Auction Galleries in New York in the autumn of 1945.

Cooper's replacement of revered monuments of antiquity with the structures of modern civilization was immediately recognized and, for the most part, highly praised. In one reverential piece, significantly illustrating *Broad Street Cañon* as its frontispiece, Albert W. Barker noted that "Mr. Colin Campbell Cooper began to paint sky-scrapers and American street scenes a year or two ago, and at once drew the attention of all who are in touch with the world of art." With faint praise, Barker noted that Cooper had been

> known as a painter of pleasant and workmanlike pictures long before he awoke to the possibilities of the modern office building, but he had been hitherto a painter of cathedrals and picturesque corners of the Old World. Our interest in these things, if we will own the truth, is only an amateur's interest, not at all a downright vital interest. . . . As students and artists we admire and study these wonderful buildings; but we have no share in the spirit that produced them, or we would be building them today. . . . They are venerable, and we have respect for them as for the ideals and works and companions of our grandparents.

In contrast, Barker noted that: "There is every mark of this spirit in Mr. Cooper's sky-scrapers. His enthusiasm is contagious; as a colorist and luminist, as a painter of light and color for their own sakes, his message rings truer and has a quicker accent than of old, and is the more convincing because he is talking of it in relation to ourselves and our own surroundings."[44]

The success of *Broad Street Cañon* may well have reinforced Cooper's determination to continue to explore the skyscrapers and modern city. A number of his major works, pictures

that were exhibited and reproduced time and again, such as his *Bowling Green*, probably painted in late 1906 or early 1907, are presently unlocated. *Broadway from the Post Office (Wall Street)* (cat. no. 21) was probably painted in 1909, when it appears in his account book as intended for the Carnegie International held in Pittsburgh, though the artist then withdrew this submission.[45] The massive gray hulk of the old Post Office, in the southwest corner of City Hall Park, shadows the left side of the canvas, while sunlight streams along Broadway past the porch of St. Paul's Episcopal Church in the foreground; in the rear rises the Singer Tower at Liberty Street, just built in 1908. The two buildings, Post Office and Singer Tower, are symbols of the old and new New York. By eliminating the mansard roof of the Post Office, Cooper devised an unbroken upward-soaring composition, characterizing the modern city, heightened as in many of his New York paintings, by an elongated vertical format for the pictorial playing field of modernity, just as nineteenth century landscape painters were prone to horizontal—at times extremely horizontal—pictorial formats.

Moving farther down Broadway, beyond the Singer Building, Cooper painted *Broadway* (cat. no. 20), which may be the painting that Cooper exhibited as *Broadway near Wall St., N.Y.* when it was first shown with the Dietrick Art Company in St. Louis. Here, beyond Richard Upjohn's venerable Trinity Church (1839–46) at the left, its age emphasized by the warm sandstone, rises the sparkling white Trinity and United States Realty Buildings (1905–1906); right behind them, surmounted by the American Flag, is the Singer Building, finished just the year before Cooper painted this picture. Now, Broadway, filled with pedestrians, trolleys, and horse-drawn cabs, is in shadow, while the viewer's attention is drawn to the massive white walls of the skyscrapers on either side of the great avenue. And while Broadway was Cooper's primary avenue for exploring the skyscraper city, it was not his sole painting ground. *Fifth Avenue, New York City* (cat. no. 13) shows a view up Fifth Avenue from Thirty-second Street, centering on the world-famous old Waldorf-Astoria Hotel, between Thirty-third and Thirty-fourth streets, built in 1897 and demolished in 1929, now the site of the Empire State Building.[46] This was a much-reproduced view of the hotel, New York's most famous hostelry at the time, with the Neoclassic façade of the Knickerbocker Trust and Safe Deposit Company on the next corner. Though a secondary element in the painting, the Knickerbocker Trust Building, with its small flat-roofed white classical façade, serves to magnify the prestigious height and soaring towers and pinnacles of the rich dark stone and multiple window openings of the great hotel. In turn, the dark stone spire of the Brick Presbyterian Church up at Thirty-seventh Street adds a distant vertical counterpoint to the Waldorf-Astoria.

In 1917, Cooper painted his dynamic view *Metropolitan Tower, New York City* (cat. no. 48).[47] Views in and around Madison Square were multiple in the works of artists such as Childe Hassam and Paul Cornoyer, but these tended to be on the Fifth Avenue side of the square, contrasting the verdant park and the structures opposite, such as the Fifth Avenue Hotel. Instead, Cooper chose to look down Madison Avenue from the west side of the park, creating three distinct architectural complexes. In the left foreground is the "old" section of the avenue, small, anonymous red brick buildings, the closest with the world "lunch" inscribed on its window, and at the end of the block, the "Garden Hotel," the name emblazoned on its north wall, certainly an inexpensive hostelry compared with those across the square. Then,

12

St. Paul's Chapel, 1905
Oil on canvas
33 x 22 inches
Mongerson Galleries, Chicago

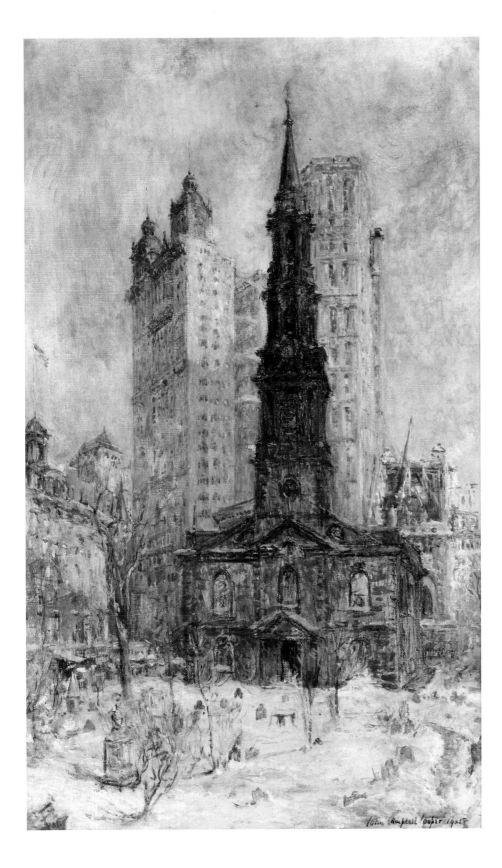

13

Fifth Avenue, New York City, 1906
Oil on burlap
39 x 27 inches
The New-York Historical Society, Museum Purchase
James B. Wilbur Fund, 1940.956

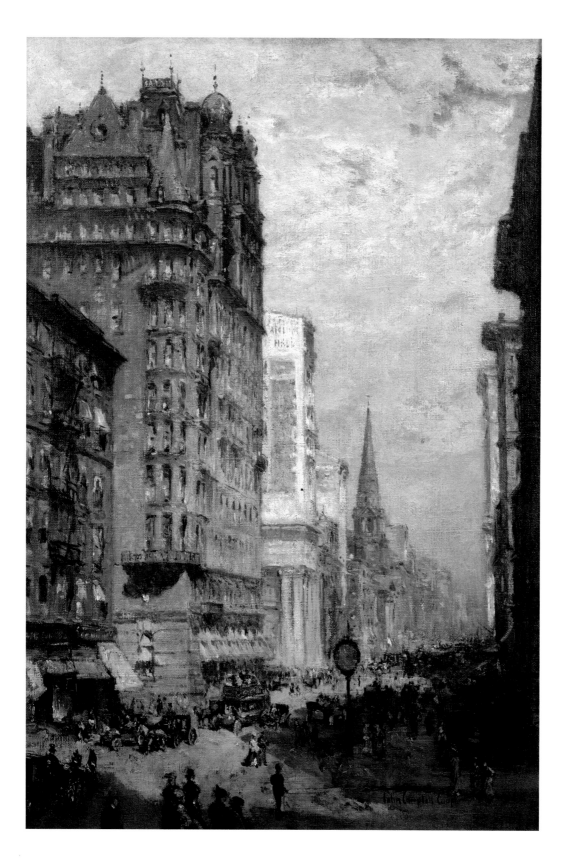

at Twenty-seventh Street rises the exotic Moorish architecture of the city's premier indoor playground, Madison Square Garden, which opened in 1890, with its great tower facing Twenty-sixth Street, modeled on that of the Cathedral of Seville, Spain. Madison Square Garden was one of the city's great architectural landmarks, hosting everything from recitals and Shakespearean performances to automobile shows and boxing bouts; its most memorable event occurred on the night of June 25, 1906, when the building's architect, Stanford White, was shot to death by Harry K. Thaw, over White's affair with Thaw's wife, Evelyn Nesbitt. The last major event to take place in the Garden was the Democratic National Convention of 1924; the wrecking ball arrived on January 9, 1925.

Beyond the Garden rises the tower of the Metropolitan Life Building, seen in glowing yellow and blue haze, truly the "skyscraper city". The original building at Madison Avenue and Twenty-third Street dated from 1892, but the tower at the corner of Twenty-fourth Street was added in 1909, making it the tallest building in the world until the completion of the Woolworth Building in 1913. The picture may be read as the progression from the world of ordinary folk, to that of entertainment, to that of corporate business. And this is a city in transition; construction is in progress on the west side of the block between Twenty-eighth and Twenty-seventh streets, while overhead fly the flags of the United Sates and Great Britain—that of the United States of course the more prominent—allies during this period of the first World War. And the street traffic is in flux, with pedestrians walking the avenue or crossing the street; one, a uniformed soldier, underscores the wartime situation. Transportation is in flux, too, with a horse-drawn delivery wagon at the left, while open and closed motorized vehicles testify to the variety of street traffic and mechanized advancement. Activity is further noted by the steam curling above the buildings at the left—a common device in many of Cooper's cityscapes, denoting industrial enterprise through the man-made "response" to the clouds in the sky.

If the flags are only incidental to *Metropolitan Tower, New York City*, they are small but key elements in Cooper's great *Lower Broadway in Wartime* (cat. no. 47), the artist's response to the American and Allied war effort as expressed through the architectural triumphs of the metropolis. Set in the verdant landscape of City Hall Park, with the 1899 Park Row Building, the old Post Office of 1875, and the Saint Paul Building, also of 1899, in relative shadow at left, Broadway is viewed from on high as a procession of infantry and cavalry proceed up the great avenue alongside a row of trolleys and witnessed by throngs of observers. The enormously elongated format of the painting allows for the representation of the full height of the Woolworth Building which reaches up to the heavens, implicitly calling down upon the procession God's beneficence. Other easily identifiable structures also on the west side of Broadway include the 1894 Home Life Insurance Company of 1894, with its peaked mansard roof, and next to it the Postal Telegraph Cable Company Building. Beyond the Woolworth Building is the Singer Tower. All are bathed in glorious sunlight, their façades only slightly interrupted again by white steam curls. *Lower Broadway in Wartime* is, in some ways, an elaboration on the earlier *Broadway from the Post Office (Wall Street)*, with additional nationalistic and reverential elements.

In *The Three Towers* (cat. no. 54), Cooper chose a viewpoint contrary to *Lower Broadway in Wartime*. Set now at ground level in a great "canyon" of New York, a military parade makes

its way down Broadway past throngs of pedestrians held back by the police, passing Trinity Church at the left, with the Trinity and United States Realty Buildings rising behind and behind them the distinctive Singer Tower. The Woolworth Building, now in the distance, is the third of the three great towers (Trinity, Singer, Woolworth), following a trajectory both geographic and chronological. The towers of the title are both religious edifices and corporate structures, and Cooper is careful to emphasize that the shadow of the church falls upon and almost caresses in benediction the commercial structures behind it. The picture also memorializes the city's strength during a time of adversity, with the flags of the Allied nations unfurled from the tall buildings. *The Three Towers* may be a wartime painting or may record a postwar celebration in 1919, for it was exhibited at Abraham and Strauss Department Store early in 1920.

Just as Cooper continued to exhibit, and presumably to paint European scenes long after he had established both his residence in the United States and his reputation as a painter of American urban subject matter, so even after he moved to Santa Barbara, New York subject matter still figured in his oeuvre. An example monumental in expression if not in scale is *Chambers Street and the Municipal Building, N.Y.C.* (cat. no. 57), painted in 1922. The view is toward the east on Chambers Street, with one of the great monuments of Victorian architecture, the New York County, or "Tweed" Courthouse (1858–78), at the right, and the much later Hall of Records (1899–1911) on the left. But the focus is upon the Municipal Building of 1914, which looms up majestically and almost spectrally in the center distance, its wings enfolding the scene, while visible rays of sunlight streaming in from the upper right onto the Hall of Records partially obscure the great central structure. In this late urban scene by Cooper, light itself is almost as much the subject as the buildings; solid architectural forms begin to dissolve, while the paint handling is looser and freer, more "impressionistic" than in his earlier city views. The picture appears to have made its debut at the Los Angeles County Museum of History, Science, and Art in March 1923.

Cooper and Childe Hassam were the two most prominent artists associated with the development of an urban iconography and the celebration of the modern city, especially New York, although there were others such as Paul Cornoyer who contributed significantly to this relatively new genre. Hassam had begun earlier and, his *Flag* series of 1916–19 aside, the greater number of his New York views date from the 1890s, rather than the first two decades of the twentieth century. Except for their nearly identical views down Broad Street—and Cooper's was painted three years earlier than his colleague's—Hassam was not primarily a painter of the skyscraper city—skyscrapers and tall buildings, in fact, are more often seen through the curtains of his *Window* series (1909–19) than as direct views of New York's great streets and avenues. There appears to be no documentation of rivalry between the two artists, though critics, then and now, made mention of their similar interests and contributions. Nevertheless, it would seem that Cooper was very conscious of Hassam's achievements and reputation, and intentionally sought to differentiate his work from that of the older artist. If Hassam's New York paintings often concentrated on Washington, Union, and Madison squares, these were urban centers that do not figure in Cooper's work. In fact, one major distinction between their urban work is implicit in the concern that Hassam (and others such as William Merritt Chase) displayed in the urban landscape—in parks and grassy,

14

Old Grand Central Station, 1906

Oil on canvas

24¼ x 32 inches

Collection of the Montclair Art Museum, Montclair, New Jersey

Gift of Mrs. Henry Lang, 1927.7

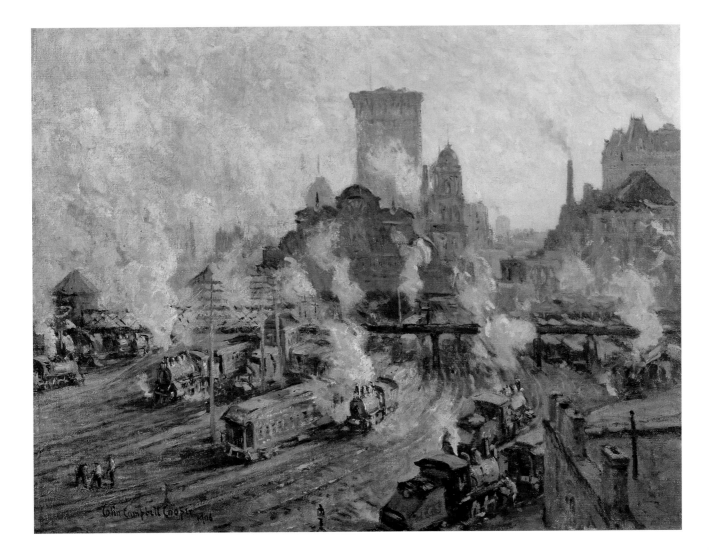

15

The Rush Hour, New York City, 1906

Oil on canvas

32 x 44 inches

The New-York Historical Society, Gift of George A. Zabriskie

1947.9

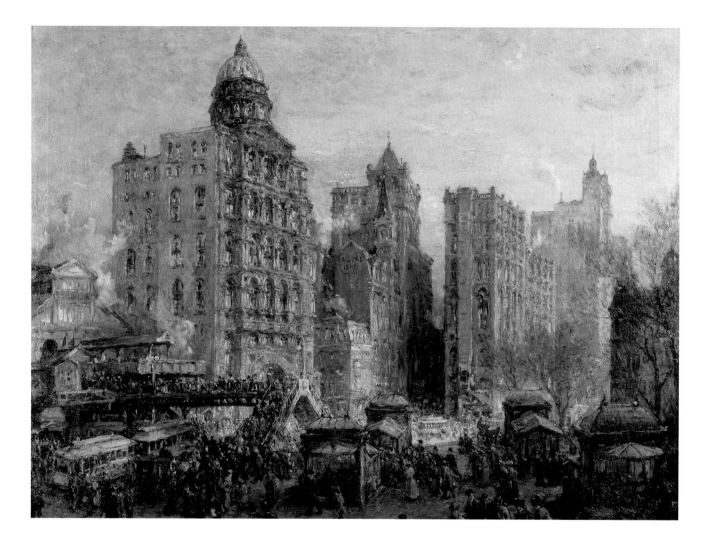

tree-lined squares. Cooper, on the other hand, rarely painted such subjects, and those that are known, his *Central Park in Winter*, *Bowling Green*, and *Bowling Green, Snow Storm* (all unlocated), along with a second *Central Park* (David Findlay, Jr.), also a winter scene, and his *City Hall Park, New York* (City of Santa Barbara), another winter scene, are devoid of the verdancy that makes Hassam's and Chase's pictures so colorful and appealing.[48] If Hassam's *Flag* pictures concentrated on Fifth Avenue at Midtown, Cooper remained in his favorite locale around lower Broadway.

And if Cooper was drawn to a favorite location farther north, it was along Central Park South, anchored at the east by the Plaza Hotel (1907), which Cooper painted,[49] and at the west by Columbus Circle, which figures relatively seldom in Hassam's artistic production, but which Cooper recorded in at least two outstanding canvases. The first, *Columbus Circle* (cat. no. 22), painted in 1909, is a panoramic view painted from the rooftop of the Gainsborough Studio Building where Cooper had moved just the year before.[50] Columbus Circle was a relatively new municipal center, so designated only in 1892 in an attempt to match the magnificence of its eastern counterpart, the Grand Army Plaza. Still, it was the meeting point of eight elevated railroads and surface lines of transportation, and in the years just before Cooper settled there, it was the subject of extensive improvement in the rerouting of traffic patterns. Rising high in the center of Cooper's composition is Gaetano Russo's statue of Columbus, a 400th-anniversary gift of Columbus's discovery of America. But Cooper's real delight was the variety of sizes, shapes, and roof lines of the buildings surrounding the circle, described by one historian as "the peculiar conflict of incompatible neighborhoods."[51] On the far horizon is the Gothic Church of St. Paul the Apostle (1876–85) on Ninth Avenue and Fifty-ninth Street, in New York second in size only to St. Patrick's Cathedral. A counterpoint in both size and purpose is the famed Majestic Theatre, with its corner dome, owned by William Randolph Hearst, which opened in 1902 with the musical extravaganza *The Wizard of Oz*, followed the following year by Victor Herbert's *Babes in Toyland*. Thus, Cooper's public would have recognized Columbus Circle as an entertainment center for the city. Typically, Cooper concentrated on the full circle of buildings, omitting only the corner of Central Park, which might otherwise be included in the lower right.

Columbus Circle (cat. no. 59), painted probably more than a decade after his earlier treatment of the subject, may have been the painting he first showed in 1923 in one of the leading commercial establishments in Los Angeles, the Kanst Galleries, and then exhibited at the 1924 annual of the National Academy of Design. Cooper perhaps painted it during a visit to New York after he had settled in Santa Barbara. The view is now from ground level, and centers on the shaft of the Columbus statue, while the turn-of-the-century buildings, such as the Majestic Theatre at the right, are dwarfed by the great high-rise structures behind them and to the left on Central Park West. The bright sunlit view appears to have been taken after a rainstorm, for the pavement, crisscrossed by numerous motorized vehicles and a significant number of pedestrians, is glistening. If Cooper's first view of Columbus Circle celebrates architectural diversity, this later painting, unusual for the artist, is more a picture of contemporary urban life, now seen afresh by an "outsider."

Another distinction between Cooper's and Hassam's depictions of New York concerns their choices of individual structures on which to center their art. Churches of all denominations figure strongly in Hassam's oeuvre, from his depiction of the First Presbyterian Church in Lower Fifth Avenue (private collection) painted in 1890 immediately after he settled in the city, to his emphasis on both St. Thomas's Episcopal Church and St. Patrick's Cathedral in his *Flag* series of 1917–18. By contrast, Cooper's depiction of churches was minimal; specifically, he painted individual images of the two structures set among the tall skyscrapers of lower Broadway, St. Paul's Chapel and Trinity Church. In his views of the great avenue, these are always overshadowed by the architecture of modernity, but in his singular images he recognized their symbolic significance as edifices religious, historic, and traditional. Furthermore, they appear in his canvases at just the same time he began to paint the city's skyscrapers. Cooper was represented in the 1905 annual of the National Academy of Design by his *Trinity Church, New York*, which may be the painting *Wall Street Facing Trinity Church* (fig. 4), which centers on the 1846 Gothic church in the distance during a snowstorm, and contrasts architecturally and fundamentally with the columned and pedimented portico of the former Greek Revival Sub-Treasury Building (1842) at the corner of Wall and Nassau streets at the right, fronted by John Quincy Adams Ward's 1883 statue of George Washington.[52]

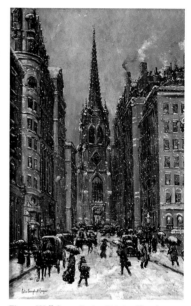

Fig. 4. *Wall Street Facing Trinity Church*, 1905; oil on canvas; 24 × 20 inches; Erwin and Margaret Zeuschner Collection

Cooper's *St. Paul's Chapel* (cat. no. 12) features New York's only pre-Revolutionary building in continual use. Located between Fulton and Vesey streets, the church, constructed in the 1760s with a tower and steeple of 1796, rises impressively from the graveyard in the snow at the rear, while it is silhouetted against the soaring skyscrapers behind it, including the Park Row Building at the left. The contrast between the chapel's dark, solid stonework and the pale tones of the tall buildings causes the skyscrapers to appear almost ephemeral, despite their imposing size. Here Cooper offered an explicit contrast between the spiritual and the commercial. *St. Paul's Church, New York*, presumably this same picture, was exhibited numerous times beginning in 1906 in Poland Springs, Maine; in Bethlehem, Pennsylvania; Fort Worth, Texas; and Columbia, South Carolina. Cooper's account book indicates that he had intended to first exhibit the painting at the Boston Art Club in 1906; this entry was crossed out and when, in 1907, a picture of that title was shown at the club, it was the watercolor version.

One of Cooper's most unusual pictorial images of a single structure is his rendition of the Neo-Gothic *Hunter College* (cat. no. 30), probably painted in 1919. Up at Sixty-eighth Street and Lexington Avenue, he was far from his usual painting haunts, and the spirit of the picture is very different, idyllic rather than aggressive, emphasizing the vermillion of the pressed brick. These warm tones contrast with the green ivy overgrowth and the impressionistically painted trees and bushes fronting the four-story building with a two-story tower rising above it, silhouetted against a cloudy blue sky, all in bright sunlight. Hunter College had been founded in 1869 as the Normal and High School for the Female Grammar Schools of the City of New York, renamed the Normal College of the City of New York one year later, and working out of rented space on Broadway until it moved into its new Neo-Gothic building on Lexington Avenue between Sixty-eighth and Sixty-ninth streets. This structure was built in 1871–73, on a plot of land that had been part of Hamilton Square, a city-owned

16
The Rialto, 1907
Oil on canvas
53 x 36 inches
Private Collection

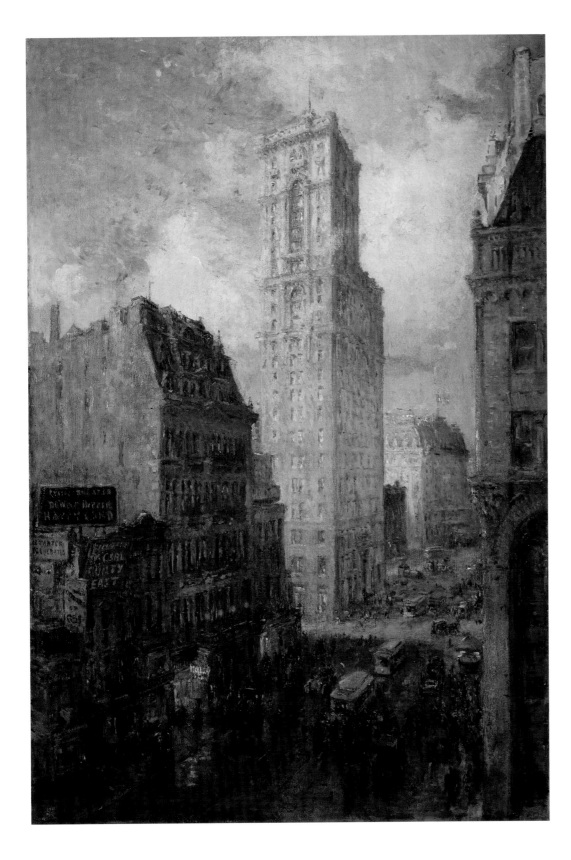

17

The Wall Street Ferry Slip (The Ferries, New York), 1907
Oil on canvas
34 x 50 inches
Collection of Greg and Sharon Roberts

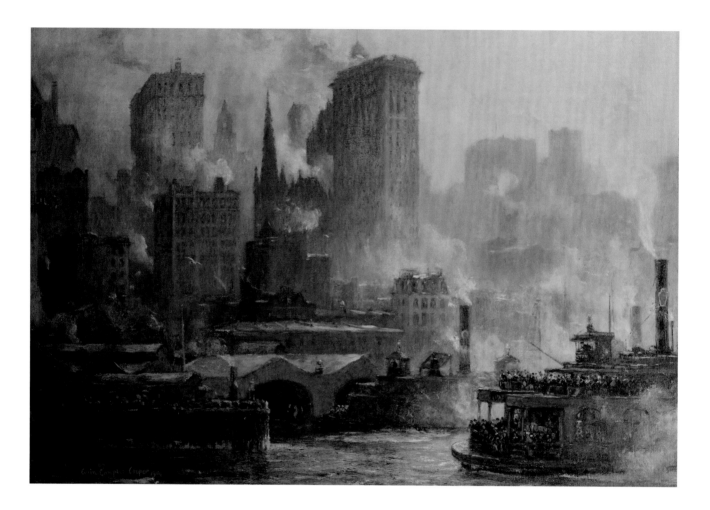

park that was eliminated as a response to the creation of the nearby Central Park. The building was designed by Thomas Hunter, a New York City school principal, who had brought the college into being and became its first president until his retirement in 1906; the structure was consistent with the Ruskinian belief that Gothic was the only appropriate architectural style for an educational institution. The school remained a women's college, and women are seen along the interior sidewalk and walking up the steps to pass through the welcoming doors, while two more ladies arrive in a horse-drawn carriage. It was renamed Hunter College after Thomas Hunter in 1914.[53]

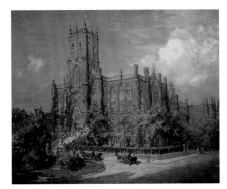

Fig. 5. *Hunter College, New York*, 1919; oil on canvas; 40 × 50 inches; Collection of Hunter College of the City University of New York

The present work is actually a complete image of the tall tower of the old Hunter College Building, and represents the left half of a painting, double its size, now in the collection of Hunter College (fig. 5). Aware of some consideration to demolish the building in 1919, a group of alumnae, led by Betsey Davis, inquired if Cooper might be interested in memorializing it in a painting, though they did not actually commission the picture.[54] In June of that year, Cooper began making studies for his painting from the window of the home of Mrs. Anderson Fowler, whose residence was on the southwest corner of Sixty-eighth Street and Park Avenue, during her last week of occupancy; the building was torn down soon after. Cooper's two oils of the college also include the shrubbery in the little park on Park Avenue, laid out in 1879, and nicknamed "The Joy Forever," which was torn up in 1920.[55] While the alumnae paid for the framing of the picture, funds were scarce for its purchase, and when Cooper was leaving for permanent residence in California, he inquired if one of the alumnae might not take possession of the work and hang it, until it was purchased for Hunter's Alumnae Hall. Mrs. Harry Content thereby became the custodian of the large picture.[56] The college continued its attempt to raise sufficient funds for the purchase of the work, which was transferred to the new quarters of the Associate Alumnae late in 1923, and it may have been at this time that the large picture came into their possession.[57] The history of the picture in the present exhibition is not known.[58]

In the main, though Cooper's New York fame rested primarily on the attention he lavished on the city's new skyscrapers, his vision encompassed the entirety of the "new New York." A structure very different from those on lower Broadway, and certainly contrary to the refined idyllicism of Hunter College, was the attraction he found in Manhattan's Grand Central Station. He painted *Old Grand Central Station* (cat. no. 14) in 1906, and then three years later, a bigger but largely unchanged version *Grand Central Station* (fig. 6). Indeed, the image is a pictorial equivalent of Cooper's aesthetic goals as defined by Albert W. Barker: "the essence of the visible turmoil and glory of industrialization."[59] The subject was a "natural" for Cooper, who had just settled in New York; he had, after all, begun his investigation of the modern city with paintings of the Broad Street Station in central Philadelphia (cat. no. 11), one of which was a not dissimilar view of the *Glass Train Shed, Broad St. Station, Philadelphia* (cat. no. 23). Differences abound, too, for in his New York paintings, the dynamics of railroad travel appear significantly increased, just as the forms of the station are obscured by the thick swirls of steam emanating from the locomotives going in and out of the station, and behind the station itself rise several tall buildings identifying the skyscraper city. At the same time, the picture is something of a memorial, as evidenced particularly by the almost chaotic pattern of billowing steam. For just at this moment, the original station, built by

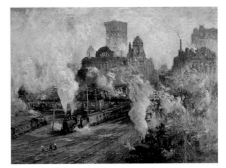

Fig. 6. *Grand Central Station*, 1909; oil on canvas; 33 × 44¾ inches; The Metropolitan Museum of Art, New York, Gift of the family of Colin Campbell Cooper, in memory of the artist and his wife, 1941 (41.22)

Cornelius Vanderbilt in 1871 on Forty-second Street, was being demolished after an accident in 1902 in which fifteen persons were killed and thirty-eight injured; within months, plans were underway to tear down the existing station. Steam locomotives were banned by 1908 and a new terminal for electric trains was completed in 1913. The pictorial treatment of the station offers some measure of the aesthetic distance between Cooper's approach to urban themes and those of members of the contemporary Ashcan School, such as Ernest Lawson and George Bellows, who were concentrating on the excavation for the new Pennsylvania Railroad Station, completed in 1910. Their paintings are primarily concerned with gritty labor and temporary deformation of the landscape, digging deep into the bowels of the earth, rather than in urban mechanization itself. Cooper sent his first version of the subject to the 1906–1907 winter exhibition of the National Academy of Design, and the larger and later painting *Grand Central Station* to the annual exhibition of the academy in 1909, the year of its completion. That same year, it was shown at the Alaska-Yukon-Pacific Exhibition held in Seattle, and again in 1910 at the Corcoran Gallery Biennial in Washington, D. C. and at the Pennsylvania Academy of the Fine Arts.[60]

Given the dearth of images of single skyscrapers in Cooper's art, it would seem as though he was in agreement with Hassam, who said:

> One must stand off at a proper angle to get the right light on the subject.
> It is when taken in groups with their zigzag outlines towering against the sky
> and melting tenderly into the distance that the skyscrapers are truly beautiful.
> Naturally, any skyscraper taken alone and examined in all its hideous detail is
> a very ugly structure indeed, but when silhouetted with a dozen or more other
> buildings against the sky it is more beautiful than many of the old castles of
> Europe.[61]

The two celebrated skyscrapers to which Cooper devoted his art are the two most isolated such structures—buildings that by their very nature lacked the architectural framework to be depicted within a group of zigzagging outlines: the Flatiron Building and the Times Tower. Interestingly, and perhaps consciously, these were two structures that Hassam did not paint.[62]

Daniel Burnham's Flatiron Building of 1902 was the most painted, printed, photographed, and illustrated of all American buildings.[63] Though not ever the tallest building in the city, it aroused great curiosity and celebrity, and on completion was referred to as "the slenderest" and "the most aquiline" of structures, likened to a ship's prow, and, like the canyons of lower Manhattan, thus absorbed into a traditional pictorial metaphor. The structure drew admiration not only for its distinct triangular shape, necessarily conforming to the ground plan of the avenue crossing, but also its location at the intersection of the city's most renowned avenues: Fifth Avenue and Broadway. Most views of the Flatiron Building were taken from below, to emphasize the impressive height of the structure, towering above the buildings facing the "Proud Tower" on either side of the two avenues.[64] Not so Colin Campbell Cooper's *Flat Iron Building* (cat. no. 10), however. Cooper situated the viewer high up on a building north of the Flatiron Building, possibly the Madison Square Bank Building, so that the structure dominates Fifth Avenue and Broadway, rising high above the architectural

18

The Financial District, c. 1908
Oil on canvas
32 x 19½ inches
Collection of Mr. and Mrs. Thomas B. Stiles II

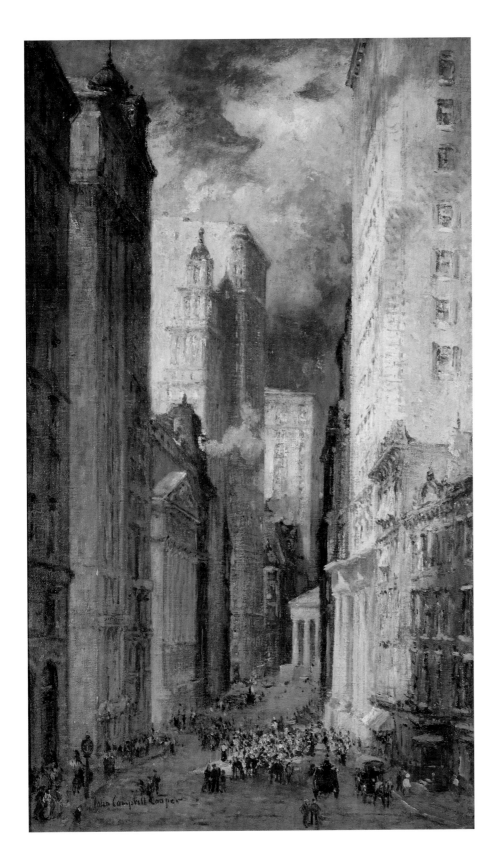

19

Main Street Bridge, Rochester, 1908

Oil on canvas

26¼ x 35 inches

Memorial Art Gallery of the University of Rochester, New York

Gift of Mr. Hiram W. Sibley

Photograph courtesy of James Via

blocks surrounding it and down Broadway particularly. In the lower left is the Worth Monument on Twenty-fifth Street, also built upon a triangle, an obelisk erected in 1857 to Major General William Jenkins Worth, a hero of the Mexican War, who died in 1849. Though the monument is negligible in height compared to the Flatiron Building, it forms a vertical counterpoint between the old and the new, both slender shafts of stone on similarly shaped plots of land, each a monument to different eras. The great plazalike meeting place of the two avenues is filled with trolleys, carriages, and pedestrians, whose haphazard movement reinforces the strength and solidity of the monolithic structure, somewhat softened by wisps of steam clouds that float across its prow. Cooper's *Flat Iron Building* was first exhibited as *The Flatiron, New York* in 1904 with the American Water Color Society. Because the medium is casein-based, its opacity straddles the distinction between watercolor and oil, and therefore Cooper could exhibit it in exhibitions that might otherwise have been restricted as to medium. *Flat Iron Building* was shown in April 1905 in the exhibition of watercolors at the Pennsylvania Academy,[65] and then the work appeared, without medium designation, among Cooper's entries in the Lewis and Clark Centennial Exposition, held in Portland, Oregon, beginning in June 1905. According to his account book, he was asking $400 for the work in 1904 and $600 in 1905, the latter a price higher than he usually asked for pure watercolor work. Again, without medium designation, the picture was shown at the Texas State Fair in Dallas in 1908 and sold for $600. *Flat Iron Building* appears to be the earliest known painting of the famous structure.

Cooper was only one of many artists who were inspired by the Flatiron Building, but he appears to have been unique in his fascination with the New York Times Tower on what had been Longacre Square, the name changed to Times Square in 1904, again a triangular patch of ground, this at the intersection of Broadway and Sixth Avenue at Forty-second Street. The Times Tower figures in a number of Cooper's major oils. It was begun in 1903, built by Cyrus Eidlitz and Andrew McKenzie, the year after the Flatiron Building, and its completion was celebrated on December 31, 1904. In fact, it was known in its day as "the second Flatiron Building," because of its shape, both buildings being characteristic of Broadway's acute-angle intersection with the avenues.[66] The New York Times outgrew the building in 1913, but owned it until 1961, after which it was stripped down to bare steel and remodeled, reopening in 1966.[67]

Compared to the Flatiron Building, the Times Tower was not particularly distinguished architecturally from other skyscrapers of the period, but in the early twentieth century it was one of three or four New York structures that were instantly recognizable to people all over the world, and that certainly would have constituted some of the appeal to Cooper. His earliest known rendition of the building is his painting *Times Square* (alternatively *The "Rialto," New York*) (The Lotos Club, New York), painted in 1906, a brilliant rendition of the soaring tower, which he enlarged the following year for the painting *The Rialto* (cat. no. 16). The name arose because the stretch of Broadway between Madison and Times Square was becoming the entertainment capital of the city, while new hostelries were growing up to accommodate visitors to the theaters, restaurants, and other places of amusement in the area.[68] Both works are nearly identical, with changes only in the positioning of the pedestrians and trolleys on Broadway, and the cloudy skies above. In the 1906 painting, the Times

Tower is silhouetted against a clear azure sky; a year later, the light remains bright, coming in from the west, but the tower itself is silhouetted against puffy white clouds. In the near right of *The Rialto* is the Hotel Knickerbocker, while behind the Times Tower between Forty-fourth and Forty-fifth streets is the Hotel Astor, which began construction in 1904.[69] Because of its elaborate facilities for entertainment and the inclusion of a roof garden, a relatively new innovation for summer activities at theaters and hotels, the Astor was perceived as a replacement for the now slightly older Waldorf-Astoria; the Knickerbocker was even more recent, opening in October 1906.[70] Thus, the Times Square area became the even "newest" New York toward the end of the first decade of the new century. Cooper first exhibited the small "Rialto" at the annual exhibition of the Pennsylvania Academy of the Fine Arts in January 1906, lent by New York's Lotos Club; the inscribed date of "1906" may have been added just on delivery or even after its return. The painting's immediate success may have led Cooper to create the larger version the following year, which he had originally planned to exhibit in the winter exhibition at the National Academy of Design in New York in December 1907. Cooper's account book suggests that this work was withdrawn. That it was the later and larger version is suggested by the values the artist placed on the pictures. The Lotos Club "Rialto" was valued at $700; the account book value for the 1907 picture was $1,500.

And then in the next several years, he created a different view of the building, initially in watercolor, which he first exhibited at the watercolor annual at The Art Institute of Chicago in 1908 as "The Times Building from Bryant Park." There is no record of an oil version of this subject, but the Cooper Family Papers reproduce the work annotated as a small oil. It appears a very different concept, a view west down Forty-second Street, with a prominent motor car by the curb, and the Sixth Avenue Elevated Railroad stretching across the scene, with wisps of white smoke, perhaps from a passing train, blocking a further view down the avenue. Only the Times Building with its dominant tower rises up against what may be a late afternoon light or sunset, a single, isolated skyscraper. Cooper here seems to have been concerned with painting a picture of the modern world of mechanized transportation and high-rise architecture, formally balancing the horizontal and vertical elements in a clear geometric structure.

The New York structure that earned Cooper's greatest attention and presumably admiration, however, was not a skyscraper at all, but the new New York Public Library (1897–1911) —again a subject ignored by Hassam. Indeed, though other artists painted the library and its grand plaza in relationship to the taller buildings along Fifth Avenue,[71] it was Cooper and Carleton Wiggins who seem to have awarded it their greatest pictorial attention. And the intent of the two artists was startlingly different: Wiggins used the broad open space to unify the divergent elements of New York during a snowstorm; Cooper, on the other hand, emphasized the firm massiveness of the modernized classical Beaux-Arts temple. Built on Fifth Avenue between Fortieth and Forty-second streets on the site of an old reservoir, the library was one of the first modern structures in the city to provide its own monumental setting, with landscaped terraces and broad steps.[72] Cooper's foray into the realm of the classical, a departure from his fascination with tall, vertical modernist skyscraper construction, would seem to defy explanation, except for the structure's contemporaneity and the

20

Broadway, 1909
Oil on canvas
30⅜ x 23 inches
Courtesy of the Biggs Museum of American Art
Dover, Delaware

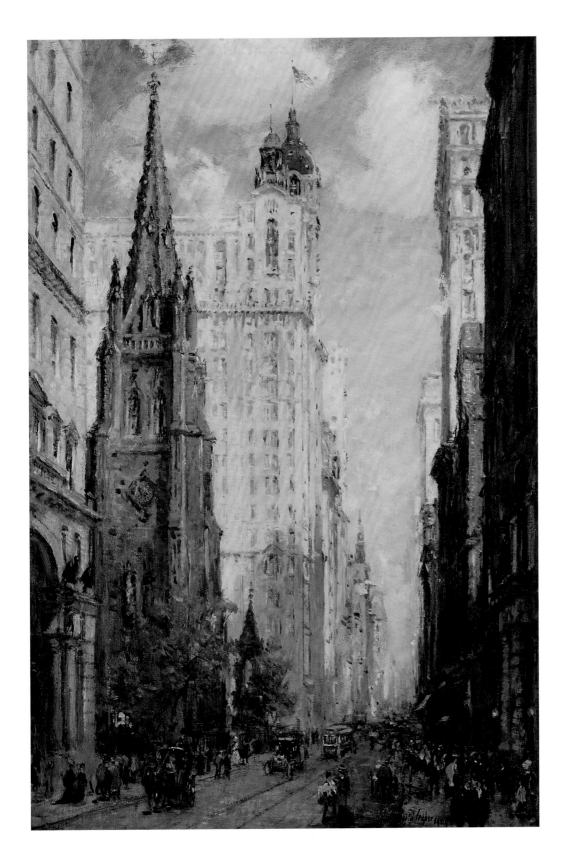

21

Broadway from the Post Office (Wall Street), c. 1909
Oil on canvas
51⅜ x 35⅜ inches
Collection of the City of Santa Barbara
Photograph courtesy of Scott McClaine

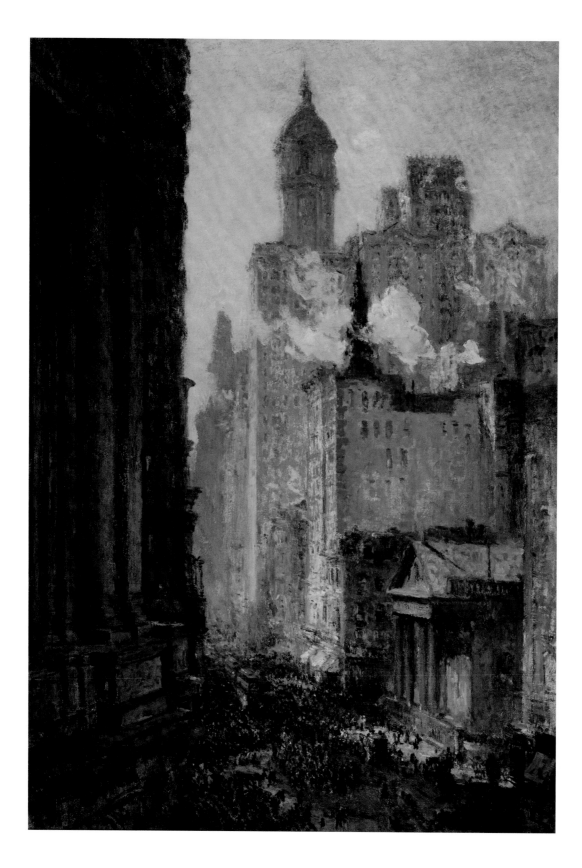

importance of the library as a temple of democracy, offering knowledge and learning to all the people of the city. When the library's design was first agreed upon in 1897, merging the existing Astor Library with the Lenox and Tilden foundations, the critic Charles De Kay noted its conservatism, but proudly announced that it would not only "make this city a home for students, but places before the poorest and meanest the intellectual treasures of the world."[73]

Although not the library view for which Cooper is now best known, his pictorial debut of the structure appeared first at the Union League Club in January 1913, and then in the annual exhibition of the National Academy of Design in March, entitled *The Library, New York* (alternatively, *New York Public Library, Easter Morning*), painted in 1912, and thus a record of one of the city's newest, most imposing, and most significant structures; it subsequently appeared in 1913 in exhibitions in Buffalo, Saint Louis, and Chicago, and in January 1914 in Indianapolis; it seems to be the same work that was shown in Dallas in 1915. It is almost a straight-on view, taken from across Fifth Avenue and just south of Forty-first Street which terminates at the library. Though seen from slightly above street level, the building still rises majestically, its three-arched opening welcoming visitors while its broad horizontal frieze and recessed pediment add grandeur to the magnificent architectural pile. The streets and steps bear numerous visitors, while both motor cars and motor coaches pass in front of the building on a sunlit spring day. Probably the most interesting detail is the lions in front of the building, or rather the "lion" in front of the massive stairway, for when Cooper painted this picture, only one of Edward Clark Potter's lions, that on the south side of the entrance, had been installed. First cast in plaster, both lions were temporarily placed on their pedestals outside the library in September 1910, before the actual carving in Tennessee pink marble by the Piccirilli Brothers was begun. In the 1930s, Mayor Fiorello La Guardia nicknamed the lions "Patience" and "Fortitude." Thus, in Cooper's painting, "Patience" guards the steps while "Fortitude" has yet to appear.

Judging by a reproduction in the Cooper Family Papers, there appears to have been a replication by Cooper of this version of the library, with the only visible changes in the pedestrian and vehicular traffic. But the library image that remains particularly associated with Cooper today is a very different one: a view from the north, possibly from a window of a building on Forty-second Street, in which both lions are in place and two large flags—one French, one American—fly from stanchions on the Library Plaza, while numerous American flags bedeck the buildings along Fifth Avenue. *New York Public Library* (cat. no. 25) is one such view, though the picture was replicated numerous times, and has appeared also under the titles *Astor and Lenox Libraries* and *Fifth Avenue and Forty-second Street*. This later view is significantly different from that painted in 1912, not only because it shows the building façade from the side, but also, and more significantly, it integrates the library among the more massive buildings from Fortieth Street down Fifth Avenue, with the substantial Knox Building (1902), at the southwest corner of Fifth Avenue and Forty-second Street, directly in the center. Again, the various replications, some known through the Cooper Family Papers, some that have passed through the New York art market, differ only through the disposition of the pedestrians and vehicles, both in their locations and in their density. Though none of the examples appears dated, the display of flags on Fifth Avenue suggests their conformity with

the parades celebrated in Childe Hassam's *Flag* series of ca. 1917–18. Furthermore, one version was illustrated in October 1920, suggesting that at least the initial examples were created at the end of the second decade before Cooper moved to California.[74] Likewise, Cooper's account book appears strangely empty of notes regarding this group of replicated paintings, though there is one reference to *The Library Terraces* in 1919, offered at a "Lowest Price $1500," indicating an oil and probably a major work. The exhibition took place at Rodin Studios at 200 West Fifty-seventh Street, newly built in 1917.

There is yet a further image by Cooper that incorporates the New York Public Library, but information about what appears to be an important painting for him remains sketchy and speculative to date. This painting was titled *The Avenue, New York* when it made its debut in the annual exhibition held at the Cincinnati Art Museum in May 1913. Cooper sent it on to the Inaugural Exhibition of the Memorial Art Gallery in Emma Lampert Cooper's native city of Rochester, New York, in October 1913, and the work then appeared in the winter exhibition of the National Academy of Design in December-January 1913–14. By the following year, the picture had assumed an alternative title, *Fifth Avenue, New York* (fig. 7). The scene is a view taken from above, probably in the Knox Building, with the library façade and lions, the various office buildings across the street, and a view up Fifth Avenue past St. Patrick's Cathedral, with Temple Emanu-El conspicuous on the east side of Fifth Avenue at Forty-third Street.[75] Only the American flag appears on a tall stanchion in front of the library. Pedestrians crowd the street and the library plaza, while some motor traffic moves along the wide avenue, and a trolley crosses at Forty-second Street. This is an afternoon scene, with the light coming from the west and the library façade in the shadows. The presence of both lions places the work clearly later than the 1912 rendition of the library, and probably earlier than the various multi-flagged versions. An important painting that captures the modernity of Midtown, and incorporates a seat of knowledge, business enterprise, and religious variety, *Fifth Avenue, New York* fully endorses the concept of this "crossroads of the world" intersection. The work first appeared with its present title as one of six pictures by Cooper at the Panama-Pacific International Exposition in San Francisco in 1915, for which he won a gold medal.[76] In turn, as *La Cinquième Avenue à New York*, and specifically dated 1913, the painting was purchased by the French government from the mammoth exhibition of American paintings organized in Paris by the Musée du Luxembourg and held at the Jeu de Paumes in 1919 after the close of World War I: "Exposition d'artistes de l'école américaine." The work entered into the collection of the Luxembourg, and was last known in collection of the Palais de Tokyo (Musée National d'Art Moderne).[77] Now in the collection of the Musée de la Coopération Franco-Américaine, Bierancourt, France, it is one of Cooper's most definitive paintings of New York in the century's second decade—a fitting representation of both the artist and the metropolis for a French national collection.[78]

Before his move to California in 1921, Cooper and his wife traveled extensively, but most of the subject matter he chose to paint and exhibit was drawn from Europe or New York City, which remained their home base until Emma's death in 1920. Given Cooper's extensive background and training in Philadelphia, and his earliest involvement with modern urban architecture with his several views of Philadelphia's Broad Street Station, it seems surprising that he did not paint the city more, but its lack of the soaring vertical structures so abundant

Fig. 7. *Fifth Avenue, New York*, 1913; oil on canvas; Musée de la cooperation franco-americaine, Bierancourt, France; Photograph: Gérard Blot; Réunion des Musées Nationaux/Art Resource, New York

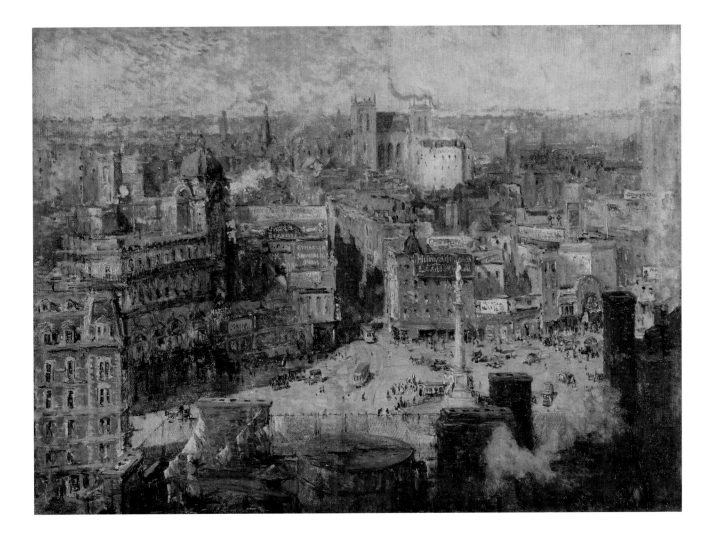

23

Glass Train Shed, Broad Street Station, Philadelphia, c. 1910
Oil on canvas
24 x 30 inches
Collection of Lee and Barbara Maimon

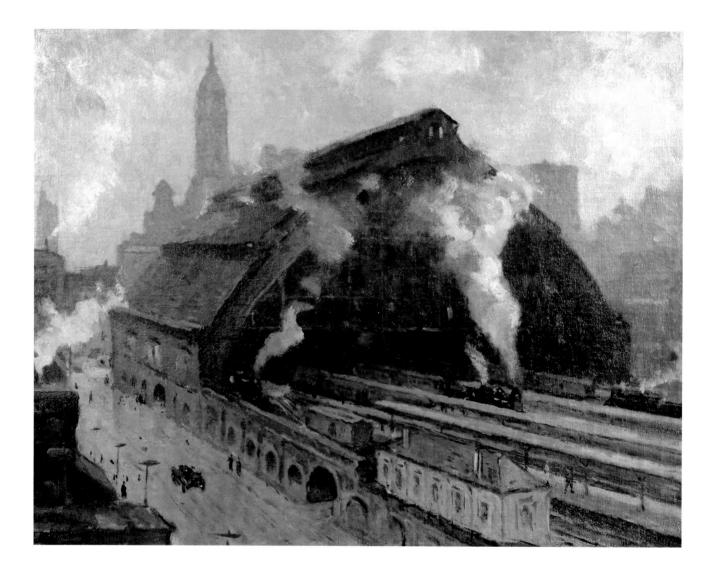

in New York may have led him to turn his back on his native city. The only major painting from Cooper's later years to depict Philadelphia is *Old Waterworks, Fairmount* (cat. no. 26), a view of the templelike neoclassic structures begun in the 1820s. Cooper's motivation for this sizable canvas—the Philadelphia Museum of Art also owns a study for it—remains unknown; it seems not to have been a commission nor did Cooper ever exhibit it, but he donated it to the Philadelphia Museum in 1936. It was painted in 1913, at a time when he had turned to more traditional forms in his depiction of the New York Public Library.

Another American city that Cooper visited and painted early on after he had returned from Europe and begun his interest in the modern urban world was Pittsburgh; he exhibited a watercolor of Pittsburgh at the Philadelphia Water Color Club in 1904, probably a prelimi-nary work for the subsequent larger oil painting and yet exhibited in its own right in a num-ber of watercolor exhibitions. The oil painting, *Pittsburgh, Pennsylvania* (fig. 8) was not created until 1906 and was first shown in February 1907 in Washington at the First Corcoran Annual Exhibition (later Biennial) and then in October at The Art Institute of Chicago; the following year, the painting was rejected from Pittsburgh's Carnegie Institute International Exhibition. In 1913, Cooper gave the work to the National Academy as his diploma picture to qualify him as a full academician. It is an unusual urban scene for Cooper, for it is a panoramic vista of the city and its hills along the Monongahela River, the two halves con-nected by the sweep of a railroad bridge, rather than an interior urban view. But it was immediately admired in its own time by Charles Caffin, one of the leading art writers, for capturing "The local characteristics of Pittsburgh, and particularly its wonderful atmos-pheric conditions . . . none have been able to reproduce them so truthfully or in a way so finely pictorial as Cooper has done in this canvas."[79]

Fig. 8. *Pittsburgh, Pennsylvania*, 1906; oil on canvas; 33 × 45 inches; National Academy Museum, New York (270-p)

It seems surprising, too, that Cooper did not devote more endeavor to Chicago, the home of the skyscraper, after the initial exhibition of *Skyscrapers: Randolph Street, Chicago* (fig. 9) in January 1904 in the annual of the Pennsylvania Academy of the Fine Arts; the painting also appeared that year in the Louisiana Purchase International Exposition held in St. Louis.[80] This is an intimate view of a crowded city scene, taken at ground level, with Randolph Street cut off by the elevated railroad—a work more dark and dramatic than Cooper's more fully Impressionist pictures of New York, Europe, and then California.[81] The view is to the west, while to the left is the imposing façade of the Old Post Office Building. To date, the only other Chicago painting of which I have located an image is a much later skyscraper view, *Tribune Tower and Wrigley Building*, that was in the collection of the Dunbar Gallery in Chicago in March 1927.[82] In emulation of his past successes in New York, Cooper chose to highlight two of Chicago's grandest and newest skyscrapers seen across the Chicago River— the Tribune Tower (1920–24) at the left, with its central section modeled upon the Giralda Tower of the cathedral in Seville, Spain, and dominating the center of the composition, the Wrigley Building (1925), thirty-four stories high and based upon the tower of Rouen Cathe-dral. The two buildings "anchored" the southern end of Chicago's "Magnificent Mile."[83]

Fig. 9. *Skyscrapers: Randolph Street, Chicago*, 1900; oil on canvas; 44½ × 33½ inches; Private collection

Once Cooper had returned from Europe and decided to turn his attention to the architec-tural features of his native land, the new vertical landscape of the skyscraper city gained pri-mary but not exclusive consideration. Nationalistic impulses also motivated Cooper, who painted a number of works devoted to the most identifiable features of the nation's Capitol.

As was not uncommon, Cooper began working in watercolor, painting *Washington, East Front of the Capitol at Night (The White House)* in 1902 and exhibiting it the next year with the New York Water Color Club, while in November 1903, he showed *Pennsylvania Avenue, Washington* (unlocated) with the Art Club of Philadelphia, again probably a watercolor, judging by its minimum price of $175. An archival photograph of this picture shows the broad avenue lined with imposing buildings leading up to the majestic Capitol, its dome breaking the distant horizon. This was then sent on to the Louisiana Purchase International Exposition in St. Louis in 1904, while the view of the Capitol at night was shown at Albert Roullier's Gallery in the Fine Arts Building in Chicago in 1905. The capital city appears to have lost Cooper's interest for a while, but in November 1913, he exhibited a watercolor of the White House (unlocated) with the New York Water Color Club, which then appeared with the Philadelphia Water Color Club, and went on to San Francisco's Pan-American International Exposition in 1915. In this work, Cooper presented a very different aspect of "official" Washington, a lawn fête with verdant bushes and trees seen from below, so that the bowed front of The White House arches out gracefully into the grassy foreground.

As is not totally unusual in Cooper's extant oeuvre, while the exhibited works, often in the less impressive medium of watercolor, are only partially located, a major oil with little or no history is known; in this case, Cooper's most imposing and notable Washington subject is his view *West Front, Steps of the Capitol* (cat. no. 24). The painting's date, history, and exhibition record are all unknown. Seen from below, the Capitol appears extremely monumental, in its overpowering effect not unlike the ancient mausoleum of Halicarnasssus in Bodrum, Turkey, as the viewer moves up the extensive stairway to the Ionic portico and then to the magnificent multiringed dome, with Thomas Crawford's statue *Armed Freedom* silhouetted against the sky and reaching the top of the canvas. Yet, countering the severity of the structure are the many men and women who move slowly and easily up and down the stairway, their colorful outfits and the rich greenery of shrubs and potted trees providing a colorful foil for the buff hue of the structure. The entire painting radiates a soft glow, in line with Cooper's increasing subscription to the Impressionist aesthetic, reinforced by the purple-blue shadows cast by the balustrade. Finally, one should note that Cooper has chosen the less formal west front for his depiction of the nation's Capitol, a more touristic approach, and not the more grandiose and ceremonial east front leading down the Mall.

Another grand governmental structure that Cooper painted was *The Capitol at Harrisburg* (unlocated), exhibited in January 1909 at the annual exhibition of the Pennsylvania Academy of the Fine Arts, and presumably painted the previous year. A monumental oil, it was shown a few months later with the South Carolina Art Association in Charleston. A decade later, in 1919, a watercolor of the same subject (also unlocated), possibly a preliminary work for the oil, appeared at the New York Water Color Club.

The one other eastern American city of size that often occupied Cooper's brushes was Rochester, New York, but there the attraction was personal, for his wife, Emma Lampert Cooper, came from there, and her family resided in Rochester and nearby Pittsford. The frequency of the Coopers' visits to Rochester is not known, but the relationship was a strong one, and the couple appear to have made numerous visits to Rochester, the second in 1908, a decade after their marriage there. It was on this visit that Cooper painted his best-known

24

West Front, Steps of the Capitol, c. 1910
Oil on canvas
36 x 22 inches
Bank of America Collection

25

New York Public Library, c. 1912
Oil with graphite on canvas laid on board
14 x 20 inches
Private Collection, St. Louis

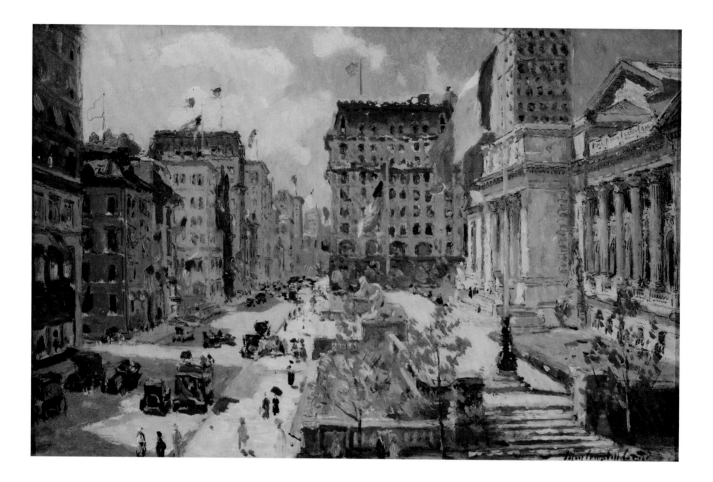

Rochester oil, *Main Street Bridge, Rochester* (cat. no. 19). The subject is a fascinating one, for the structure Cooper painted is not a simple support across the waters of the Genesee River, but an architecturally substantial one, six stories high, supporting numerous commercial enterprises, and flanked at the left by another massive building. Although this is not a sky-scraper image, Cooper has transferred his New York predilections to a smaller, industrial town, relieving the harshness of the structural geometry with the pink and buff coloration of the buildings and the soft gray-greens of the water flowing beneath the bridge. Cooper surely considered this his major Rochester painting, for he exhibited it at the Pennsylvania Academy annual in January 1909 and at The Art Institute of Chicago, sending it on to the St. Louis Museum and the John Herron Art Institute in Indianapolis in 1910. Cooper himself noted in 1911 that "Mrs. Cooper says that the Main Street Bridge picture, whenever it has been shown at art exhibitions, has attracted much attention, because people are surprised that such a foreign looking place can be found in America. . . . People always compare it with the Ponte Vecchio at Florence, which rather proves my assertion that 'any old thing' is good enough when the sun falls on it right."[84] But during 1908–1910, he also painted numer-ous watercolors in the Rochester-Pittsford area, exhibiting them in such venues as the New York Water Color Club and the Dunbar Galleries in Chicago. In 1911, Cooper authored the article "Rochester as a Subject for Artists," suggesting that an artist need not go too far afield, and could find a wealth of subject matter in

> the great cities, as New York, Chicago, Pittsburgh, Washington or Rochester, [where] are to be found equal opportunities for the artist with the picturesque cities abroad. Rochester, it seems to me, is particularly favored in these opportu-nities. The splendid river with its bridges and falls; the great wooded cannon below; the hills and water views about Irondequoit Bay; the Dugway with its cliffs and marshes; the charming country out Pittsford way and beyond are all exceptionally good material for the painter. . . . Rochester is filled with subjects which need no other idealization to make beautiful than an eye receptive to the glory of light and color and the ability to register these things on canvas.[85]

Until Emma's death in 1920, Cooper appears to have regarded Rochester as a second home.

For a painter who achieved a great deal of critical notice and success, first with his views of old European architecture and then certainly as the painter of the skyscraper city, surpris-ingly little is known of Cooper's life before his move to Santa Barbara in 1921. He maintained his New York quarters in the artists' studio area near the Art Students League and in the Gainsborough Studios on Central Park South, though much of each year, at least until World War I, he and his wife traveled a great deal throughout Europe. Perhaps the most exciting event during their numerous trans-Atlantic crossings occurred as passengers on the *S. S. Carpathia* when it assisted in the rescue of survivors of the *S. S. Titanic* on April 15, 1912. There is no record of close association with colleagues, with the possible exception of Joseph Pennell, and yet there is no indication of a hermetic existence. We know that Cooper had a distaste for modernism—he expressed that in print a number of times—but he wrote of that in general, sometimes pathological terms, rather than in reference either to artists of whose work he disapproved or those he admired.[86] Unlike many of his fellow artists, once he

gave up teaching at the Drexel Institute in Philadelphia in the late 1890s, there is no suggestion that he taught. And while a picture by him might have appeared from time to time at such New York galleries as Macbeth, where he had a one-artist show in February 1915, Milch, Folsom, Blakeslee, and Babcock, and in Chicago at O'Brien's and Dunbar's, he seems to have maintained no ongoing affiliation with any commercial establishment. He and Emma had a number of two-person exhibitions, one at the Philadelphia Art Club in May 1902, at the Empire Moulding Works Gallery in Rochester in March 1905, at Marshall Field & Company in Chicago in May 1910, at the Memorial Art Gallery in Rochester in 1915, and one with no date specified at the art galleries of C. Theo Sevin in Buffalo, which were active around 1910. One wonders, too, how the Coopers maintained their life style. He seems to have been a fairly prolific painter, but not exceptionally so, since so many of his better-known works, those located and those still missing, appear recycled over and over—to be sure, often in very prestigious venues where his pictures always seemed welcome. But in his account book, relatively few of them are annotated with the word "Sold." Although purely speculative, it is possible that Emma Lampert had or inherited some wealth that afforded the Coopers their comfortable life.

One aspect of Cooper's career during his New York years, however, seems to have been overlooked. While he built his reputation on his urban views, particularly of New York, during the period from about 1914 until his departure for California, during the last half of the second decade of the century, Cooper was already investigating other themes—architectural, to be sure—but often diametrically opposed to those for which he was celebrated. Indeed, as early as 1911, he won the Beal Prize at the New York Water Color Club for his *Salem Mansion*, a work later shown at the Panama-Pacific International Exposition in San Francisco, and that picture, together with other watercolors painted in the small New England town of Salem, were shown in numerous other venues in Boston, Philadelphia, Chicago, and New York. In 1914, on a trip south, occasioned most likely because of the war in Europe which inhibited travel abroad, Cooper painted watercolors in Annapolis, in Richmond, several historic houses in Charleston, and in Savannah; in 1915, he painted in Edgartown on Martha's Vineyard, and he spent the winter of 1915–16 in Southern California. Nor did the cessation of hostilities immediately take the Coopers back to Europe, for in 1918 he was exhibiting scenes of Westport and Middletown, Connecticut, in 1919 at Newport, Rhode Island, and in February 1920, he exhibited *Main Street, Nantucket* (unlocated), presumably a large oil given its price of $1,500, at New York's Lotos Club. Two years later, after his move to Santa Barbara, he showed a large group of Nantucket watercolors on the island. It is possible, of course, that Emma's health may have been deteriorating, making European travel difficult or impossible, and that trips to the South and nearby shore and island climes became advisable; she died in 1920 in the home of her sister in Pittsford.[87] Yet, during this period, Cooper appears to have been joining Hassam and a good many other American artists in seeking out the more traditional aspects of American life, almost in contradistinction to the architectural "newness" with which he had become associated, concentrating on the "old" America rather than the modern, a nationalistic preference that could only have received further motivation from America's entry into World War I.[88] From that point of view, it is

26

Old Waterworks, Fairmount, 1913

Oil on canvas

35 x 45 inches

Philadelphia Museum of Art: Gift of the artist, 1936

probably significant that the first illustration that he included in his article "The Poetry of Cities" in 1920 was a modest, presumably New England, dwelling, followed by images of seven majestic American cityscapes.[89]

NOTES

1. In 1909, Cooper donated his diploma presentation portrait to qualify for his election to Associate of the National Academy. Sometime in the 1920s, he presented the Academy with a second *Self-Portrait* (fig. 1) painted in Santa Barbara, "to replace a portrait given when I was elected an Associate." However, Cooper never retrieved the earlier work and both remain in the Academy's collection. See the entry on Cooper in David B. Dearinger, ed., *Paintings and Sculpture in the Collection of the National Academy of Design. Volume I, 1826–1925* (New York and Manchester, New Hampshire: Hudson Hills Press, 2004), p. 115.

2. However, despite the rapidly growing interest and the recognition of Cooper's singular achievements, there have been only two modern publications devoted to him, both exhibition catalogues. See James M. Hansen, *An Exhibition of Paintings by Colin Campbell Cooper* (Santa Barbara, California: James M. Hansen, 1981); and Marshall N. Price, *Colin Campbell Cooper: Impressions of New York* (Santa Barbara, California: Santa Barbara Museum of Art, 2002).

3. Colin Campbell Cooper, "The Picture that First Helped Me to Success," *The New York Times*, January 28, 1912, section 3, p. 5. The first of these was the basis for Tina Gollsby, "Colin Campbell Cooper: An American Impressionist with a Global Perspective," *Art and Antiques* 6 (January/February, 1983), pp. 56–63.

4. –Autobiographical Notes, Santa Barbara Museum of Art artist file, quoted in Price, p. 2.

5. This material, and much else in the ensuing discussion of Cooper's life and career, is derived from the Colin Campbell Cooper Family Archives, Thousand Oaks, California. The author also wishes to express his appreciation to the late Sherrill Seeley Henderson, Cooper's grand-niece, who provided the author with a copy of Cooper's account book and numerous other papers long before this project was underway. At that time, Ms. Henderson was also working with Dr. Joy Sperling of Denison University on a projected, never-realized exhibition of Cooper's art, and Dr. Sperling was also extremely generous in sharing information.

6. See Cooper's illustrations, shared with Henry Rankin Poore, for Bunford Samuel, "The Father of American Libraries," *Century Magazine* 26 (May 1883), pp. 81–86. Several of Cooper's illustrations here already evince an interest in the depiction of architectural structures, in this case, library buildings. Cooper also provided illustrations for Edward Eggleston's article "Social Life in the Colonies," *Century Magazine* 30 (May 1885), pp. 387–408.

7. See, for instance, Cooper's short story, "Parthenope's Love," in *The Septameron* (Philadelphia: David McKay, 1888), pp. 115–24; and his tribute to Velásquez, "A Spanish Painter," *Lippincott's Monthly Magazine* 51 (January 1893), pp. 76–82, with Cooper's sketches after some of Velásquez's finest works, an article surely resulting from Cooper's visit to Spain in 1890, where he went first to Madrid to copy the old masters, and then made an extended visit to Seville, painting landscapes and making studies of the Spanish peasantry. See *Arts for America* 5 (Midsummer 1896), p. 233.

8. "Germantown," excerpted from Cooper's unpublished "Autobiography," courtesy of Sherrill Seeley Henderson. This is referenced in Elizabeth Robbins Pennell, *The Life and Letters of Joseph Pennell*, 2 vols. (Boston: Little Brown and Company, 1929), vol. 1, p. 28.

9. One of the most perceptive discussions of the skyscraper, which allies Cooper and Pennell, is Frances B. Scheafer, "The Picturesque Aspect of the Sky-Scraper," *The Atlantic Daily News*. This issue is not dated, but it may be found in the Emma Lampert Cooper Papers, University of Rochester Archives. A clue to the dating of the piece may be found in its reproduction of Cooper's *The Ferries, New York*, painted in 1904.

10. "Modern Art and Artists. Colin Campbell Cooper. Portraiture and Architectural Subjects," *Fine Arts Journal* 14 (October 1903), p. 386.

11. In December 1892, Blakeslee Galleries in New York held an exhibition of Cooper's scenes in and around the village of Mystic. See *Brooklyn Eagle*, December 18, 1892, p. 4.

12. Annette Stott, "American Painters Who Worked in the Netherlands 1880–1914," Ph.D. diss., Boston University, 1986, p. 228.

13. Ibid., pp. 222–42.

14. *Dromen van Dordrecht. Buitenlandse kunstenaars schilderen Dordrecht 1850–1920* (Bussum, The Netherlands: Thoth, 2005), p. 180.

15. Annette Stott, *Holland Mania. The Unknown Dutch Period in American Art & Culture* (Woodstock, New York: Overlook Press, 1998), pp. 29, 38, 41.

16. One of a number of problems that a study of Cooper's paintings presents is the replication of titles and sometimes of works themselves, either in the same or in different media. Thus, a watercolor called *Chartres Cathedral*, dated 1910, in a private collection is obviously not *Cathedral at Chartres*, presumably an oil, exhibited in January 1901 at the Pennsylvania Academy, nor the watercolor of the same title shown in November at the New York Water Color Club that year. It was not uncommon for Cooper to produce similar or identical work in the two mediums in which he was equally adept and most frequently exhibited; whether the 1910 version replicated his earlier image or was based on a subsequent visit to Chartres simply cannot be determined.

17. "Modern Art and Artists. Colin Campbell Cooper Portraiture and Architectural Subjects," *Fine Arts Journal* 14 (October 1903), p. 388.

18. I strongly suspect that Cooper may have merely redated his earlier work. His original oil *Beauvais Cathedral* is reproduced, admittedly only in black and white, in *Illustrated Catalogue National Academy of Design Eighty-Seventh Annual Exhibition 1912* (New York: National Academy of Design, 1912), opp. p. 31, and shows no dissimilarity from the picture now dated 1926.

19. For the specifics of Cooper's movements in 1902, see *Fine Arts Journal* 14 (October 1903), p. 387. It is noteworthy that within a year after he was back in this country, he was already being lauded for his turn to the modern American urban environment.

20. Beginning in 1907, Cooper began exhibiting a watercolor of the same title, presumably an updating of the subject, which now would include the recently built Plaza Hotel.

21. Barr Ferree, "The High Building and Its Art," *Scribner's Magazine* 15 (March 1894), pp. 297–319; "Two Views of New York," *Harper's Weekly*, August 11, 1894, p. 759, with two illustrations; Louis Sullivan, "The Tall Office Building Artistically Considered," *Lippincott's Magazine* 57 (March 1896); "New York Sky-Scrapers—The Effective Change Wrought by These Buildings on the City's Appearance within a Few Years," *Harper's Weekly*, March 20, 1897, pp. 292–93, 295.

22. Price, p. 2.

23. John C. Van Dyke, *The New New York* (New York: Macmillan Company, 1909). Van Dyke's book had been preceded by E. Idell Zeisloft, *The New Metropolis* (New York: D. Appleton and Co., 1899), the most fully illustrated volume devoted to New York during this period.

24. Randall Blackshaw, "The New New York," *Century Magazine* 64 (August 1902), pp. 493–513; Sylvester Baxter, "The New New York," *Outlook* 83 (June 1906), pp. 409–24; J. M. Bowles, "A New New York," *World's Work* 13 (December 1906), pp. 8301–8306.

25. Edwin A. Cochran, *The Cathedral of Commerce* (New York: Broadway Park Place Co., 1916).

26. "S.M.I.," "Colin Campbell Cooper," *Memorial Exhibition Colin Campbell Cooper, N. A.* (Santa Barbara, California: Free Public Library, 1938).

27. See Cooper's own description of the painting in "The Poetry of Cities," *Century* 100 (October 1920), p. 795.

28. Some confusion reigns here between Cooper's two *Broad Street Station* paintings, exhibited and reproduced with similar, sometimes identical, identifications, but the picture featuring solely the station does not include skyscrapers. Also, *Skyscrapers: Broad Street Station* was often reproduced, presumably regarded as one of Cooper's most successful paintings—probably the most successful of his Philadelphia works. The painting offers further complication by being dated 1905, a year after it was first shown.

29. Charles H. Caffin, "Some Younger Painters and Others," *International Studio* 22 (June 1904), p. cclxx.

30. Willis E. Howe, "The Work of Colin Campbell Cooper, Artist," *Brush and Pencil* 18 (August 1906), pp. 76–77.

31. Cooper's original title accompanies the illustration of the painting in Cooper, "Skyscrapers and How to Build Them in Paint," *Palette and Bench* 1 (February 1909), p. 107.

32. Carol Lowrey, *A Noble Tradition. American Painting from the National Arts Club Permanent Collection* (Old Lyme, Connecticut: Florence Griswold Museum, 1995), p. 25; information on the United States Army Building as communicated to Dr. Lowrey by Christopher Gray, Office for Metropolitan History in New York. See Gray: "The Old U. S. Army Building on Whitehall Street," *The New York Times*, March 5, 1995, p. R7.

33. For a slightly earlier view of the mélange of surface and elevated traffic at Chatham Square, see the photograph by Edmund V. Gillon, Jr., in *New York Then and Now* (New York: Dover Publications, 1976), p. 150.

34. The picture is not dated, but it is illustrated in Cooper, "Skyscrapers and How to Build Them in Paint," p. 106.

35. Henry James, *The American Scene* (London: Chapman and Hall, 1907), pp. 139–40.

36. Ibid., p. 76.

37. Robert A. M. Stern, Gregory Gilmartin, and John Montague Massengale, *New York 1900 Metropolitan Architecture and Urbanism, 1890–1915* (New York: Rizzoli International Publications, 1983), p. 146.

38. For a good summation of the aesthetic debate, see Price, pp. 2–5.

39. "Art Topics," *Washington* Post, January 31, 1904.

40. Cooper, "Skyscrapers and How to Build Them in Paint," *Palette and Bench* 1 (January 1909), pp. 90–92; ibid. (February 1909), pp. 106–108.

41. "The Picture That First Helped Me to Success," *The New York Times*, January 28, 1912, section 5, p. 5.

42. Cooper, in "What Is the Most Beautiful Spot in New York?" *The New York Times*, June 18, 1911, magazine section, part 5, p. 4. Cooper noted that "Recently the big Gillender Building on Nassau Street, the continuation of Broad, was torn down and another skyscraper of a different kind put up. But the latter, to my mind, has actually improved the view looking north from Beaver Street." By the time this article was written, Cooper was "considered the skyscraper artist par excellence in America." The Gillender Building was demolished in 1910 and replaced by the thirty-one-story Bankers Trust Company Building.

43. The facsimile edition, each signed by Cooper, was published by A. W. Elson & Company, 146 Oliver Street, Boston. Their flyer announced it as "A Banking-House Picture The Financial Center of the United States."

44. Albert W. Barker, "A Painter of Modern Industrialism. The Notable Work of Colin Campbell Cooper," *Appleton's Booklover's Magazine* 5 (March 1905), pp. 326–27.

45. I can find no record of Cooper's exhibiting this oil, though a watercolor of the same subject appeared in numerous watercolor exhibitions from 1911 on, in such cities as New York, Philadelphia, Boston, and Chicago.

46. It seems likely that this is the picture *Fifth Avenue, N. Y.*, which Cooper exhibited with the Municipal Art Society in New York in April 1911. See Richard J. Coke, compiler, *American Landscape and Genre Paintings in the New-York Historical Society*, 3 vols. (New York: The New-York Historical Society, in Association with G. K. Hall & Co., Boston, 1982), vol. 1, pp. 214, 216.

47. A truncated version of this picture showing only the lower half but otherwise identical, entitled *Looking South on Madison Avenue from 23rd [sic] Street Showing Madison Square Garden*, dated 1917, was sold through Alex Cooper Auctions in Maryland, March 23, 2003, lot 601.

48. Cooper exhibited the painting *City Hall Park, New York* with the Society of American Artists in New York in 1904, marking it as one of his earliest New York views. If it is the presently located work, it is interesting that it centers on the Old Post Office and does not involve skyscraper construction. *Bowling Green, New York* was probably painted in 1906, as it was first shown at the Lotos Club before appearing in the annual exhibition of the National Academy of Design, both in February 1907; it was also one of the pictures Cooper chose to show at the Panama-Pacific International Exposition in San Francisco in 1915. *Bowling Green, Snow-Storm* appeared at the National Academy annual in 1910, and was therefore probably painted the previous winter. The Philip and Muriel Berman Museum of Art at Ursinus University in Collegeville, Pennsylvania, owns a painting inscribed by Cooper *Bowling Green*, but, though similar, it is not

the same picture of the subject that was much reproduced and heralded in its own time. Cooper's choice of the winter season in many of these relatively rare park pictures suggests a conscious choice to avoid involvement with the more colorful elements of landscape. I can find no exhibition record for his painting *Central Park in Winter*.

49. *The Plaza, New York* (unlocated) sold at the Kende Auction Gallery, May 4, 1945.

50. When Cooper exhibited the work later in his career, he noted that it was painted from the Gainsborough Studio rooftops and dated the picture "around 1908." He had originally intended to send the picture to the Eighth Venice International Biennale, which opened in April 1909, but his record book is annotated "not sent."

51. Helen W. Henderson, *A Loiterer in New York* (New York: George H. Doran Co., 1917), p. 345.

52. Often in attempting to identify specific works by Cooper, the problem of multiple images arises; those of Trinity Church and St. Paul's Chapel provide cases in point. The Zeuschner painting may or may not be the work shown at the National Academy in 1905; Cooper again showed a painting of Trinity Church at the John Herron Art Institute in Indianapolis in October 1906 and the University Settlement House in April 1907, and later that year presumably both in St. Louis and at the St. Paul, Minnesota, Art Guild, since the picture had been shipped there from St. Louis. In January 1908, it appeared with the Boston Art Club. These may all have been the same painting, or as many as two or even three different pictures.

53. After the fire, the original building was repaired and became the home of Hunter High School, but in 1977, the High School, along with the Hunter College Elementary School, was relocated to Ninety-fourth Street between Park and Madison Avenues.

54. The old building, in fact, remained standing until it was destroyed in a fire in 1936; the present Hunter College building was opened in 1940.

55. Jessie W. Day, "Hunter College on Canvas," [Hunter College] *Alumni News*, June-July 1920, p. 3.

56. "Painting of Hunter College," [Hunter College] *Alumni News*, January 1921, p. 4.

57. Hunter College does not have records of the actual date or terms of acquisition of the painting. It seems likely that Cooper accepted the funds that had been raised, much less than he would have asked for a picture of this size. My thanks to Deborah Gardner, Assistant to the President of Hunter College, for bringing this picture to my attention, and to Eli Schwartz for information drawn from the Hunter College Archives.

58. In 1997, Mildred Thaler Cohen, a Hunter College alumna and Director of the Marbella Gallery in New York, presented the college with a watercolor of the old building, painted by Cooper in 1919.

59. Albert W. Barker, "A Painter of Modern Industrialization: The Notable Work of Colin Campbell Cooper," *Booklover's Magazine* 5 (March 1905), p. 330.

60. For Grand Central Stration, see William D. Middleton, *Grand Central: The World's Greatest Railway Terminal* (San Marino, California: Golden West Books, 1977); Carl W. Condit, *The Port of New York*, 2 vols. (Chicago: University of Chicago Press, 1981); and Deborah Nevins, ed., *Grand Central Terminal, City Within a City* (New York: Municipal Art Society of New York, 1982).

61. "New York the Beauty City. Childe Hassam Declares That Paris and London Have Nothing to Compare with It, Though We May Not Know It," *Sun* (New York), February 23, 1918, part 2, p. 16.

62. One of Hassam's most powerful and beautiful etchings, however, is his *Washington's Birthday* of 1916, which is a traditional view of the Flatiron Building seen from below and rising to splendid height.

63. The structure was officially named the Fuller Building, after the George A. Fuller Construction Company, which financed and erected the edifice and had its headquarters there until 1929.

64. The term is taken from the title of the brilliant catalogue devoted to the Flatiron Building by Bruce Weber, *The Proud Tower* (New York: Berry-Hill Galleries, 1991), upon which I have drawn for this discussion.

65. In 1904, the Pennsylvania Academy decided to exclude watercolors and works on paper from their annual exhibitions. In response, the Philadelphia Water Color Club initiated the First Annual Philadelphia Water Color Exhibition in November 1904. The second annual took place the following April; Cooper's *Flatiron*

was illustrated in the review of the show, "Water Colors at the Pennsylvania Academy," *Public Ledger*, April 2, 1905.

66. The tower had also been referred to as "Giotto's Campanile, New York Style," in reference to its similarity to the campanile adjoining the Cathedral of Florence. William R. Taylor, ed., *Inventing Times Square. Commerce and Culture at the Crossroads of the World* (New York: Russell Sage Foundation, 1991), p. 356.

67. Nathan Silver, *Lost New York* (New York: American Legacy Press, 1967), pp. 170–71.

68. The definition of a "rialto" is the theater district of a town.

69. I want again to thank Christopher Gray for his help in identifying the buildings in this painting.

70. Stern, Gilmartin, and Massengale, pp. 267–69.

71. See, for instance, Edmund W. Greacen, *Fifth Avenue (Library and Lion, New York, Fifth at Forty-second Street)* (private collection) of 1915, reproduced in William H. Gerdts, *Impressionist New York* (New York: Abbeville Press, 1994), p. 53.

72. Stern, Gilmartin, and Massengale, pp. 91–95.

73. Charles De Kay, "Manhattan's Public Library," *The Critic* 28 (December 11, 1897), pp. 355–56.

74. *Fifth Avenue and Forty-second Street, New York City* was reproduced in an article featuring eight of Cooper's pictures, "The Poetry of Cities."

75. The very distinctive Moorish Temple Emanu-El, built in 1868, was one of the most distinguished structures on Fifth Avenue above Forty-second Street and was demolished between 1927 and 1929.

76. According to Cooper's account book, he was also originally planning to send *The Library* to San Francisco in 1915, but this was crossed out and eliminated.

77. Veronique Wiesinger, "La Politique d'acquisition de l'Etat français sous la Troisième République en matière d'art étranger contemporain: l'example américain (1870–1940)," *Bulletin de la Société d l'histoire de l'art français*, 1994, p. 272. Cooper's painting was reproduced in Léonce Bénédité, *Le Musée du Luxembourg. Peintures des Ecoles Etrangères* (Paris: Librairie Rensuard, 1925), ill. p. 3.

78. Much later in his career, Cooper exhibited a painting *Fifth Avenue, New York* in a number of venues such as the San Diego Fine Arts Gallery in 1927. This may be totally unrelated to the painting he had sold to the French government, or, alternatively, either a watercolor study for that picture or a replica done after it. It is more likely the former, for when a painting of that title was shown in 1928 at the California State Fair, Cooper noted its date as 1907, pricing it at the very high valuation of $2,000. It was shown again in a one-artist show of Cooper's work held in Santa Barbara at the end of that year.

79. Charles H. Caffin, *The Story of American Painting. The Evolution of Painting in American from Colonial Times to the Present* (New York: Frederick A. Stokes Co., 1907), p. 334.

80. The work was later identified and sold on the New York and then Chicago art markets as *Downtown Chicago—The Loop.*

81. It was *Skyscrapers: Randolph Street, Chicago* that Charles H. Caffin chose to illustrate when he reviewed the 1904 annual exhibition of the Pennsylvania Academy of the Fine Arts. Caffin, "The Exhibition of the Pennsylvania Academy," *International Studio* 22 (March 1904), p. ccxxxii; three months later, in the same magazine, Caffin commented favorably upon Cooper's turn "from the study of old architecture abroad to the painting of street scenes in American cities with a very marked advance, both in reality of representation and pictorial quality." Charles H. Caffin, "Some Younger American Painters and Others," *International Studio* 22 (May 1904), p. cclxxx, surely referring back to the Chicago picture he had previously reproduced.

82. "Tribune Tower and Wrigley Building—Cooper," *Chicago Evening Post*, "Magazine of the Art World," March 15, 1927.

83. Cooper's picture may have been painted in 1926. His account book suggests some dealings with the well-known O'Brien Galleries in Chicago, and a partially illegible entry may note a transfer from O'Brien to Dunbar. For a comparable but somewhat later view of these two great structures within a panorama of Chicago's tall buildings, see the painting by the local Chicago artist J. Jeffrey Grant, *Michigan Avenue*, ca. 1934, in the Collection of Clifford Law Offices (Chicago), and reproduced in Elizabeth Kennedy, ed.,

Chicago Modern 1892–1945 Pursuit of the New (Chicago: Terra Museum of American Art and Terra Foundation for the Arts, 2004), p. 116.

84. Archival files, Memorial Art Gallery, University of Rochester, New York. Cooper, in fact, did paint *Ponte Vecchio in Florence*, a work he exhibited in the winter annual at the National Academy of Design in New York in 1912.

85. Colin Campbell Cooper, "Rochester as a Subject for Artists," *The Common Good: An Independent Magazine of Civic and Social Rochester* 5 (October 1911), p. 17. I am tremendously grateful to my friend and colleague Marjorie B. Searl, Chief Curator at the Memorial Art Gallery, University of Rochester, for this and much other material on Emma Lampert Cooper and her family. Searl is preparing a study on Emma Lampert, one of Rochester's leading artists.

86. Colin Campbell Cooper, "Mission of Post-Impressionism," *American Art News* 9 (July 15, 1911), p. 3; Cooper, "The Pathology of the Fine Arts," *Sun* (New York), February 11, 1912.

87. The one major eastern city Cooper appears to have avoided during his New York years was Boston, perhaps because of its lack of monumental vertical architecture. However, in 1921, possibly due to its religious connotations after Emma's death, he painted the Christian Science Church, Boston (unlocated), which he showed in January at the National Arts Club in New York as as *The Mother Church* and then at the National Academy of Design winter exhibition that year, while the following year the painting went on tour on the circuit exhibition of the American Federation of Arts.

88. In regard to the attraction of such New England towns as Salem or locales such as Nantucket, see the various essays in William H. Truettner and Roger B. Stein, eds., *Picturing Old New England. Image and Memory* (New Haven, and London: Yale University Press, 1999).

89. Cooper, "The Poetry of Cities," p. 793.

27

Taj Mahal, Afternoon, c. 1913
Oil on canvas
29 x 36 inches
Private Collection
Photograph courtesy of Sullivan Goss—An American Gallery

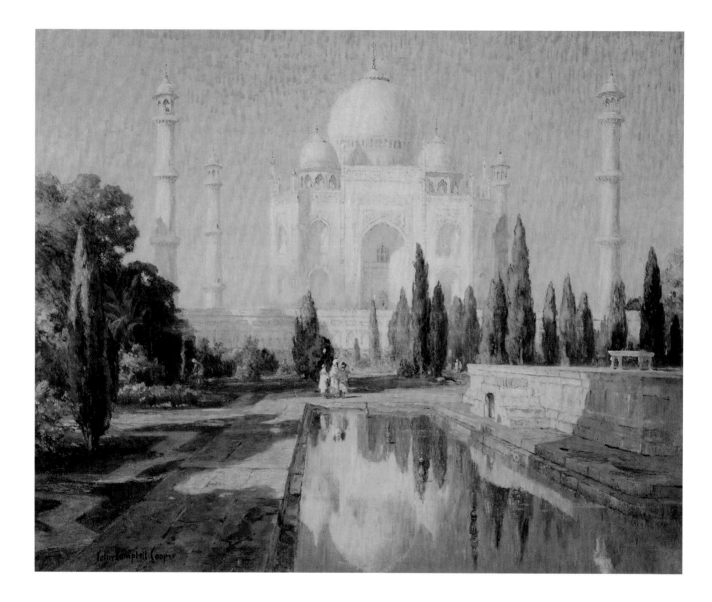

Cooper in California and Beyond

Deborah Epstein Solon

By the second decade of the twentieth century, Colin Campbell Cooper's career and reputation were well established. He lived in and was associated primarily with New York—and certainly his fame rested on his splendid skyscraper paintings and his celebratory images of the modern city—but a series of events that unfolded during the teens would radically change his life by 1920.

Cooper and his wife, Emma, traveled extensively, chiefly throughout Europe, in the early years of their marriage and into the twentieth century. However, their most exotic trip was undoubtedly to India. According to Cooper's diary, the couple left New York on October 11, 1913. Traveling via Italy and through the Suez Canal, they arrived in India by early November and remained abroad until mid-March of the following year, retracing their route through the Suez Canal and returning via France to America.[1] The impetus for this trip is uncertain. An article purportedly based on an interview with the artist claims that "he [Cooper] and his wife the late Emma Lampert were commissioned to paint in India by an American patroness of art."[2] This intriguing suggestion lacks any archival support. Although Cooper recorded his impressions of India in a diary for that year, he offers no indication of how or why they chose this destination.

India was hardly a common tourist destination for American artists—even the most seasoned and intrepid—despite the fact that the actual journey had been made somewhat easier by the opening of the Suez Canal in 1869. If the period known as the British Raj (1858–1947), the informal term for the period of British Colonial rule of the Indian subcontinent, can be praised for any virtues, it allowed periods of stability that precipitated the spread of the railroads and facilitated travel throughout the country.

The American artist who undoubtedly served as inspiration to Cooper was Edwin Lord Weeks (1849–1903), whose exploits in India were legendary.[3] Weeks, the scion of a New England family, was perhaps the most famous American orientalist painter in the expatriate community in Paris during the late nineteenth century. A student of Jean-Léon Gérôme and Léon Bonnat, Weeks was fascinated with oriental subjects. He made several daring expeditions to North Africa in the 1870s—especially to Morocco where foreigners were particularly unwelcome—resulting in paintings exhibited at the Salon beginning in 1880.[4] Building on his penchant for exotic subjects, Weeks made three trips to India (1882–83, 1886–87, and 1892–93). His series of illustrated articles about his adventures were published in *Harper's New Monthly Magazine* in the 1890s and subsequently reprinted in *From the Black Sea through Persia and India* (1896).

Weeks's Indian subjects vary from pedestrian images of tradesmen offering their wares in the ubiquitous bazaars to monumental depictions of the pomp and circumstance of Indian court life. Such scenes were often an amalgamation of real and imagined events, however, painted with such verisimilitude and attention to detail that they appear as near journalistic accounts. His careful description of the pageantry—the costumes, weaponry, elephants bearing gilded howdahs—underscored the exoticism of a land and culture completely distinct from Western traditions. And his interest in architecture extended from the magnificent jeweled palaces to detailed studies of simple balconies overlooking the streets, in which he explored the striking effects of light. Of the Taj Mahal, a building whose very name embodies romanticism and the tragic love story that inspired its creation, Weeks waxed poetic:

Seen from across the Jumna . . . it rises like a summer cloud against the clear sky, and its inverted mirage trembles in the deep blue of the water. There is no blackness in the shadows on the sunlit faces, and even under the deeply recessed arches the color is luminous and opalescent, while on the shadowed side it borrows the cool reflected tones of the sky, and is as full of transparent tints and hues of mother-of-pearl as the lining of a shell.[5]

Cooper's interest in India was evident as early as 1895 with his exhibition of *The Taj Mahal, Agra* (unlocated) at the Cotton States International Exposition in Atlanta, for which he was awarded a bronze medal. By the late nineteenth-century, engravings and watercolors of the building were easily available.[6] However, Cooper may have seen Weeks's now-famous imagery of India in person. According to the scholar Ulrich Hiesinger, some of the first Indian pictures that Weeks publicly exhibited, including *A Street in Ahmedabad* and *The Maharaja's Boat on the Ganges*, were shown in Cooper's native city at the Pennsylvania Academy of the Fine Arts in the fall of 1883.[7] Especially interesting is that *The Taj Mahal* was Cooper's first significant architectural picture—a precursor to his major European cathedrals and to the skyscraper paintings with which his name would become synonymous within the next few years. And since at least 1895, with the exhibition of his Taj painting, he had been seduced by beauty of this building. The opportunity to actually see it, along with India's other treasures, undoubtedly motivated him.

Cooper's diary is a travelogue of their journey, which included the cities Bombay, Ahmedabad, Udaipur, Jaipur, Delhi, Agra, Benares, Darjeeling, Calcutta, Rangoon, and Madras. "Certainly, for the most part," he wrote in his final diary entry for the trip, "we have enjoyed our experiences. I do not say that I do not care to go back again."[8] The Coopers remained in France through the summer of 1914 and the outbreak of World War I, where he worked up the studies made in situ. He outlined his progress in a letter to the New York dealer William Macbeth:

> We are here in this little fishing village near Marseilles, engaged in elaborating the studies onto canvas and I have made a good start toward getting together at least ten pictures of good importance of India. I am hoping that I may be able to show these together as a collection more or less. . . . It may be of course that you will not care for my work, but supposing that you were pleased with it, what prospect would there be for an exhibition at your galleries say sometime in the early part of January?[9]

The situation in Europe became increasingly volatile—Cooper was briefly arrested as a "German spy" for photographing the mobilization—and the couple returned to New York in November.[10] Cooper again wrote to Macbeth:

> Although Mrs. Cooper and I have been back in our studio for several weeks we have not really unpacked yet, being so busy with other things and there I have not had my India pictures in a condition to show you. I would be very glad, however, now to have you see what there is even though it may not be advisable to have an exhibition this season. One of the more important canvases, and

28

Kanchenjunga, The Himalayas, 1914
Oil on canvas
24 x 32 inches
Collection of Harry and Cricket Wilson
Photograph courtesy of Sullivan Goss–An American Gallery

29

Palace Gate, Udaipur, India, 1914
Oil on canvas
36¼ x 46⅛ inches
Santa Barbara Museum of Art, Gift of the family of the artist
Photograph courtesy of Scott McClaine

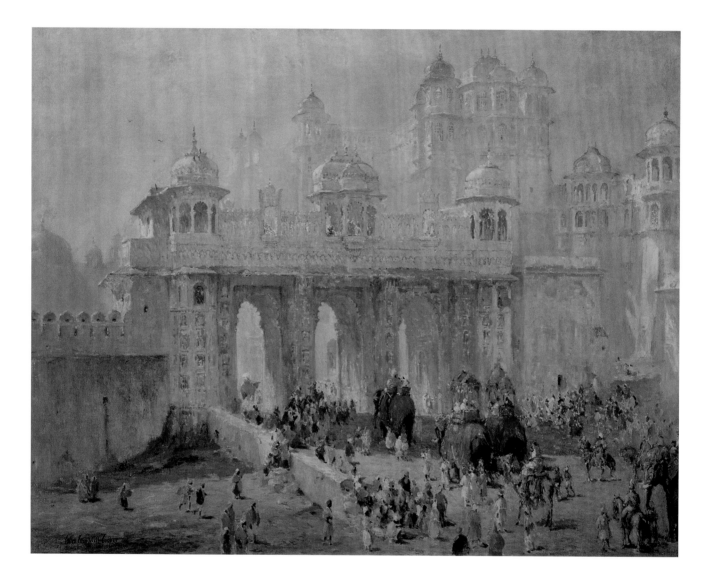

30

Hunter College, c. 1915
Oil on canvas
40 x 25 inches
Courtesy of Sullivan Goss—An American Gallery

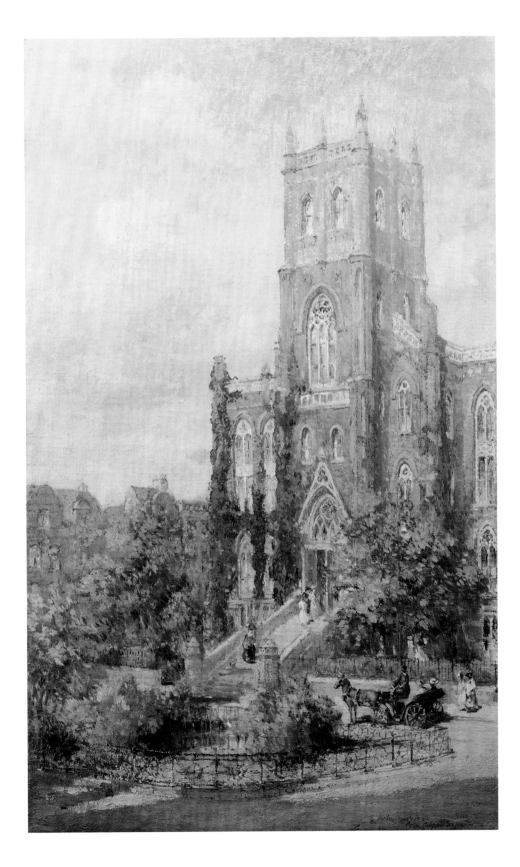

perhaps the most complete is wanted by the Corcoran exhibition and I would
like to have you see it before it goes. . . .[11]

Impressed, Macbeth organized a show of Cooper's India pictures that opened in February
1915. Included were two versions of the Taj Mahal, *The Taj Mahal, Agra (Afternoon)*, and *The
Taj Mahal, Agra (Morning)*.

The Taj Mahal is arguably one of the most famous mausoleums in the world and the pre-
eminent monument of the Mughal Empire (1526–1857).[12] Commissioned by Emperor Shah
Jahan as the final resting place for his beloved wife, Mumtaz Mahal, it is part of a larger
funerary complex and gardens; Shah Jahan was also eventually laid to rest in the mauso-
leum. Begun in 1630 and largely completed by 1643, its unique architectural construction
includes a dome surrounded by four clustered kiosks and encased by four minarets.[13] Fash-
ioned of white marble, jewel-encrusted, and adorned with intricate floral and geometric
inlays in profuse surface detailing, it is approached through gardens and monumental
reflecting pools. The original, densely planted gardens were replaced by lawns during a late
nineteenth-century restoration.

While Cooper was critical of Indian architecture, noting a "sameness about their
mosques, minarets, and pavilions that is somewhat disappointing," he was overwhelmed by
the Taj. "That has rare distinction," he noted, "plus an unforgettable and elusive quality
which makes it extraordinarily precious."[14] Cooper did several versions of the building from
different perspectives and viewpoints. The gardens surrounding the Taj were an essential
aspect of the site's architectural program. Known as the Chahar Bagh (Persian for Gardens
of Paradise), the rectangular gardens are divided into four quadrants, four being a sacred
number in Islam. Within these gardens are two main water channels that bisect at right
angles. At the intersection of the channels is the main water tank, the Pool of Abundance,
situated on a raised platform. Smaller reflecting pools then surround the water tank. Typical
views of the Taj generally include the main water channel: we know that Cooper exhibited
one such view at the Macbeth exhibition. Cooper's view in *Taj Mahal, Afternoon* (cat. no. 27)
is slightly more elusive. The regal white palace emerges like an apparition from the land-
scape. However, the foreshortened reflecting pool in the foreground is not one of the main
axial water channels. It may be that we are looking at a view from the west side of the water
tank and one of the smaller reflecting pools.[15] Cooper established the viewer's perspective
from literally "inside" the water, while the three figures help to indicate the scale of the 250-
foot-high edifice. Cooper's flickering, Impressionist brushwork creates an overall light that
saturates the building and casts shadows in the foreground. The effect is a shimmering
pictorial approximation of how the interplay of light and shadow must have struck the visi-
tor's eye.

Critics singled out the Taj Mahal paintings. "The chefs-de-oeuvre [sic] of the exhibition
are of that highest expression of Indian architectural beauty, the Taj Mahal. Artists without
number have exhausted their talents on its symmetry of design, the delicate grace of its
domes, and the Arabian Nights atmosphere that surrounds it. Mr. Cooper has admirably
depicted the inspiring structure and has embodied in his two pictures the romance of the
East."[16] One reviewer noted: "Mr. Cooper has exemplified a variation of viewpoint in the

31

Panama-Pacific Exposition Building, c. 1915
Oil on canvas
36 x 54 inches
Collection of the City of Santa Barbara
Photograph courtesy of Scott McClaine

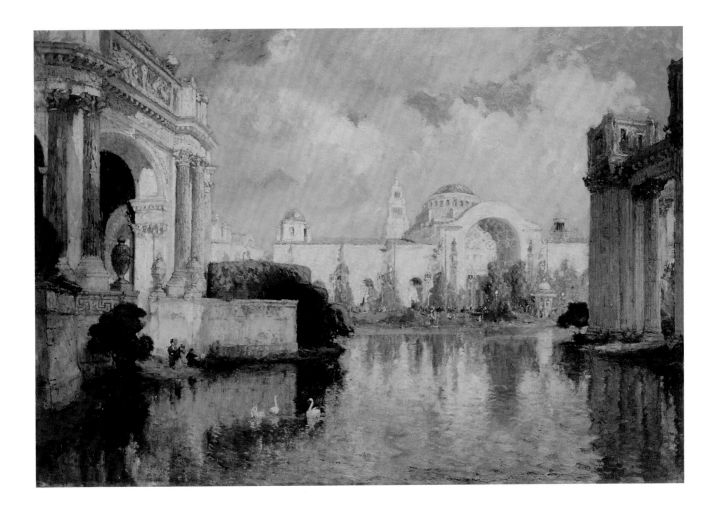

32

Shwe Dagon Pagoda, Burma, 1915
Oil on canvas
40½ x 27¾ inches
Courtesy of Edenhurst Gallery, Los Angeles and Palm Desert

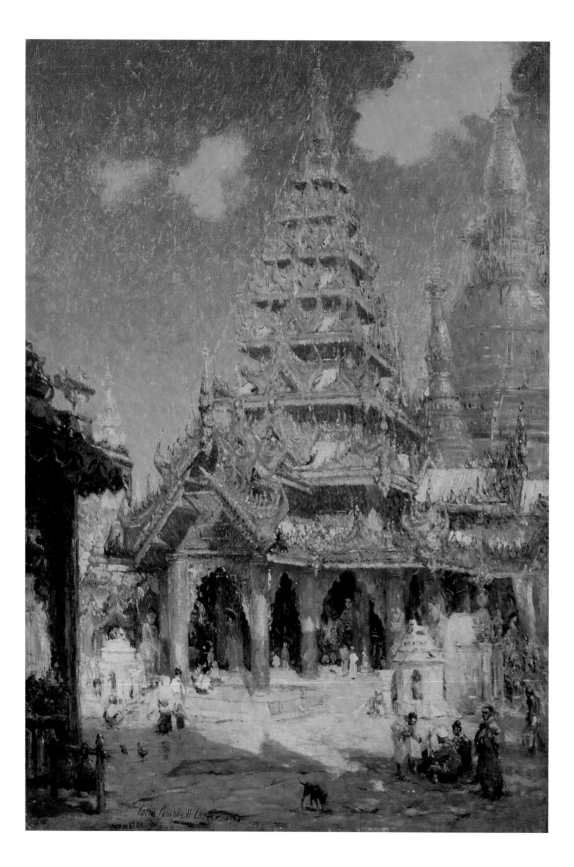

33

Tower of Jewels, Panama-Pacific International Exposition, 1915
Oil on canvas
18 x 22 inches
Private Collection

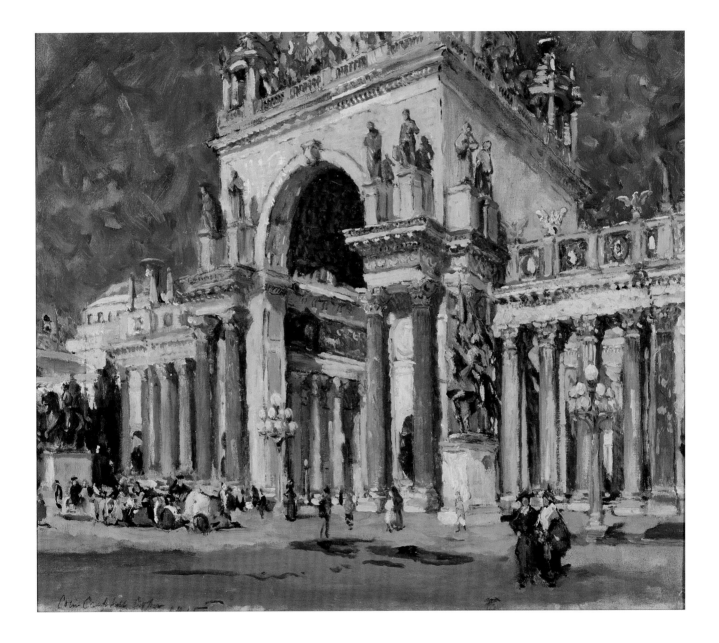

34

An Afternoon Stroll (Pool and Canadian Building), 1916
Gouache on paper
17 x 20¾ inches
Redfern Gallery, Laguna Beach, California

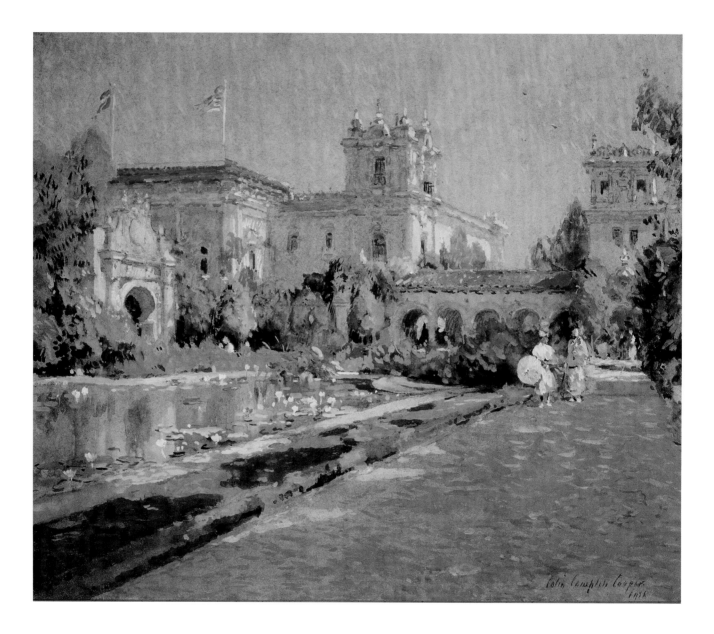

present display, for he has two pictures of the scene . . . which are artistically so different from the other. . . ."[17] In comparison to his predecessor, Edwin Lord Weeks, it was observed that "Mr. Colin Campbell Cooper has . . . an exhibition of pictures painted in India, full of the color of that country and skillfully done. He is as accurate as an observer as the late Edwin Lord Weeks, and he has a much more sympathetic touch, a much finer sense of color."[18] And another critic summed up the enthusiastic responses:

> The colorful brush of Colin Campbell Cooper, so sensitive to decoration, atmosphere and environment, has found in India inspiring subjects and translated them with such grace and charm that will . . . greatly delight his admirers and will be a surprise to those art lovers who do not know his work—if there be any. . . .[19]

When Cooper wrote to Macbeth in 1914 about the possibility of an exhibition, he especially wanted him to see "one of the more important canvases, and perhaps the most complete," which was wanted for exhibition by the Corcoran.[20] *Palace Gate, Udaipur, India* (cat. no. 29) was indeed exhibited at the Corcoran Gallery of Art, but returned for the Macbeth exhibition.[21] The Coopers spent several weeks in Udaipur, where they witnessed a "procession" that may have inspired this painting.[22] Udaipur is located in the southern part of what is now Rajasthan, the largest state in northwestern India. In Weeks's illustrated article published in 1895, he dubbed it "the white city," observing that "not only the pavilions, kiosks, and arcades which rise from the shores of the lake, but the lower walls of the great palace . . . are positively dazzling with whitewash."[23] Perhaps the most renowned structure was the Lake Palace complex, which was accessed on one side through a massive, three-arched gate. Weeks described and illustrated the palace in "Oedeypore, The City of Sunrise":

> The great white palace, which is the key-note and the dominant feature of the landscape, and which so fascinates the eye when first seen in the morning light rising above the tree-tops background of mountains, gains in interest as we approach it. . . . From the landward side, and from the city, the most imposing approach is through the first gate at the end of a long bazaar, where one enters the outer precincts and stands in front of the "trifolia," or triple-arched gateway, which is in itself a noble structure, placed high upon rising ground, commanding the entrance to the long terrace in front of the castle walls, and crowned by open and delicately fashioned cupolas, connected with each other by a white wall or curtain of transparent stone lattice-work.[24]

Cooper's painting is the pictorial realization of this description. Placed outside the great trefoil gate, the viewer joins the procession slowly moving toward the palace grounds. Elephants with their howdahs, camels, horses, a swirl of humanity in vibrant costumes, are all beautifully described. Carefully articulated architectural structures are juxtaposed against mere dabs of color suggesting the staffage figures massed at the gates. One reviewer described it as "perhaps the most striking work in the display . . . a remarkable portrayal of the rich colored, strange life of an ancient city under tropic skies."[25] The painting's extensive exhibition history undoubtedly establishes it as one of Cooper's most acclaimed Indian works.[26]

35

Balboa Park, Varied Industries Building, 1916
Gouache on paper
17½ x 21¾ inches
Private Collection

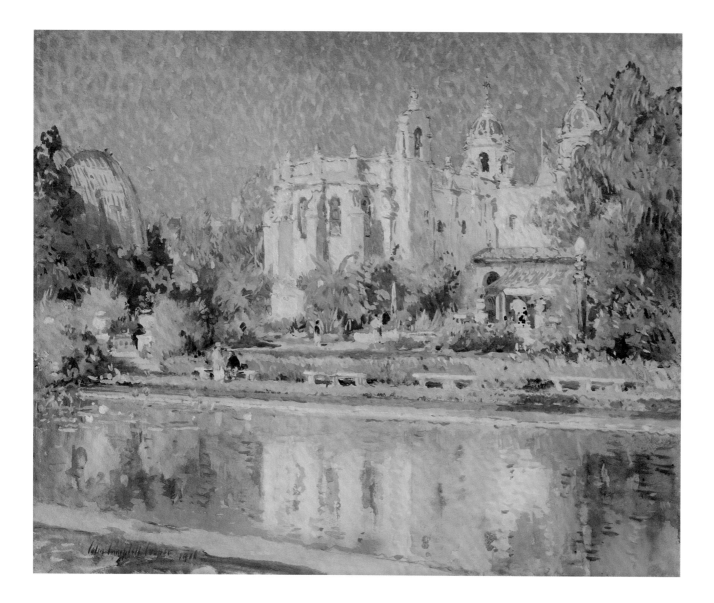

36

California State Building, San Diego Exposition, 1916

Oil on canvas

26 x 20⅛ inches

Santa Barbara Museum of Art, Gift of the family of the artist

Photograph courtesy of Scott McClaine

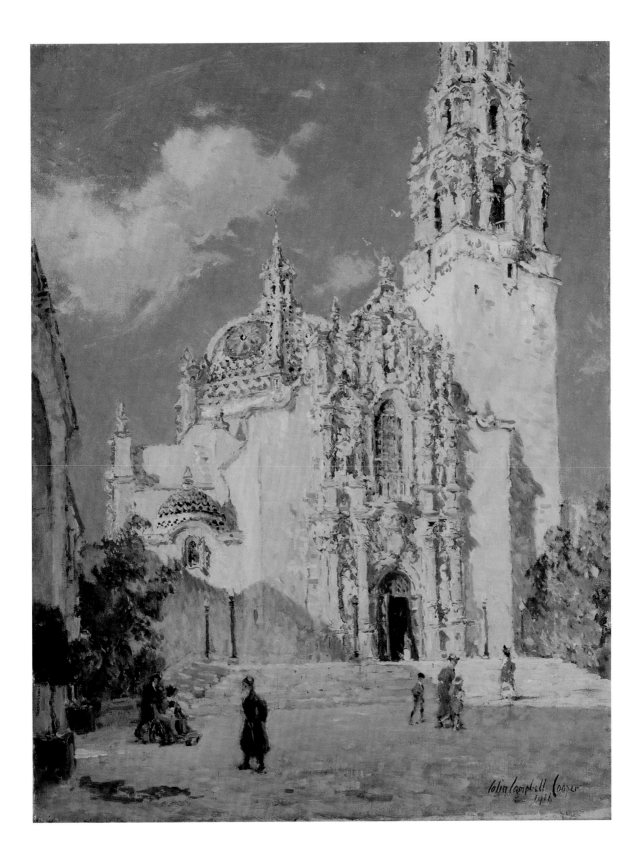

In 1915, both Colin and Emma Cooper mounted a joint exhibition of their respective Indian pictures at the Memorial Art Gallery in Rochester.[27] Cooper's ten paintings included *Taj Mahal, Agra*, and *Palace Gate, Udaipur, India* in addition to *Shwe Dagon Pagoda, Burma* (cat. no. 32).

In *Letters from the East* (1889), Rudyard Kipling described Shwe Dagon Pagoda as a "golden mystery . . . a beautiful winking wonder that blazed in the sun, of a shape that was neither Muslim dome or Hindu Temple spire."[28] Cooper notes that in late January 1914, the couple was in Burma, where he sent several days sketching at Shwe Dagon Pagoda, the most notable and revered Buddhist reliquary in Yangon, Myanmar (formerly Rangoon, Burma). The huge complex consists of a cone-shaped brick stupa (Buddhist reliquary) completely covered in gold and surrounded by sixty-four small and four larger pagodas. The crown of the stupa is tipped with thousands of precious gemstones, including diamonds and rubies. Built sometime between the sixth and tenth centuries, the stupa is believed to hold eight hairs of the Buddha.

The complex was a visual feast for Cooper. Emma penned descriptions of the paintings and their locations in the Rochester catalogue, carefully explaining the monument:

> The pagoda is a structure 370 feet high and very much resembles a huge dinner bell. It is entirely gilded, the upper part or handle being covered with gold plates which are contributed by the natives and cost about three hundred rupees—one hundred dollars—each. Round about this central building are enormous temples such as the one shown in this picture. They are built by wealthy Burmese to propitiate their gods.[29]

Cooper's orientation from the north focuses the traditional Myanmar "pyatthyat tazaung," which features a distinctive multitiered roof in a pyramidal shape surmounted by a spire.[30] Interestingly, he did not select the largest, most famous dome pagoda—merely including a truncated glimpse of it at the right—but instead explored this ancillary exquisite structure that soars upward like the layers of an enormous wedding cake. Here Cooper found an analogue, as it were, to his New York skyscrapers and European cathedrals. All are visionary shrines of one sort or another—to gods, to money, to human ingenuity.

The Panama-Pacific International Exposition in San Francisco was one of the seminal events of 1915. Intended as a celebration of the completion of the Panama Canal, and marking the 400th anniversary of the discovery of the Pacific Ocean, it showcased San Francisco's phoenixlike resurgence from the rubble of the 1906 earthquake and fire. Opening on February 20 and running through December 4, 1915, the fair was a monumental enterprise.[31] Every state had a representative building on the six-hundred-and-thirty-five–acre site; twenty-four nations participated, despite the fact that World War I was raging in Europe.[32]

The art pavilion, the Palace of Fine Arts, contained 113 galleries, housing thousands of paintings from all over the world. Among the American delegation were Childe Hassam, Frank Duveneck, William Merritt Chase, John Singer Sargent, and James McNeill Whistler. Cooper exhibited six works, receiving a gold medal for oil painting and a silver medal for watercolor. Eugen Neuhaus, author of a detailed critique of the exposition's art, commented briefly on Cooper's submissions: "Typically American and very unusual are Colin

37

Half Dome, Yosemite, 1916

Oil on canvas

20 x 26 inches

Collection of Paul and Kathleen Bagley

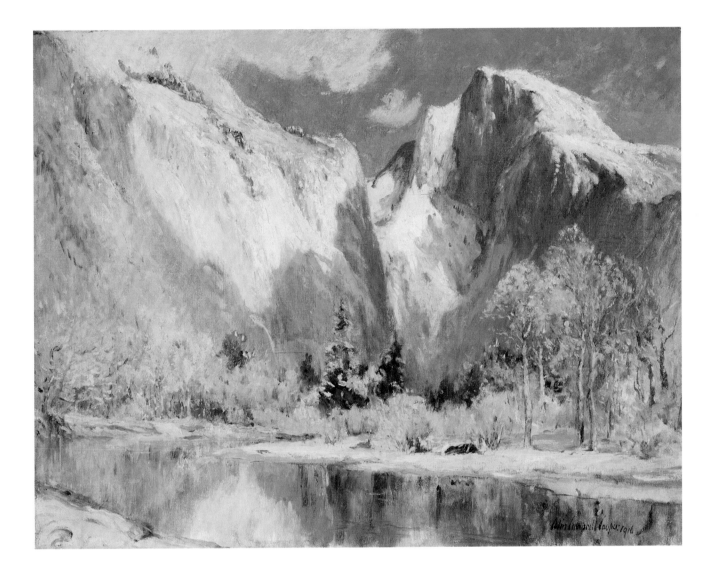

38
Japanese Tea Garden, c. 1916
Oil on board
10 x 14 inches
Private Collection

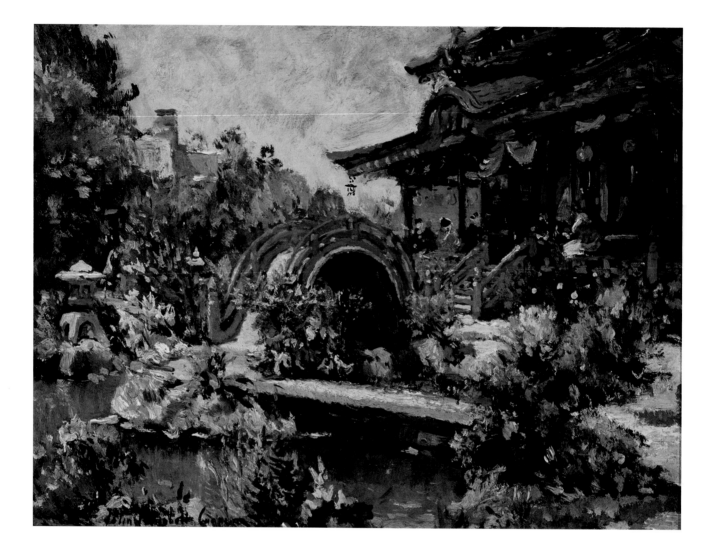

Campbell Cooper's New York street perspectives. His originality as a painter is well demonstrated by this choice, which must have taken courage at the time when American subjects were more or less despised."[33] The Coopers went to San Francisco to visit the exposition, probably in late 1915; he found many of the buildings apt subject matter.

The Tower of Jewels, the 435-foot centerpiece, was the largest structure. Its surface was covered with 102,000 "novagems" of faceted cut glass.[34] They were hung freely from the sides and mounted on brass hangers with small mirrors for maximum effect. Designed by New York architect Thomas Hastings, the tower symbolized the Panama Canal as a resplendent jewel.

Cooper's *Tower of Jewels, Panama-Pacific International Exposition* (cat. no. 33) offers an unusual perspective. He truncated the tower, showing only the main arch and the first tier. Included are the four sculptural figures by John Flanagan that flanked the arch (*The Adventurer, The Priest, The Philosopher,* and *The Warrior*), along with the sculptures of Cortez by Charles Niehuas, and Pizarro by Charles Rumsey, which were placed on either side of the tower. Although the forms are clearly articulated, the sketchy paint handling underscores the immediacy of a moment captured in time.

The one building that Cooper revisited in various iterations was the Palace of Fine Arts. Louis Christian Mullgardt, architect of the Court of the Ages and author of a critique of the architecture and landscape gardens, characterized the building:

> The Palace of the Fine Arts is, in reality, not one complete building, but four
> separate and and distinct elements. The rotunda, an octagonal structure, forms
> the center of the composition. On either side is a detached peristyle which fol-
> lows the curve of the gallery itself, as it describes an arch about the western
> shore of the Laguna. . . . The architecture, as a whole, is early Roman, with
> traces of the finer Greek influences.[35]

The Palace of Fine Arts was the brainchild of San Francisco architect Bernard R. Maybeck, who sought to integrate it seamlessly within a timeless landscape. Set in the lagoon, the building was physically isolated from the rest of the exhibits. An eight-color pastel theme was enforced for all the architecture; the fine-arts building sported ocher and green columns, and burnt-orange Corinthian capitals and dome. The San Francisco exposition was commonly referred to as the Domed City (undoubtedly a subtle play on the Chicago's 1893 World's Columbian Exposition known as the White City), as several of the buildings were domed. The profusely decorated Palace of Fine Arts was constructed to be viewed under different lighting conditions; Cooper, in fact, painted it under both natural and artificial illumination. Tremendous effort was expended on lighting the fair at night. General Electric designed the overall plan, involving thousands of carefully hidden spotlights that gave the buildings a magical, ethereal glow. Cooper distilled that nocturnal experience in *Palace of Fine Arts, San Francisco* (cat. no. 43). Against the night sky, the building resembles a high-relief sculpture; reflections in the dark water create a mirror image. An impressive 40-by-50 inches, the painting offers a seemingly realistic vision of this exceptional and riveting tableau. One reviewer noted that "a dreamlike quality hangs about it, an air of unreality and enchantment. One thinks of Xanadu's stately pleasure dome."[36]

Cooper often made multiple versions of his images and gave them similar titles. A smaller, nearly identical painting exists (private collection, California), however, it was undoubtedly the larger one that was exhibited at the National Academy of Design (1916–17), the Pennsylvania Academy of the Fine Arts (1917), at the Memorial Art Gallery, Rochester (1918), and other venues during the 1920s and 1930s. Additional views of the building include a panoramic view from the shore (cat. no. 44) and another from the perspective of looking out from the lake in which the Palace of Fine Arts is only partially visible and the Tower of Jewels can just be seen in the background (cat. no. 31). Cooper's virtuoso handling of full sunlight and shadow on water and the impact of the pastel color scheme are especially resonant.

The exposition's "palaces" celebrated American ingenuity on a number of different levels.[37] Freestanding sculpture was interspersed throughout the grounds. Cooper focused on one of these sculptures in *Panama-Pacific International Exposition (Court of the Four Seasons)* (cat. no. 45), of which Evelyn Beatrice Longman's imposing *Fountain of Ceres* was the centerpiece. Ceres, the goddess of agriculture, is propitiously situated between the Palace of Food Products and the Palace of Agriculture. Poised on a globe, she holds a corn sculpture and a cereal wreath. Cooper must have been especially impressed by this particular scene, for his account books record few other such courts and sculptures. Typical for Cooper is the play of light and shadow against the building façades and the massing of the colorfully costumed visitors.

By March 1916, the artist had exhibited three paintings of Panama-Pacific Exposition subjects at the Oakland Public Museum and the Schussler Galleries in San Francisco.[38] Also that spring, he showed *Half Dome, Yosemite* (cat. no. 37) at the Los Angeles Museum of History, Science and Art (now Los Angeles County Museum of Art). Cooper visited Yosemite National Park during his stay in Northern California. Nearly nine thousand feet high, Half Dome, located at the eastern end of Yosemite Valley, is part of the Sierra Nevada Mountain Range. From the vantage point of a stream at the base of the mountain, Cooper painted a cool winter scene in lavenders, blues, and whites, but with warm shadows throughout. The mountain, a geological skyscraper, leaves its distinctive imprint on the horizon, nature's equivalent to the urban towers that Cooper so enthusiastically embraced. The previous year, Cooper had exhibited *Kangchenjunga, The Himalayas* (cat. no. 28), another paean to the wonders of nature. Nonetheless, Cooper's interest in grandiloquent landscapes was limited and later, when he relocated to California, his interest was in nature cultivated and civilized.

The Coopers spent several weeks in April 1916 in Los Angeles before continuing to San Diego.[39] En route, they stopped at the Mission San Juan Capistrano, one of a chain of twenty-one missions located throughout the state. The missions were part of the misguided Spanish plan to Hispanicize and convert the native Indian population to Christianity.[40] Mission San Juan Capistrano was founded by Father Junipero Serra on November 1, 1776. Its great cathedral, completed in 1806, was reduced to rubble during Southern California's devastating earthquake on December, 8, 1912.[41] By mid-century, the building had fallen into complete disrepair, its materials cannibalized for other structures. The mission was returned to the Church after California attained statehood, and by the 1860s the land around it was

39

Lily Pond, Balboa Park, c. 1916

Gouache on canvas

37 x 55 inches

Collection of the City of Santa Barbara

Photograph courtesy of Scott McClaine

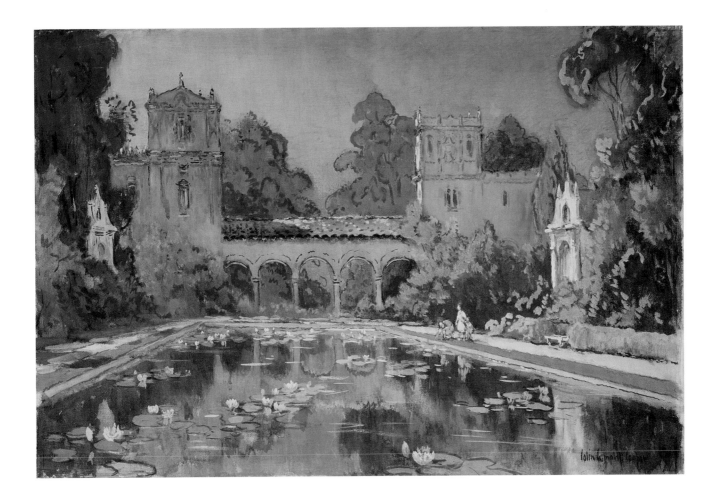

parceled out to homesteaders. When the Santa Fe Railway established a stop at Capistrano, the town was, quite literally, put "on the map."

With the railroad came real-estate developers, buyers, and tourists. The drive to salvage the mission was spearheaded by Charles Fletcher Lummis, whose California boosterism and propaganda flooded the pages of his magazine *Land of Sunshine*.[42] Loomis's attempt to polish the mission's tarnished image, making it appealing to tourists, was couched in romantic tales and legends of its halcyon days.[43] Artists, by the early twentieth-century, were already attracted to the aura of the ruins. According to scholar Jean Stern, interest crested by the mid-1920s, no doubt fueled by its geographic proximity to the art colony in Laguna Beach.[44] Among the many Impressionist artists who painted at the mission were Anna Hills, Joseph Kleitsch, Guy Rose, Donna Schuster, Elmer Wachtel, and William Wendt.

Cooper, too, was seduced by Southern California's most historic buildings. His many paintings of the mission include *Mission Corridor, San Juan Capistrano* (cat. no. 40), *Mission San Juan Capistrano* (cat. no. 42), and *Mission Courtyard (San Juan Capistrano)* (cat. no. 41).[45] The first two pictures have similar viewpoints.[46] *Mission Corridor*'s repetition of arches culminates in a deep spatial recession. A variety of surfaces—stone floors, wood-beamed ceiling, stucco walls—allowed Cooper to experiment with different textures. The shadowed corridor provides a strong contrast to the raking light of the courtyard. *Mission San Juan Capistrano*, a watercolor, is a foreshortened version of the same corridor. Cooper's facility with the medium is evident in the sunshine that penetrates the arches, creating shadows and highlights. And as if to remind viewers that this was a functioning parish, Cooper included a padre and altar boy. The painting was reproduced on the cover of *California Southland* for September 1927. The oil painting *Mission Courtyard* combines architectural elements with brightly colored vegetation.[47] Light bathes the canvas, capturing the mellow hues of the aging walls; dabs of strategically placed color suggest the blooms. In addition to the mission itself, Cooper painted small vignettes of the town, such as *Capistrano Train Station* (fig. 1), and *Near Mission San Juan Capistrano* (fig. 2), a view looking west from the mission toward the present-day Ortega Highway.[48]

By early May, the *Los Angeles Times* noted that Cooper had already spent a considerable amount of time in San Diego painting the "fair grounds," a reference to the Panama-

Fig. 1. *Capistrano Train Station*, c. 1916; watercolor and gouache on paper; 11 × 14½ inches (sight); James Irvine Swinden Family Collection

Fig. 2. *Near Mission San Juan Capistrano*, 1916; mixed media; 5 × 7 inches; Private Collection, Courtesy of The Irvine Museum, Irvine, California

40

Mission Corridor, San Juan Capistrano, c. 1916
Oil on canvas
21½ x 17¾ inches
Collection of Peter and Gail Ochs

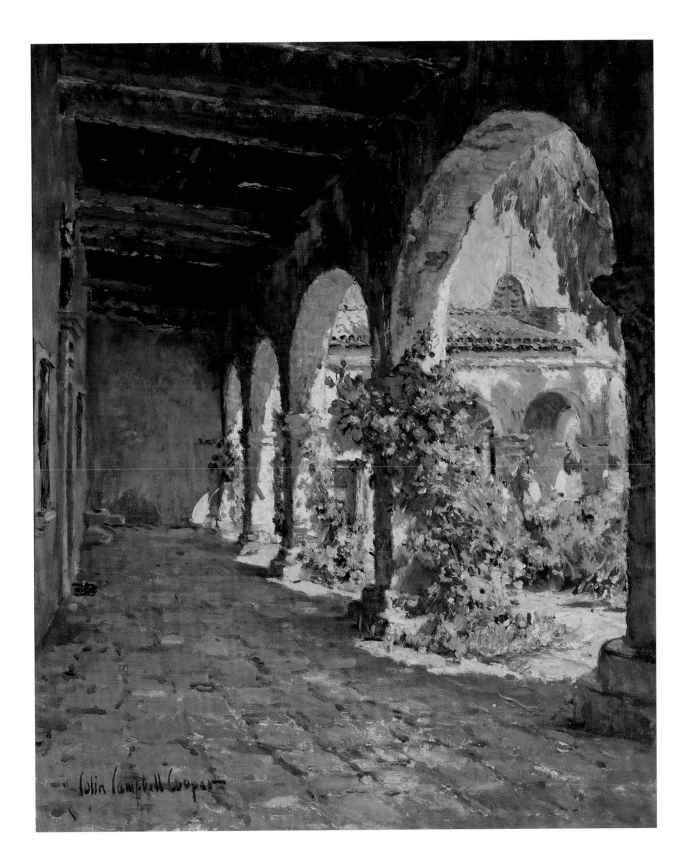

41

Mission Courtyard (San Juan Capistrano), c. 1916
Oil on board
17½ x 21½ inches
Private Collection, Courtesy of The Irvine Museum
Irvine, California

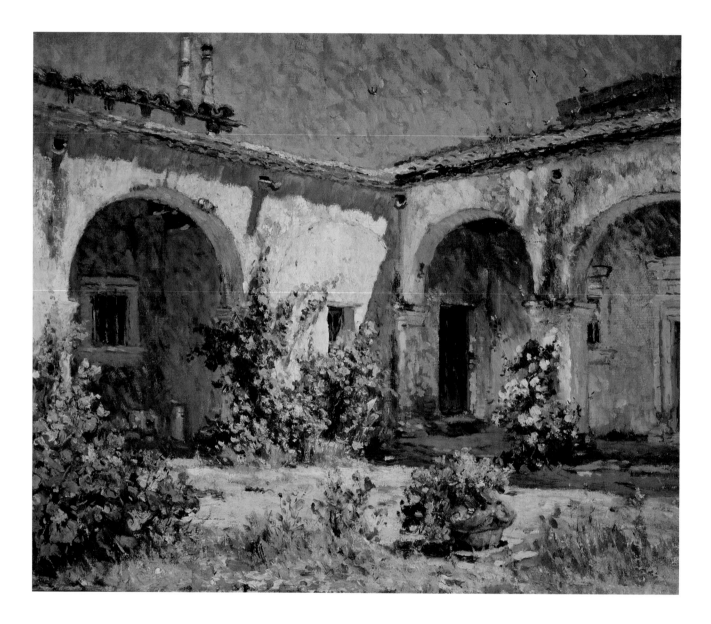

42

Mission San Juan Capistrano, c. 1916

Gouache on canvas

36 x 46 inches

Collection of the City of Santa Barbara

Photograph courtesy of Scott McClaine

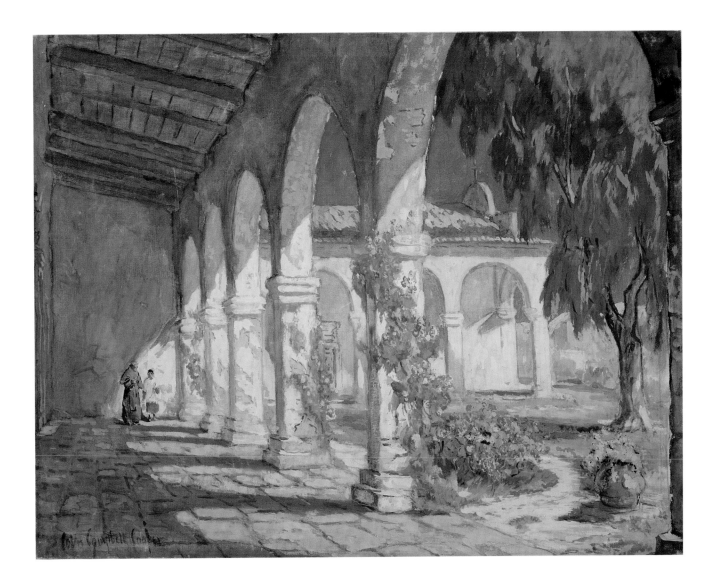

43

Palace of Fine Arts, San Francisco, 1916
Oil on canvas
40¼ x 50½ inches
Crocker Art Museum, Sacramento, California,
Gift of Helene Seeley in memory of Mr. and Mrs. C. C. Cooper
Conserved with funds provided by Mr. Gerald D. Gordon
through the Gifts to Share program

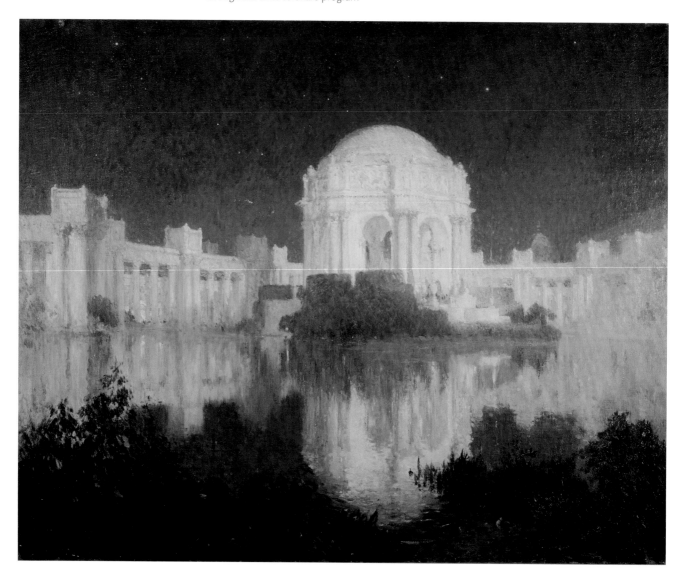

California Exposition that opened in San Diego on January 1, 1916.[49] An editorial in the *San Diego Union* summed up the collective pride at the fair's opening:

> The New Year's gift to San Diego is the triumph of the most ambitious enterprise ever undertaken by any city of Southern California. . . . Four years ago, when assurance was given that the dream of the centuries was to become true—that the Isthmus of Panama could be pierced by a waterway that would be completed in 1915—the very proper suggestion was made by a public-spirited resident of San Diego that this city, as the nearest port to the new avenue of commerce, and the one that would chiefly profit from it, should celebrate that world event by a great Exposition. . . . [50]

The actual circumstances culminating in the San Diego fair were a bit more complicated. In 1909, San Diego, San Francisco, and New Orleans were all lobbying the United States Congress to "host" an exposition to celebrate the opening of the Panama Canal. When the San Diego organizers realized that their bid for an international fair was futile, they agreed to support San Francisco over New Orleans in exchange for being allowed to sponsor a smaller fair demonstrating how industrial, agricultural, and commercial achievement could give rise to cities in the West. Ironically, the year-long Panama-California International Exposition opened as "international" on January 1, 1916.

The ambitious landscape program was originally given to John C. Olmsted and his brother Frederick Law Olmsted, Jr. (scions of the great designer Frederick Law Olmsted). The brothers were esteemed landscape designers in their own right, having laid the grounds for the 1905 Lewis and Clark Exposition and the 1909 Alaska-Yukon-Pacific Exposition. New York architect Bertram Goodhue was named supervisory architect, assisted by a local architect, Irving Gill. The original concept for the buildings was a Mission Revival style. Following a disagreement, Gill and the Olmsteds resigned, leaving Goodhue to spearhead the project. He jettisoned the more sedate mission style in favor of a highly ornate Spanish-Mexican style known as Churrigueresque. His magnum opus of the fair was the eclectic, highly detailed California State Building—part Gothic cathedral, part Baroque church, part Hagia Sofia, part Mexican cathedral—that somehow achieves harmony and balance.[51]

Cooper's *California State Building, San Diego Exposition* (cat. no. 36), is a view from the Plaza de California of the complex ornamental and architectural detailing of the façade and the colored tiles that form geometric patterns on the domes. The foreground is cast in lavender shadows, but scintillating sunlight on the building reflects off the various surfaces. And Cooper masterfully manipulated small amounts of color to achieve maximum effect in the colorful clothing worn by visiting women and children.

Cooper painted several splendid watercolors of the exposition grounds. The Laguna de las Flores, or the lily pond, was the subject for *Lily Pond, Balboa Park* (cat. no. 39), a foreshortened, frontal view looking south of the pond, which, fully shown, would have included a balustrade and white urns at the opposite end. From this perspective, the viewer virtually floats in the pool among the lily pads. Cooper did at least one additional, nearly identical scene in oil (Sullivan Goss–An American Gallery). *An Afternoon Stroll (Pool and Canadian Building)* (cat. no. 34) includes the pond in deep recession with the Canadian Building to the

44

Panama-Pacific Exposition, c. 1916
Oil on canvas
19 x 22 inches
Private Collection, Courtesy of The Irvine Museum
Irvine, California

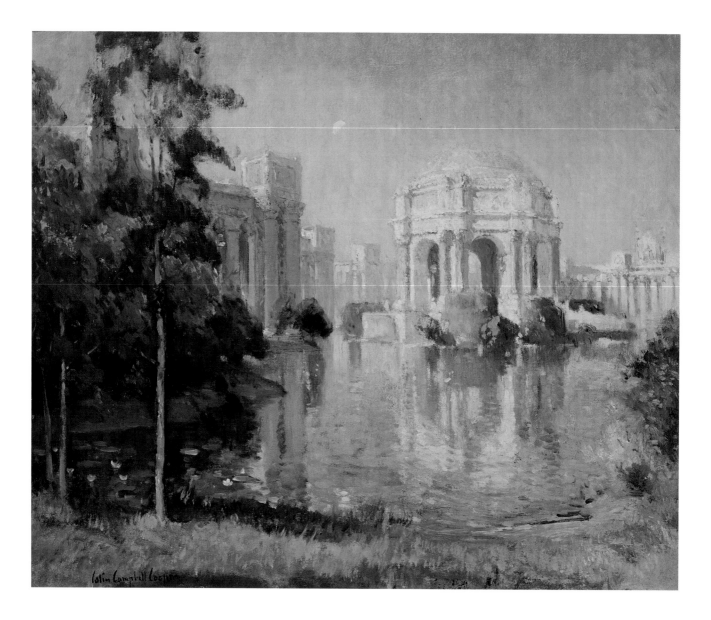

45

Panama-Pacific International Exposition (Court of the Four Seasons), c. 1916
Oil on canvas
20 x 26 inches
Collection of Paul and Kathleen Bagley

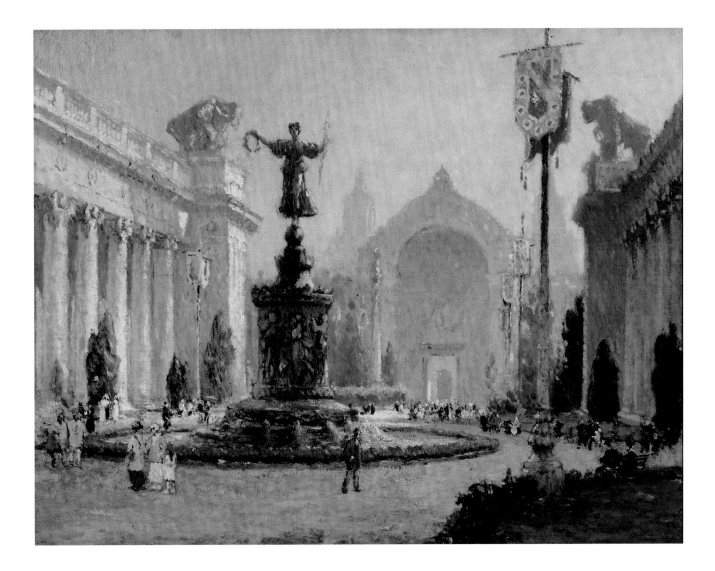

left. Originally known as the Commerce and Industries Building, it became the Canadian Building when the exposition went international. In this beautiful integration of buildings, pond, and visitors on a glorious, sunny afternoon, Cooper's facility as a watercolorist is underscored. It is likely that both pictures were exhibited at in 1916 at the Philadelphia Art Watercolor Exhibition, and at the American Watercolor Society in 1917. Another jewellike watercolor, *Balboa Park, Varied Industries Building* (cat. no. 35), is a view from the Laguna de las Flores toward the structure's west façade with the Botanical Building seen to the left.[52]

Particularly intriguing was the Japanese tea house and garden. Modeled after a Buddhist temple rather than a traditional tea house,[53] the building was approached by a curved red vermilion lacquer bridge. Tea was served inside and on the open verandas. The landscape included a winding stream, a rock garden, azaleas, wisterias, dwarfed cedars, and weeping junipers. *Japanese Tea Garden* (cat. no. 38) is a gemlike rendition of the building and its grounds.

In 1920, when Cooper reproduced eight paintings in *The Century* under the title "The Poetry of Cities," he included *The Magic City, San Diego* (unlocated), a view from a hillside outside the San Diego fair grounds looking toward the Cabrillo Bridge and the California Tower. Grouped with images of the Metropolitan Tower, New York, Broad Street Station, Philadelphia, and the Main Street Bridge, Philadelphia, the picture seems incongruous. Yet Cooper's title indicates that he must have viewed the exposition grounds and buildings as a "city" of sorts, and therefore compatible with his other choices.[54]

The Coopers returned to New York in October 1916. The productive period in California had resulted in paintings of the architecture at both the San Francisco and San Diego fairs, part of the continuum originating with his European cathedrals and extending through his skyscraper and India pictures. The paintings of approximately 1917–19 suggest a transition. While Cooper continued to exhibit skyscraper paintings throughout his career, his focus began to change, shifting from urban to more rural and nostalgic architecture and to figure paintings.

From New York to Washington, D.C., Philadelphia, and Rochester, Cooper had spent the first decade of the century spearheading scenes of urban architecture. That his oeuvre was so synonymous with this genre may have been a mixed blessing. In his own words, "to confine oneself to one class of subject seems to me to narrow the vision and limit the endeavor."[55] His renewed interest in figure paintings recalls his early academic roots, as exemplified in *Portrait of a Lady in a Green Dress* (cat. no. 5) and his sensitivity as a portraitist.

The later figurative works reflect a different sensibility. His genteel women, occasionally wearing oriental costumes and holding parasols, set in gardens, boats, or fashionable parlors, undoubtedly relate to similar scenes popularized by artists of the "Giverny Group," such as Frederick Carl Frieseke, Richard Miller, and Lawton Parker.[56] While these artists also portrayed nudes, a subject Cooper eschewed, they painted images of women at leisure and dressed in beautiful costumes, articulated through Impressionist light and color. Although the group's popularity crested in the earlier teens, their influence endured.

Cooper's *The Mandarin Coat* (Private Collection), exhibited at the 1917 winter exhibition at the National Academy of Design, is a tour-de-force. The intricately patterned floral designs of the figure's kimono and parasol are subtly echoed in the background floral garden

46

Entrance to the Maharaja's Palace, Jaipur, 1917
Oil on canvas
22 x 18 inches
Private Collection

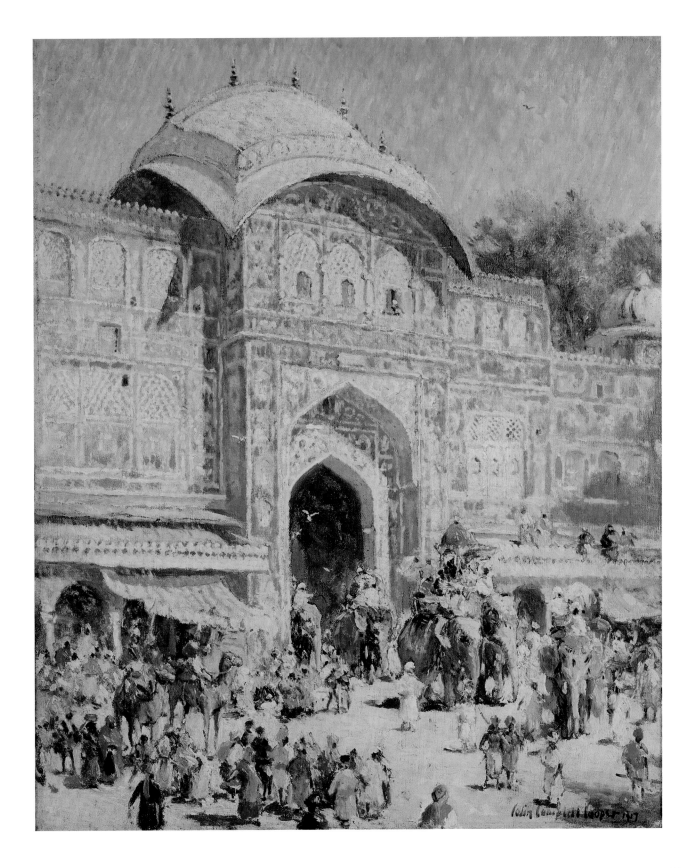

47

Lower Broadway in Wartime, 1917

Oil on canvas

57½ x 35¼ inches

Courtesy of the Pennsylvania Academy of the Fine Arts

Philadelphia, Joseph E. Temple Fund

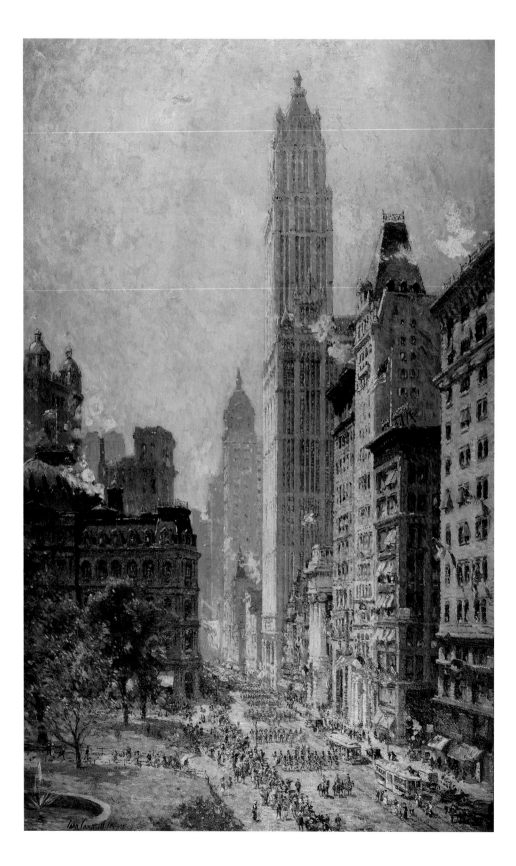

48

Metropolitan Tower, New York City, 1917
Oil on canvas
28⅛ x 20⅛ inches
Private Collection

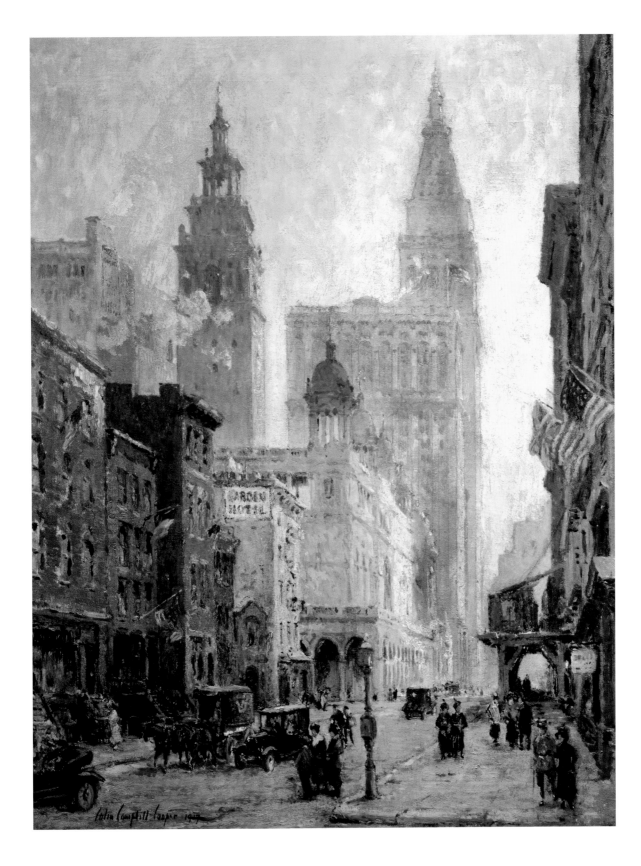

49

South Ferry, New York, 1917
Oil on canvas
29½ x 36¼ inches
The National Arts Club, New York

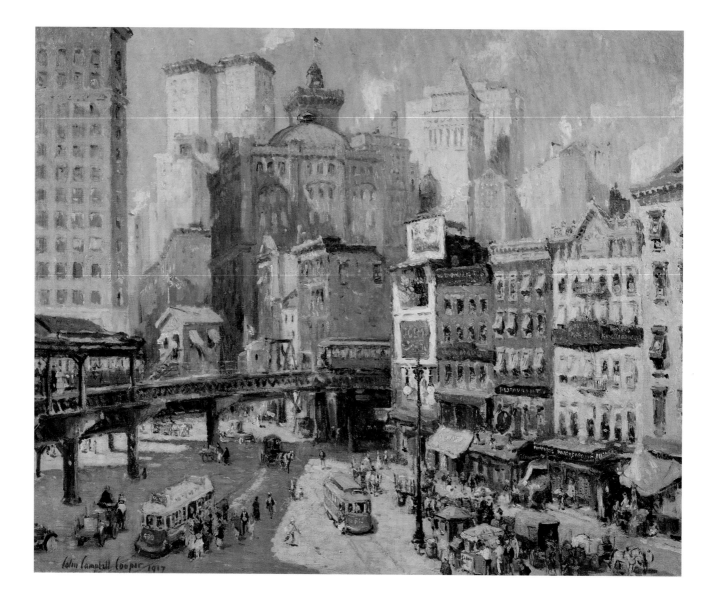

setting. The painting was the cover illustration for *Town and Country Magazine* in March 1918. *The Rustic Gate* (cat. no. 51), exhibited at the 1918 winter exhibition of the National Academy of Design and at the Memorial Art Gallery in Rochester in 1919, also features a woman in a garden but this time enveloped by flowers. She stands within a trellis holding a red bouquet and gazes rather wistfully into the distance. *Summer*, 1919 (Private Collection), showing two women in a boat leisurely afloat on a lily pond, was awarded the distinguished Walter Lippincott Prize in 1919 from the Pennsylvania Academy of the Fine Arts. It was the cover illustration for the March 1919 issue of *The International Studio*.[57]

Another pair of figures, this time in an interior setting, is slightly more enigmatic. *Two Women* (cat. no. 50) may be the painting exhibited as *Naomi and Irma* at the 1917 spring exhibition at the National Academy of Design. Two young, attractive, beautifully dressed women are seated in a parlor; one looks out at the viewer, the other, seen in profile, reads a book while using her free hand to grasp a piece of furniture, as if steadying herself. The pose enabled Cooper to explore the long, languid curve of her neck, shoulder, and arm, down through her hand. The oppositional direction of the figures creates a circular movement, reiterated in the round framed picture on the back wall. If this painting is a portrait of specific individuals, it would distinguish this work from others of the period using paid models.

While Cooper's artistic focus was in the process of changing, his personal life took a dramatic turn with the death of his wife in 1920. Although no extant correspondence or diaries discuss her death from tuberculosis, her passing must have been a tremendous blow.[58] The two were constant companions for over twenty years.[59] Emma's death may have initiated Cooper's desire to begin a new life or at least change his surroundings. In the absence of any documentation, however, we can only speculate on why he moved, seemingly rather suddenly, to Santa Barbara in January 1921.

Cooper's surprising decision must have looked like artistic suicide to his established East Coast colleagues. Cooper himself stated that in California he was "isolated from the artistic universe of America," and that "after spending nearly twenty years identified with the art life of New York, I miss the many friends with whom I was associated there."[60] By no means, however, did Cooper abandon New York, but maintained a studio there for ten years after he relocated.[61]

The notion that California was remote—an "island on the land," where artists toiled in relative isolation—was a refrain often repeated by both Eastern and Western critics.[62] Recent scholarship on Impressionists in California within the context of American Impressionism has proven that notion fatuous.[63] And Cooper's remarks can be seen as part of a persistent, exaggerated parlance that lingered throughout the twentieth century. At last, American art history is now beginning to debunk the concept of "synecdochic nationalism," whereby painting and painters on the East Coast were seen as representative of the entire country.[64] Like Cooper, many artists who worked in California maintained studios elsewhere, exhibited throughout the United States, and were associated with dealers in major cities. And they traveled frequently, both within the country and abroad, scarcely suffering any "tyranny of distance" from New York.[65] Cooper's exhibition history during his California years bears out his rather full participation in the artistic communities locally and farther afield.

50

Two Women, c. 1917–18

Oil on board

24½ x 21½ inches

Private Collection, Courtesy of The Irvine Museum

Irvine, California

51

The Rustic Gate, c. 1918

Oil on canvas

46 x 36 inches

The Irvine Museum, Irvine, California

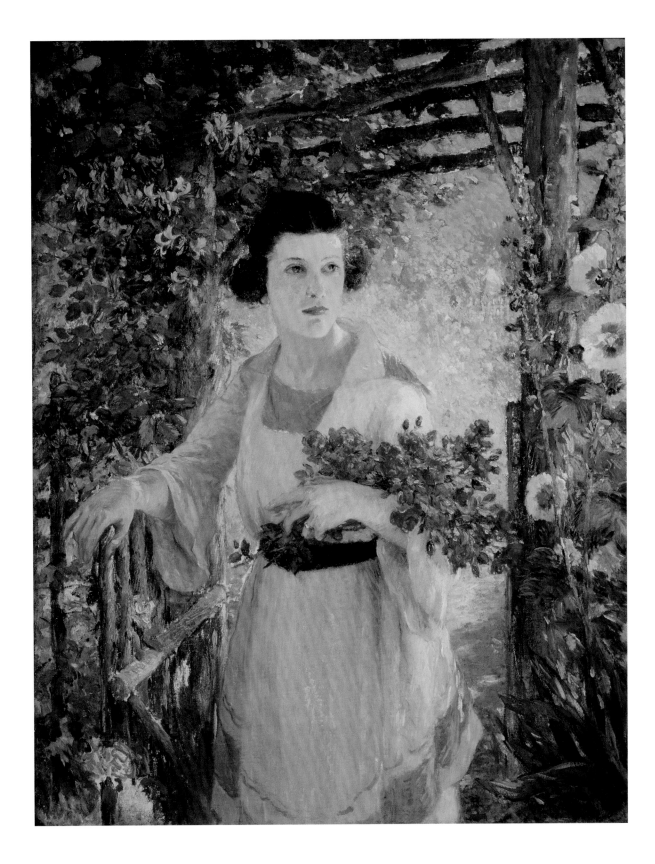

52

Chatham Square Station, New York City, 1919
Oil on canvas
40 x 50 inches
Guillaume Family Collection

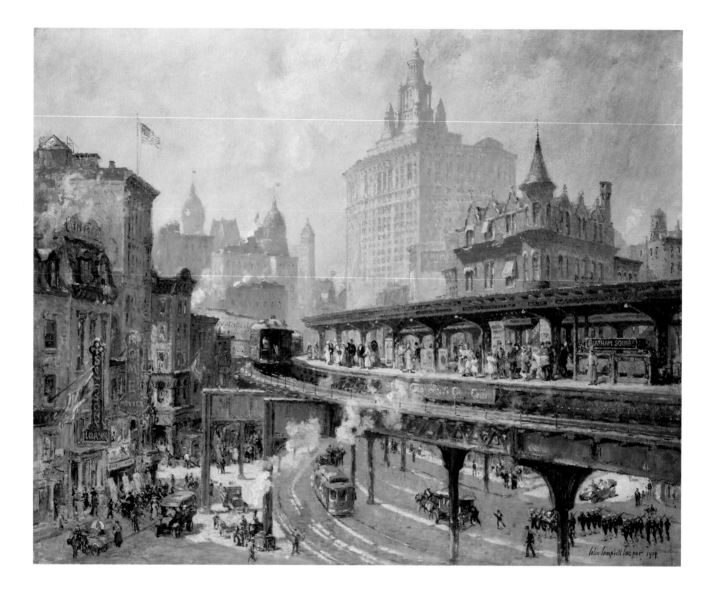

53

Chatham Square, New York City, c. 1919
Watercolor, gouache, and pencil on paper
13¾ x 17¼ inches
Guillaume Family Collection

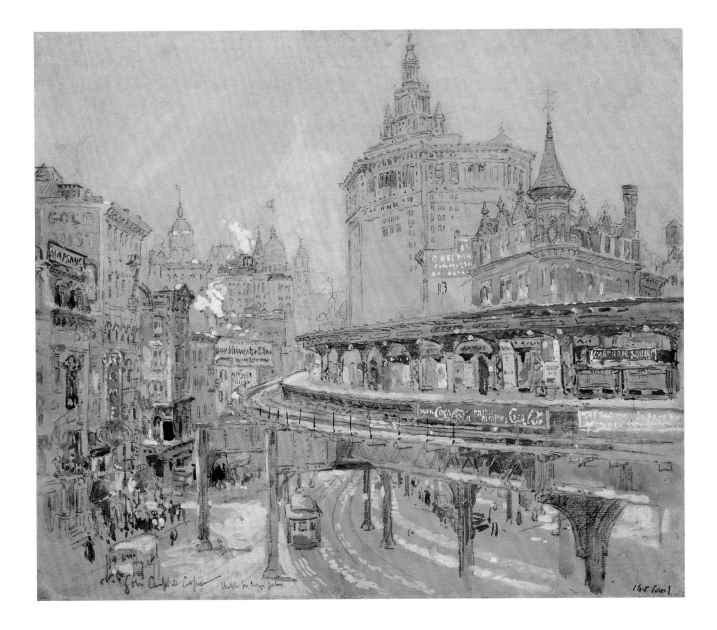

It is certainly possible that Cooper visited Santa Barbara in 1916 when he traveled from San Francisco to San Diego. He later wrote that he found "Santa Barbara conducive to the sort of thing a painter craves—climate, flowers, mountains, seascapes, etc. with a community interested in all sorts of artistic matters."[66] In addition to exquisite scenery, it had an art colony that had been established in the late nineteenth century by the artist Alexander Harmer.[67] As in so many California cities, Santa Barbara's growth was the result of the railroads: a rail link completed in 1901 made the city easily accessible. Capitalizing on that accessibility, Harmer built a studio complex intended to entice artists in the hope of creating a colony. Over the next two decades, the thriving colony included Thomas Moran, Fernand Lungren, Carl Oscar Borg, John Marshall Gamble, and Albert and Adele Herter.

Although the presence of an established art colony would have appealed to Cooper, Santa Barbara was not unique; by 1920, Laguna Beach, nestled along the coast between Los Angeles and San Diego, hosted the most important colony for Impressionist artists in the Southland. The Laguna Beach Art Association had hundreds of charter members and an art gallery whose visitors numbered in the thousands.[68] Accessible by rail, the small city's art community included luminaries such as Joseph Kleitsch, William Wendt, Edgar Payne, and Gardner Symons. Many artists, such as Symons, maintained studios in Laguna and on the East Coast.

Nonetheless, Santa Barbara had two unique ingredients: a surrounding community of great wealth and an art school. Between 1890 and 1930, forty "great estates" were built in Santa Barbara and its neighboring community Montecito. These estates were home to families such as those of CKG Billings, George Owen Knapp, and Frederic Gould.[69] They funded civic projects, established exclusive day schools, and certainly could afford to patronize the arts. Perhaps more compelling for Cooper, The Santa Barbara School of the Arts, founded in 1920, adopted a mission to "develop a spirit of fellowship in the arts . . . to lead the individual student to worthy achievement."[70] The art faculty included Fernand Lungren, De Witt Parshall, Carl Oscar Borg, Belmore Browne, and John Marshall Gamble. Although Cooper had not taught since his early years in Philadelphia, this may have been an opportunity to supplement his income, since the financial source of his fairly comfortable lifestyle remains unclear. By joining the faculty in 1921 to teach an outdoor landscape class, he was able to work in a convivial and beautiful environment, and his association bolstered the reputation of the nascent institution.

Believing that the gardens in Europe were "charming . . . [but] I do not think that anywhere in the world will be found anything more exquisite in that respect than the gardens of California in Pasadena and Montecito," Cooper explored the Santa Barbara area.[71] By the early 1920s, there were several major resort hotels set on exquisitely landscaped grounds. El Encanto (The Enchanted), originally a group of small cottages, was transformed into a small hotel complex with the addition of a large central building. With views from the Channel Islands to the Goleta Valley, the grounds included native plants and large eucalyptus trees; the centerpiece was an Italian red brick pergola in a setting of small waterfalls and a lily pond.[72] El Encanto's gardens became a favorite location for Cooper. He made several paintings of the pond and pergola. *The Lotus Pool, El Encanto, Santa Barbara* (cat. no. 56) is a foreshortened, axial view from inside the pond looking out toward the pergola and the eucalyptus trees silhouetted in the distance. Cooper's established mastery of plein-air

54

The Three Towers, c. 1919

Oil on canvas

43¾ x 29¼ inches

Private Collection

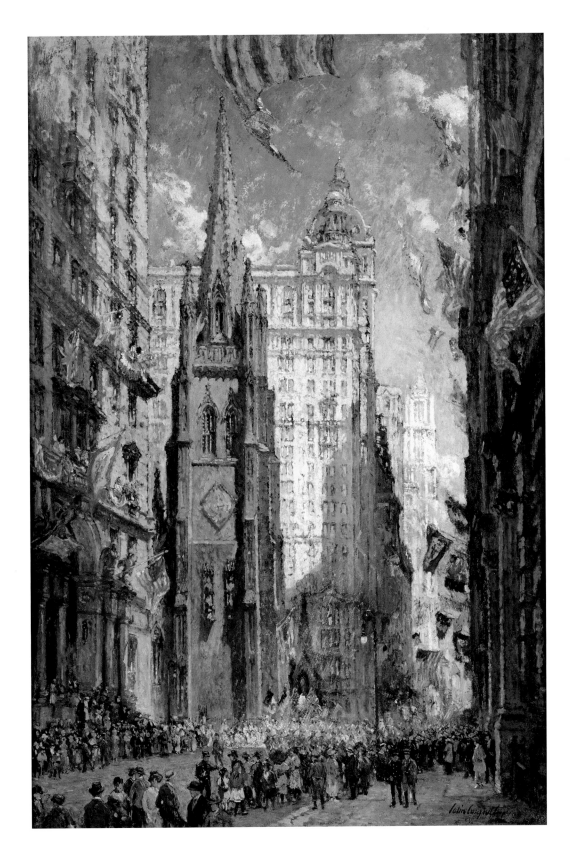

55

Hudson River Waterfront, c. 1921

Oil on canvas

36 x 29 inches

The New-York Historical Society, Gift of Miss Helene F. Seeley

In memory of the artist and his wife, 1943.180

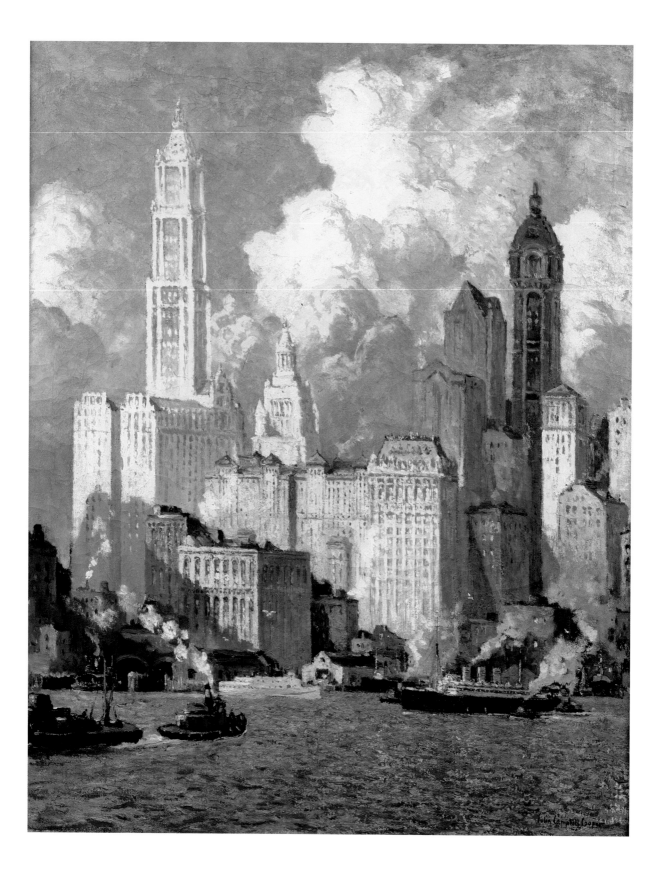

56

The Lotus Pool, El Encanto, Santa Barbara, c. 1921–22

Oil on canvas

36 x 29 inches

Courtesy of the Reading Public Museum

Reading, Pennsylvania

57

Chambers Street and the Municipal Building, N.Y.C., 1922

Oil on panel

30 x 24 inches

The New-York Historical Society, Museum Purchase

James B. Wilbur Fund, 1940.957

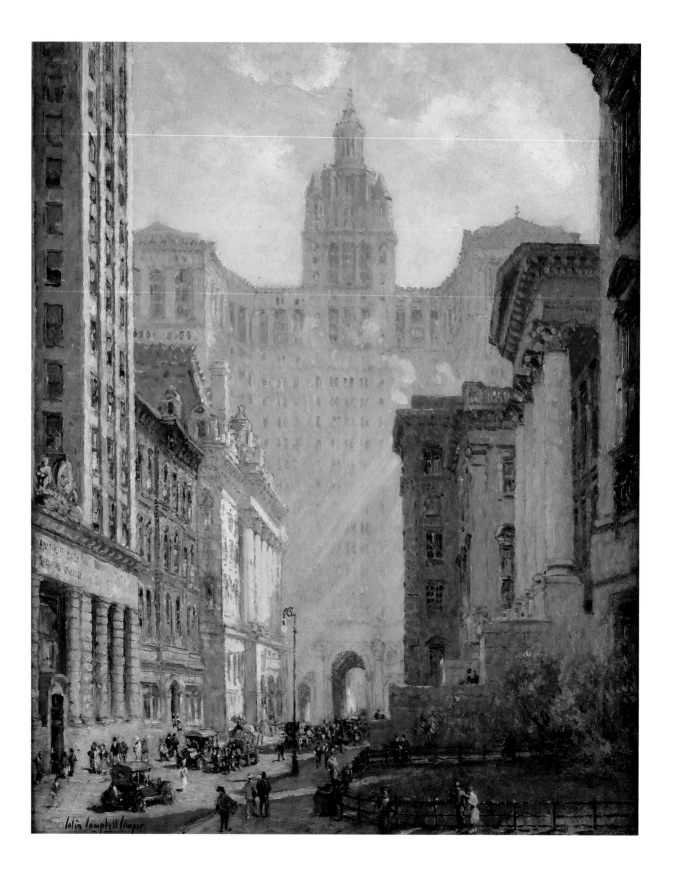

painting reaches a new level in works such as this. The lush landscape, drenched in sunlight and filled with an array of brightly colored flowers, underscores the tranquil ambience of the gardens. It is likely that this picture was exhibited at the Pennsylvania Academy of the Fine Arts in 1922. *Lily Pond, El Encanto, Santa Barbara* (cat. no. 64), situates the viewer to the left of the partially shown pond, allowing a more in-depth view of the pergola and gardens to the right. Brilliantly colored vines flow over the red brick columns; the entire composition is awash in light. In neither painting do figures interrupt the viewer's sense of private contemplation.

The Samarkand Hotel (Persian for "land of heart's desire") was originally the site of a private boys school built by Dr. Prynce Hopkins in 1915. Surrounding the two-story main building with wings for dormitories and classrooms, its exotically planted garden terraces led to a large artificial lake. When the school failed in 1918, Hopkins's mother renovated the complex into a small, exclusive hotel catering to an Eastern clientele who summered in Santa Barbara. Its magnificent gardens attracted many, including Cooper. In *Pergola at Samarkand Hotel, Santa Barbara* (cat. no. 60), profusions of plants in the ground and in pots overrun a terrace, creating a riot of color that contrasts with the blue, cloudless California sky. Once again, no figures intrude on this private moment, shared only with two swans just barely visible in the pond to the left. This painting may be the one exhibited under the title *The Pergola* at the Pennsylvania Academy of the Fine Arts in 1922.[73]

In addition to painting hotel gardens, Cooper also depicted more intimate spaces. *In a Garden, San Diego* (cat. no. 61) is possibly the spectacular garden of a private home. Depictions of domestic gardens were common among East Coast Impressionists such as Edmund Greacen, George Burr, Clark Voorhees, and Childe Hassam.[74] The "Grandmother's Garden," a symbol of home and hearth, had become a pictorial metaphor for conservative values and family life in the early twentieth century.[75] And while Cooper's scenes are not their exact pictorial equivalent, they are certainly closer in spirit than the uncultivated landscapes favored by so many Impressionist artists in California.

In March 1922, Cooper returned to New York to serve on the award's jury for the 97th Annual Exhibition of the National Academy of Design, but by September, he was once again in San Diego visiting friends.[76] The following May, Cooper made a nearly ten-month-long trip to Spain.[77] His sporadic trip diary records stops in Segovia, Seville, Madrid, Granada, Pedrago, and Burgos. In Madrid, he "paid his respects to the Prado," and he found Segovia a "wonderfully picturesque town."[78] Contemporary Spain was not to his liking. "Spain of today—in the big cities and some of the smaller ones—doesn't interest me very much. Their art, their architecture, their manner and appearance are all rather . . . downright dismal, but Spain of the past with its glorious art, its beautiful buildings, its age and traditions, that is worthwhile."[79] He returned to America at the end of January 1924 by way of New York City. His final entry poignantly records that "new outlooks have presented, new perceptions have developed. . . . It has been a period of experiences very lonely, too, for the most part. . . ."[80] This was Cooper's first major trip since Emma's death, and clearly her companionship was missed. He remained in New York for several weeks, writing to a friend that he was

> pausing on my way to Santa Barbara to settle some matters in this busy and
> nerve racking city. I long for the tranquility of Santa Barbara. . . . I wrote to

58

New York from Brooklyn, c. 1922

Oil on board

25 x 30 inches

Jersey City Museum, New Jersey, Gift of Nellie Wright Allen

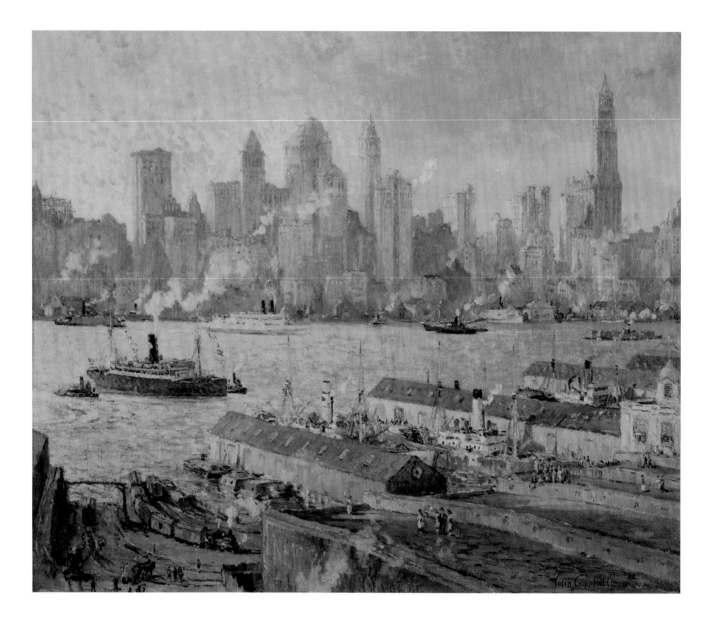

59

Columbus Circle, c. 1923
Oil on canvas
25 x 30 inches
Norton Museum of Art, West Palm Beach, Florida
Gift of Elsie and Marvin Dekelboum, 2005.57

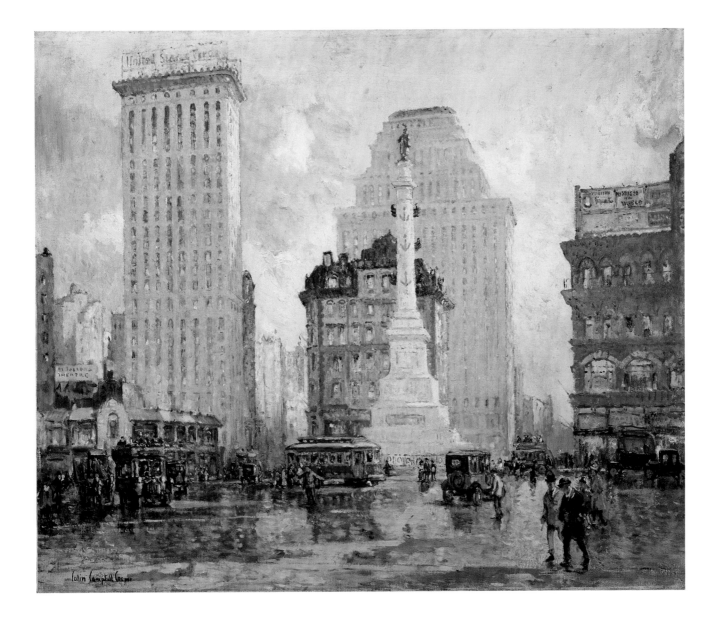

Mr. Harmer to ask if I could get my studio again . . . but no answer has yet come. I also wrote about the possibility of getting one of those apartments at the little court on Anacapa. . . . At this time, I hope to stay quite a while in your midst. . . . I have worked quite hard in Spain and have a lot of studies and sketches which I shall carry into larger canvases. . . .[81]

Cooper did secure a studio at 116 de la Guerra Street and an apartment at 1320 Anacapa Street upon his return.[82] He began to work furiously in preparation for an exhibition that opened at the Fine Arts Gallery, San Diego, in December 1924. Of the fifty-eight works, half were Spanish scenes and half were a fairly eclectic mix of Indian, European, and California pictures. Watercolors made up approximately half of the Spanish pictures.[83] One critic noted that in this medium, "Mr. Cooper has achieved most of the quality of the oil technique with an added subtle delicacy."[84] Among the several major oils were *Palma de Mallorca* (cat. no. 62), and *Segovia, Spain* (cat. no. 63). *Segovia, Spain* shares a lineage with Cooper's earlier cathedral paintings, but his style had now become much freer and his paint handling far more liberal. The viewpoint is probably from atop the Alcazar castle and fortification, which would have allowed a comprehensive panorama of the cathedral. Seen under bright sunlight, the burnt sienna rooftops of the surrounding buildings and the lush landscape in the foreground punctuate the canvas. *Palma de Mallorca* is a spectacular view of the major city and port on the island of Majorca and the capital city of the Balearic Islands off the coast of Spain. From a vantage point overlooking the city and the medieval fortress of Bellver Castle, the painting combines landscape, seascape, and sky. A critic advised readers weary of life's trials, that an antidote was to be found at the Fine Arts Gallery in Balboa Park, where "heaven in the world [was] depicted by Colin Campbell Cooper's brush." His Spanish pictures were "not a fairy land, not a figment of the imagination, but a land of real trees and stone walls, of buildings used by men and women." Cooper's interpretation was through the "poet's eye."[85]

The San Diego show also included a watercolor, *Jardin de Principe, Aranjuez*, which may have been a study for the large oil *The Pool, Prince's Park, Aranjuez* (cat. no. 66), exhibited at the National Academy of Design in 1933. During the eighteenth century, Aranjuez, located just south of Madrid, became the spring residence for the Spanish royal court. Its castle and gardens had become a popular tourist site by the early twentieth century. The bucolic, Claudian Prince's Park dotted with small Neo-Roman garden architecture offered Cooper the perfect confluence of familiar subjects.

On the heels of the San Diego exhibition, many of the same paintings were shown at Stendahl Galleries in Los Angeles in March 1925. Antony Anderson, critic for the *Los Angeles Times*, offered encomiums:

Cooper is not one of those painters who disdains a "subject." He is not afraid of the pictorial. Indeed, he is eager in his constant search for the picturesque, more often when it lurks in hiding in out-of-the way-corners. He is a discoverer of cities. Everybody paints the bulls and the caballeros, the mantillas and the senoritas of Spain. But all these things are incidentals. Bits of bric-a-brac. Not

60

Pergola at Samarkand Hotel, Santa Barbara, c. 1923

Oil on canvas

29 x 36 inches

Private Collection, Courtesy of The Irvine Museum

Irvine, California

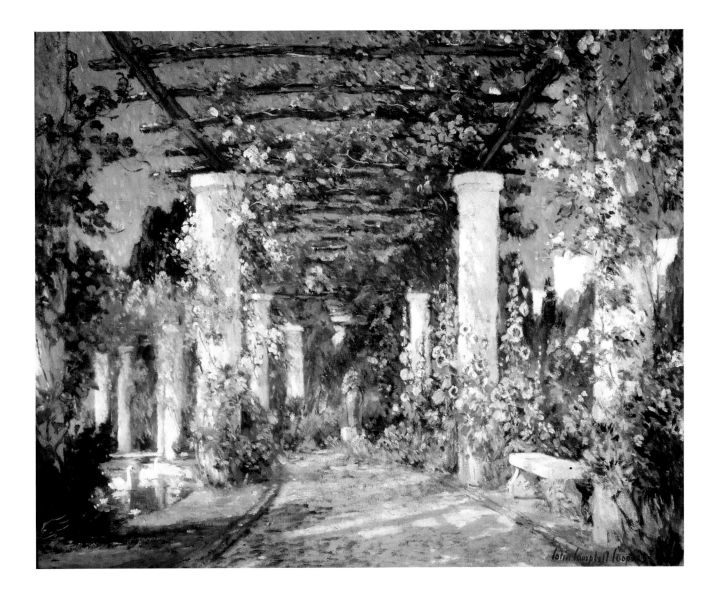

61

In a Garden, San Diego, 1924
Oil on canvas
18 x 24 inches
Private Collection

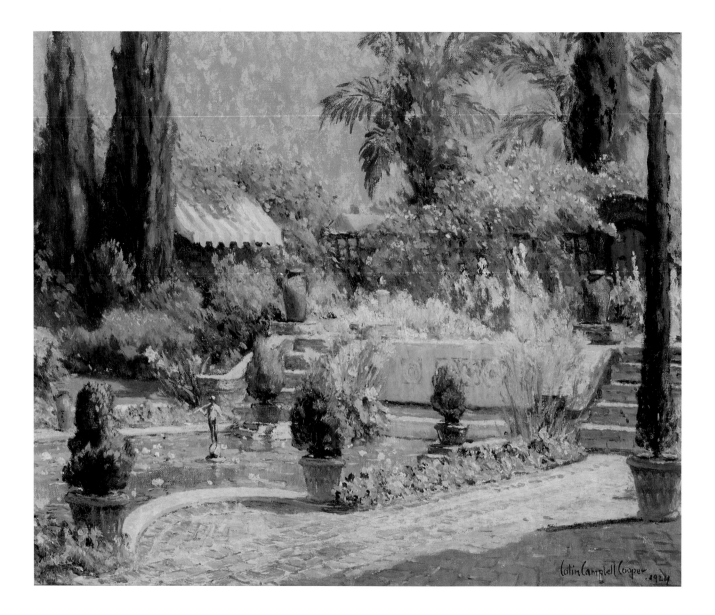

62

Palma de Majorca, c. 1924

Oil on canvas

30 x 50 inches

Collection of Harry Parashis

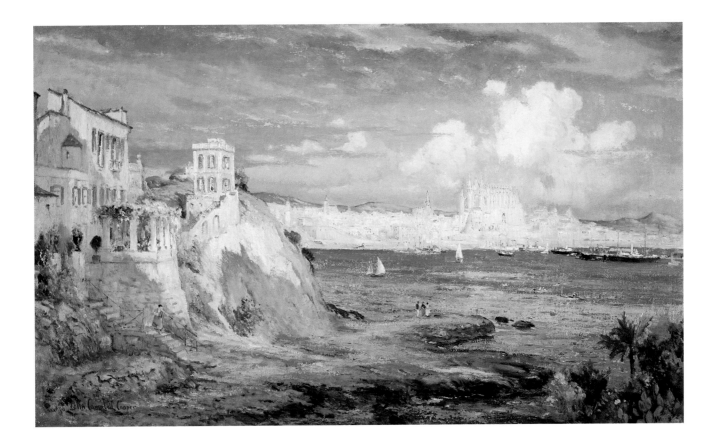

63

Segovia, Spain, 1924

Oil on canvas

36⅛ x 33⅛ inches

Santa Barbara Museum of Art, Gift of the family of the artist

Photograph courtesy of Scott McClaine

the actual life of the country. At Stendahl Galleries, where an exhibition of his paintings may now be seen, Cooper shows not only the street scenes for which he is noted, but also a group of Spanish architectural studies and views. . . .[86]

Cooper's exhibition schedule in the mid-to-late 1920s, both in California and elsewhere, remained consistent. He developed relationships in Los Angeles not only with Stendahl, but with Ainslie and Ilsley galleries. Little is known about his marriage in April 1927 to Marie Henriette Frehsee. A brief announcement simply noted that the couple was married in Arizona.[87] Beginning in the mid-1920s, Cooper began to cultivate another aspect of his career: that of playwright and author. As a young man, he had published short stories and articles, and he continued to write throughout his life. However, during the 1920s, his passion for literature became more focused and serious. He wrote numerous plays, including *Head Acres, Knighthood's Flower, The Cold Storage Husband*, and *At Cross-Roads*, which were reprised by local theater companies in Pasadena, Redlands, and Santa Fe in the late 1920s–30s. Cooper was a founder and president of the local Santa Barbara theater club, The Strollers, which staged several of his plays. And he reviewed theater productions in the local paper, occasionally offering sharp and vitriolic assessments of his peers. By the early 1930s, Cooper had written an autobiography, *In These Old Days*; a historical novel, *Old Ironsides Last Battle Cruise*; and an illustrated book on India, *Pen and Brush in India*.[88]

The year 1929 was particularly eventful, beginning with a one-person exhibition of forty-five paintings at Kievits Galleries in Pasadena. Arthur Millier, Antony Anderson's replacement as the critic for the *Los Angeles Times* (and not especially sympathetic to Impressionism), offered a positive, if tempered, assessment:

> This charming show will be much admired. Gentle and refreshing—as though he had the power always to dip into the fountain of youth. . . . The exhibition bowls no one over, but hangs discreetly on the walls. . . . There is never shouting or bad taste. Occasionally the paintings do not go much above the level of illustration, but usually there is a discernible loving attention to all parts of the canvas and a close working out of the subtle gradations of color in the reflected light and shadows that bring the pictures . . . to pleasant harmony.[89]

After it opened, Cooper and his wife spent nearly eighteen months in Europe visiting many of the haunts of his youth in Italy, France, and England. He rented a studio in Paris for four months beginning in December 1929. According to his diary, the pace of the trip was fairly grueling, but most significant were Cooper's notations of persistent ailments. "I cannot stand at my easel for any length of time without feeling a lack of balance that I should fall if I don't hold on to something," he wrote in October 1929.[90] He complained of shaking, rheumatism, and failing eyesight. "When I stand I hold Marie. . . . I do not even walk without her even for a short distance. . . ."[91] Nonetheless, he continued to work, preparing sketches, for example, at the cathedrals in Canterbury and Chartres, and at Windsor Castle. They returned to New York in August 1930, remaining only a few days. "New York was hot and stuffy," he wrote. "Four days of it were quite enough. But what a fairy land it is. A few years ago the Woolworth tower stood out as a great landmark. Today with the immensely

64

Lily Pond, El Encanto, Santa Barbara, c. 1925
Oil on canvas
30 x 36 inches
Private Collection

65

A Santa Barbara Courtyard, c. 1925
Oil on canvas
15½ x 18 inches
Santa Barbara Historical Society, California
Gift of Helene F. Seeley, 1956.14

higher towers it is only one of the smaller ones. Always coming into the harbor the sight has been impressive, but now it is awe inspiring."[92] His delight in architectural wonders had not wavered; the dramatic, changing skyline, punctuated by the increasingly upward trajectory of new and bigger buildings, remained fascinating.

Within a few months of returning to Santa Barbara, Cooper held a small exhibition in his studio. Despite his prolonged absence and the continued erosion of Impressionism's popularity—even in California, where its relevance and importance were sustained far longer than on the East Coast—Cooper's personal appeal had not waned. Supporters applauded his brilliant "technique" and definable "subjects"—criteria that by this date had long been held in contempt by avant-garde artists and critics. Well aware that detractors considered his art retrograde and insipid, Cooper nonetheless held firm in his convictions:

> Art is a great expression of emotion, which covers your attitude toward people and things. It can have no formulas, as it is a registration of reactions. Nevertheless, I don't agree with modern artists. Their theory seems to be that art musn't look like anything at all, and that there is nothing creative except that evolved from the inner consciousness. That if you paint something material, it is copied art. . . . They even go so far as to say that technique is nothing. That's misleading to people. They ought to know how to draw, at least. I don't like to see a face with a nose three times too long and a neck out of joint just because the artist's mind happened to conjure it that way.[93]

Cooper's vituperative condemnation of modern art (and contemporary jazz) was underscored in a missive he called "The Open Mind." Whether it was intended for publication is unclear, but it expresses utter disgust for "the cult of ugliness" that characterized the work of abstract painters.[94] Believing "that which is genuine . . . will endure always," he hopes that there will be an eventual return to reason and the appreciation of technical excellence and individual expression.

According to his account books, a few large-scale paintings were exhibited following his European trip. One of the most impressive was *Greco-Roman Theater at Night, Taormina* (cat. no. 68). Taormina, Sicily, is an ancient city known for its ruins and fortress; it was here, for example, that D. H. Lawrence was inspired to write *Lady Chatterly's Lover.* Perhaps its most famous monument is the Greco-Roman amphitheater, built in the third century B.C. by the Greeks, and then expanded by the Romans. Cooper's nocturnal version dramatically captures the great walls and columns just as the last shadows are cast. They represent the builders and buildings of antiquity whose brilliance laid the foundations, both literally and figuratively, for generations to come. Although ravaged by time, they stand as a counterpoint to the cathedrals and skyscrapers.

During the 1930s, Cooper exhibited mostly smaller works, as indicated by the prices noted in his account book. The instances of more substantial prices appear to be for works recycled from earlier years. To be sure, this was a terrible time for the art market. In a 1932 letter, art dealer Philip Ilsley reminds Cooper that "it has been our experience that any sales made during the past few months have been made at reductions of at least thirty percent from 1930 prices. . . . I am sure that you realize that prices of most commodities, even of necessities,

66

The Pool, Prince's Park, Aranjuez, c. 1925–30
Oil on canvas
36 x 40 inches
Collection of Paul and Kathleen Bagley

67

Beauvais Cathedral, 1926
Oil on canvas
45 x 33 inches
Courtesy of Sullivan Goss–An American Gallery

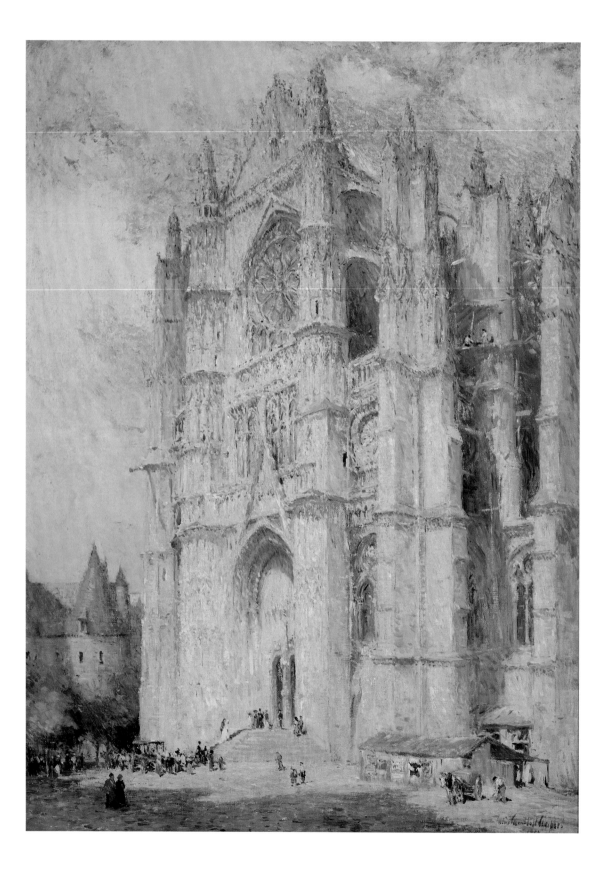

68

Greco-Roman Theater at Night, Taormina, Sicily, c. 1933
Oil on canvas
29 x 36 inches
Courtesy of Sullivan Goss–An American Gallery

have dropped fully fifty percent in the last three years."[95] While Cooper may have intentionally reduced the sizes and prices of his work in response to the market, the changes more likely reflect his declining physical condition. For example, in 1934 the Faulkner Memorial Art Gallery in Santa Barbara hosted an exhibition of seventy-seven works. Over one third of the thirty-three paintings had been done before Cooper settled in California; of the balance, only perhaps five had been completed after 1930. Nevertheless, the show was a smashing success.

Cooper's deteriorating health is reflected in his account book beginning in 1935, when his wife took over the task of recording the entries. Exhibitions in Los Angeles, San Diego, Rochester, and Springville, Utah, contained only recycled pieces. In a poignant twist, Cooper's eyesight failed in the last years of his life, ending his long and heralded career.[96] When he died in November 1937 at the age of eighty-one, his obituary ran in newspapers from New York to Los Angeles, from San Diego to Philadelphia and Rochester, New York.[97] In a moving tribute to his colleague and friend, John Gamble wrote that Cooper "saw beauty wherever he went and joyed in the endeavor to pass on to others through his work some of the pleasure which was his."[98]

Cooper's long and fruitful career was enviable. Subsequent to his death, Faulkner Memorial Art Gallery staged a memorial exhibition in 1938. The images of New York, India, Europe, New England, and California were like the pieces of a large jigsaw puzzle which formed a picture of his life. He was eulogized as a man whose "credo was beauty."[99] Cooper's work was neither simplistic nor unsophisticated. His paintings married a high level of technical acuity with a delight and curiosity in a range of subjects. Through Cooper, the effectiveness of labels—Eastern versus Western American painter—is challenged. His artistic precepts were consistent, regardless of his home address. And his art remains timeless.

NOTES

1. Colin Campbell Cooper diary (hereafter CCC diary), 1913–14, in Colin Campbell Cooper Family Collection (hereafter CCCFC). The authors are indebted to Jennifer Dahlke, the artist's great grand-niece, for generously allowing access to the Cooper Family Papers, which included the artist's diaries, correspondence, and book and play manuscripts, among other personal papers.

2. Unidentified newspaper clipping, Colin Campbell Cooper file, reference desk, Santa Barbara Public Library, courtesy of Gloria Rexford Martin.

3. For an overview of Weeks's life, see Ulrich Hiesinger, *Visions of India* (New York: Vance Jordan Fine Art, 2002).

4. His inclusions at the 1880 Salon were *Camels Embarking on the Shore of Sale (Morocco)* and *The Gate of the Ancient Fondak in the City of Sale (Morocco)*. See Lois Marie Fink, *American Art at the Nineteenth-Century Paris Salons* (New York: Cambridge University Press, 1990).

5. Edwin Lord Weeks, *From the Black Sea through Persia and India* (New York: Harper and Brothers, 1896), p. 322, quoted in Pratapaditya Pal et al., *Romance of the Taj Mahal* (New York: Thames and Hudson, 1989), p. 215. While Weeks was the first artist to paint the Taj on the spot, other Americans preceded him in India. Bayard Taylor, a novelist and journalist who had accompanied Commodore Matthew Perry on his naval expedition to Japan, visited India sometime in the early 1850s. See Pal, p. 211.

6. See ibid. pp. 199–210.

7. Hiesinger, p. 28.

8. CCC diary, March 12, 1914, CCCFC. According to James Hansen, "during his Santa Barbara years, he

[Cooper] returned to India and continued as far East as Burma, where he did studies of the Schwedagon Pagoda." Cooper went to Burma during his 1913–14 trip to India; no evidence suggests that he returned to India in the 1920s. See James M. Hansen, *An Exhibition of Paintings by Colin Campbell Cooper* (Santa Barbara, California, 1981), n. p.

9. Cooper to Macbeth, June 21, 1914, Archives of American Art, Smithsonian Institution, Washington, D.C. (hereafter Archives of American Art), reel NMc35, frame 97. Phil and Marian Kovinick compiled extensive research on Cooper which was graciously loaned courtesy of Ray Redfern, Redfern Gallery (hereafter Kovinick research).

10. See "Poland Spring Exhibition, Twenty-First Summer Show in Maine State Building," Emma Lampert Cooper Papers, Memorial Art Gallery, Rochester, New York, courtesy of Marjorie B. Searl, chief curator, Memorial Art Gallery, Rochester. Ms. Searl has graciously provided extensive research material on both Emma and Colin Campbell Cooper.

11. Cooper to Macbeth, November 8, 1914, Archives of American Art, reel NMc35, frame not available.

12. Identifying the Taj Mahal paintings presents a particular problem. According to Gloria Rexford Martin, author of an unpublished exhibition history of the present painting, Cooper executed at least seven renditions of the building, several with similar or identical titles. Extant labels attached to this painting indicate that it was exhibited under at least two titles, *The Taj Mahal*, and *The Taj Mahal, Agra, India*. In a review of the Macbeth exhibition, the writer describes two Taj paintings, one matching the particular cropped viewpoint of the pool seen here. However, the matter is complicated by the fact that another similar version is extant (see Sotheby Parke Bernet, Los Angeles, June 18–19, 1979, lot 170). Martin believes that this painting was probably exhibited at the Macbeth Gallery in New York (1915) and at the Memorial Art Gallery in Rochester, New York (1915) under the title *Taj Mahal Agra (Afternoon)*. Another version of the Taj exhibited at Macbeth, *Taj Mahal Agra (Morning)*, with the more typical axial view, was reproduced in *The Art World*, October 1915. I am grateful to Ms. Martin for graciously sharing her research.

13. For a full description, see Janice Leoshko, "Mausoleum for an Empress," in Pal, pp. 53–87.

14. CCC diary, January 1, 1914, CCCFC.

15. It has been suggested that the stone structure to the right of the pool might be a sarcophagus. See Matin research.

16. "Cooper Showing His Pictures of India: Exhibition of Fifteen Canvases the Result of Artist's Recent Eastern Trip—Paintings are Colorful," [1915], unidentified newspaper clipping, CCCFC.

17. "News of the Art World," *The World*, February 21, 1914, CCCFC.

18. Unidentified newspaper clipping, Archives of American Art, Macbeth Gallery Scrapbook, reel NMc2, frame 261. I am grateful to Ms. Martin for this citation.

19. "Colin Campbell Cooper's Indian Pictures," *American Art News* [February 1915], CCCFC.

20. Cooper to Macbeth, November 8, 1914, CCCFC.

21. Cooper's account book was graciously provided to the author by Dr. William H. Gerdts.

22. CCC diary, December 6, 1913, CCCFC.

23. Edwin Lord Weeks, "Oudeypore, The City of Sunrise," *Harper's New Monthly Magazine* 90 (February 1895), p. 437.

24. Ibid., p. 439. The illustration is entitled "Castle of the Ranas of Oudeypore."

25. "Colin Campbell Cooper's Indian Pictures," unidentified newspaper clipping, CCCFC.

26. For information on the work, see Curatorial Catalogue Sheet, Santa Barbara Museum of Art, California. Among the venues were the Corcoran Gallery of Art, Washington, D.C. (1915), Macbeth Gallery, New York (1915), The Brooklyn Museum, New York (1915), Mystic Art Association, Connecticut (1916), The Art Institute of Chicago (1916), Dallas State Fair (1917), the Pennsylvania Academy of the Fine Arts (1918), and the Faulkner Memorial Art Gallery, Santa Barbara (1934). The painting was reproduced in the *California Graphic*, May 1927.

27. See "India Pictures at Art Gallery: Work of Mr. and Mrs. Colin Campbell Cooper on View," *Rochester Democrat and Chronicle*, October 31, 1915. I thank Marjorie Searl for a transcript of this review.

28. Rudyard Kipling, *Letters From the East* (New York: F. F. Lovell Co., 1890).

29. "An Exhibition of Paintings Made in India by Colin Campbell Cooper and Emma Lampert Cooper" (Rochester, New York: The Memorial Art Gallery, 1915), n. p., Kovinick research.

30. See www.tracyanddale.50 megs.com/burma/html/site 18.

31. The Palace of Fine Arts remained open until May 1, 1916. See Laura Bride Powers, "Art and Artists About the Bay," *Oakland Tribune,* April 2, 1916, p. 13, courtesy of Jessie Dunn-Gilbert, The North Point Gallery, San Francisco.

32. Implicit in the fair's conception was the belief that it could elevate the public's taste. According to a critic, "One of the best results to be looked for from the exposition is the effect on public taste in architecture, painting, and sculpture. Here are assembled numerous examples of what is really good art—seen time and again by the people who will enter the gates and grown familiar to the public mind, these cannot fail to mold taste." Ben Macomber, "Exposition Art Bound to Leave Lasting Impression," *San Francisco Chronicle,* June 6, 1915, p. 26, courtesy of Jesse-Dunn Gilbert, The North Point Gallery, San Francisco.

33. Eugen Neuhaus, *A Critical Review of the Paintings, Statuary, and Graphic Arts in the Palace of Fine Arts at the Panama-Pacific International Exposition,* Project Gutenberg etext, www2.cddc.ut.gutenberg/etext03.

34. For an explanation of the building, see "Fairgrounds and Buildings," The Panama-Pacific International Exposition, www.sanfranciscomemories.com/ppie/TowerOfJewels.

35. Louis Christian Mullgardt, *The Architecture and Landscape Gardening of the Exposition,* www.books-about-california.com/Pages/PalacesandCourts.

36. "Cooper's Temple of Art," unidentified newspaper clipping, CCCFC.

37. The palaces included: Machinery, Varied Industries, Transportation, Manufactures, Liberal Arts, Agriculture, Food Products, Education and Social Economy, Horticulture, Mines and Metallurgy, and Transportation. See Juliet Helen Lumbard James, *Palaces and Courts of the Exposition,* www.books-about-california.com/PalacesandCourts.

38. Anna Cora Winchell, "Artists and Their Work," *San Francisco Chronicle,* March 19, 1916, p. 19, courtesy of Jessie Dunn-Gilbert, The North Point Gallery, San Francisco.

39. "Artists Visit City," *Los Angeles Times,* April 26, 1916, section 2, p. 10. The article notes the couple stayed at the Hotel Clark, which may have been a popular spot for artists. Alson and Medora Clark stayed at this hotel when they visited California in 1919. I am grateful to Gloria Rexford Martin for this citation.

40. For information on the missions, see James Rawls, "The California Mission as Symbol and Myth," *California History,* Fall 1992, pp. 342–61; Gerald Miller, "The Mission: A Story of Romance and Exploration in California," in *Romance of the Bells* (Irvine, Califorina: The Irvine Museum, 1995), pp. 19-43.

41. For a history of Mission San Juan Capistrano, see Pamela-Hallen Gibson, "Mission San Juan Capistrano," in ibid., pp. 45–71.

42. For information on Lummis, see Susan Landauer, "The Culture and Consumption of Plein-Air Painting," *California Impressionists* (Athens, Georgia: Georgia Museum of Art, and Irvine, California: The Irvine Museum, 1996), p. 36.

43. The attempt to rewrite history, turning the hardships imposed upon the Indians into accounts of benevolent missionaries who transformed aboriginal, uncivilized natives, is highlighted by a series of articles that appeared in *The Californian.* See especially Laura Bridge Powers, "The Missions of California," *The Californian* (September 1892), pp. 547–56. For a lengthy discussion of the mission, see Deborah Epstein Solon, "The Life and Work of Alson Skinner Clark," PhD diss., Graduate School of the City University of New York, 2004.

44. Jean Stern, "Art in California: 1880 to 1930," in *Romance of the Bells,* p. 73.

45. We know that Cooper returned to the mission at least once more, as a small gouache of the church's exterior is dated June 24, 1926 (The Irvine Museum, Irvine, California).

46. This was not an uncommon viewpoint for artists. Alson Clark's *Mission Cloisters, San Juan Capistrano,* 1921 (The Irvine Museum, Irvine, California) is nearly identical.

47. Cooper did a similar but smaller gouache from the same perspective of the courtyard. See *Mission San Juan Capistrano,* 1916, gouache on paper, 10 x 12 inches (The Irvine Museum, Irvine, California).

48. Stern, "Missions in Art 1890 to 1930," pp. 118–19.

49. The small notice stated that "Colin Campbell Cooper, the New York etcher and painter, has been sketching in the fair grounds at San Diego for several months past. He is so taken with Southern California that in all probability he will open a studio at Laguna Beach and remain there through the summer." See "News and Notes," *Los Angeles Times*, May 7, 1916, p. 3. No evidence supports the claim of a possible Laguna Beach studio.

50. "The Exposition Auspiciously Opened," *San Diego Union,* January 1, 1915, section 2, p. 4. For an exhaustive list of articles relating to the fair, see www.sandiegohistory.org. See especially Richard Amero, "The Making of the Panama-California Exposition, 1909–1915."

51. For a discussion of the exposition, see D. Scott Atkinson, "A Mediterranean Encounter: Art and San Diego," in *Picturing Paradise* (San Diego: San Diego Museum of Art and San Diego Historical Society, 1999), pp. 22–39.

52. The Varied Industries Building housed manufacturing and industrial exhibits.

53. Richard Amero, "East Meets West in Balboa Park," www.sandiegohistory.org.

54. Cooper, "The Poetry of Cities," *The Century* 100 (October 1920), pp. 793–800.

55. Autobiographical Notes, Santa Barbara Museum of Art artist file, CCCFC.

56. Frieseke, Miller, Parker, Guy Rose, Karl Anderson, and Edmund Greacen exhibited together in 1910 at the Madison Art Gallery, where they were dubbed the "Giverny Group," reflecting their residence at the art colony in Giverny, France. See Bruce Weber, *The Giverny Luminists and Their Circle* (New York: Berry-Hill Galleries, 1996).

57. See *International Studio* 67, 266 (March 1919) in Kovinick research.

58. Emma died on July 30, 1920 from tuberculosis. I am grateful to Marjorie Searl for obtaining a copy of her death certificate.

59. See obituary, *The New York Times*, August 21, 1920. It appears she became ill and went to stay with her niece, Esther Steele, a nurse, in Pittsford, New York.

60. Cooper, Autobiographical Notes, CCCFC.

61. For information on Cooper's residences, see Kovinick research.

62. The phrase refers to the title of a book by Carey McWilliams, *Southern California: An Island on the Land* (Los Angeles: Carey McWilliams, 1946; reprint 1973).

63. See my two studies *Colonies of American Impressionism: Cos Cob, Old Lyme, Shinnecock and Laguna Beach* (Laguna Beach, California: Laguna Art Museum, 1999), and *In and Out of California: Travels of American Impressionists* (Laguna Beach, California: Laguna Art Museum, 2002).

64. See Angela Miller, *The Empire of the Eye: Landscape Representation and American Culture Politics, 1825–1875* (Ithaca, New York: Cornell University Press, 1993), p. 17, quoted in Charles Eldredge's excellent foreword to Nancy Boas, *The Society of Six* (Berkeley and Los Angeles: University of California Press, 1997), p. 6.

65. The phrase refers to how the British colonials viewed themselves in relation to the imperial centers. See Eldredge in ibid.

66. Cooper, unsigned typescript letter, Santa Barbara Historical Society [1933], CCCFC.

67. For the development of the Santa Barbara artist colony, see Gloria Rexford Martin and Michael Redmon, "The Santa Barbara School of the Arts," *Noticias* 9, 3 and 4 (Fall and Winter 1994), pp. 45–83.

68. For information on the colony in Laguna Beach, see *Colonies of American Impressionism: Cos Cob, Old Lyme, Shinnecock, and Laguna Beach.*

69. See David F. Myrick, *Montecito and Santa Barbara: The Days of the Great Estates*, vol. 2 (Pasadena, California: Pentrex Media Group, 1991).

70. For a history of the school, see Martin and Redmon.

71. Cooper, Autobiographical Notes, CCCFC.

72. For information on the El Encanto, see Michael Redmon, "History 101: What is the History of the El Encanto Hotel?" *The Independent*, October 13, 1994, p. 76. I am grateful to Michael Redmon, Director of Research and Publications, Santa Barbara Historical Society, for this citation.

73. Another image titled *The Pergola* (unlocated), this view including glimpses of the hotel, was reproduced in a 1933 article. A reproduction in the clipping file of the Santa Barbara Public Library includes the date of the article, February 1, 1933, but not the title of the publication.

74. Lisa N. Peters, "Cultivated Wildness and Remote Accessibility: American Impressionist View of the Home and Its Grounds," in *Visions of Home* (Carlisle, Pennsylvania: Trout Gallery, 1997), p. 14.

75. See May Brawley Hill, "The Domestic Garden in American Impressionist Painting," in ibid., pp. 53–54.

76. In a letter to Macbeth, March 20, 1922, he wrote that "I am just leaving for the Pacific Coast . . . ," Kovinick research. "Colin Campbell Cooper was the guest of Wheel J. Bailey in La Jolla in September and spent many hours sketching in Balboa Park, San Diego," in *California Southland* 33 (October 1922), p. 3.

77. Before leaving, Cooper gave an enlightening interview reflecting the depth of his concern with his adopted city. "If I am fortunate enough to bring home in my pictures any suggestions that may be helpful to the future city planning of Santa Barbara I shall be only too happy to have performed a service to the city. There is no city in California that is better adapted to the Old Mexican and Spanish traditions of architecture than Santa Barbara. We should preserve those traditions very carefully and build on them, and on them only." "Artist Cooper Going to Spain: Hopes to Bring Back Suggestions of Value to Santa Barbara Plan," unidentified newspaper clipping, CCCFC.

78. CCC diary, June 25, 1923, CCCFC.

79. Ibid., September 24, 1923.

80. Ibid., January 29, 1924.

81. Cooper to Litti Paulding, February 11, 1924, CCCFC.

82. "Noted Artist Returns Home," *Santa Barbara News* [1924], CCCFC. Cooper's residence remained 1320 Anacapa until 1931 when he moved to number 1715.

83. See *Paintings by Colin Campbell Cooper, N.A.* (San Diego: Fine Arts Gallery, San Diego Museum, 1925).

84. Beatrice de L. Krombach, "Colin Campbell Cooper's Collection at Fine Arts Gallery Closes Sunday," unidentified newspaper clipping, CCCFC.

85. H.L.D., "Cooper's Art Takes Jaded Mortal to Glamorous Sphere," December 7, 1924, unidentified newspaper clipping, San Diego Museum of Art artist file, courtesy of D. Scott Atkinson.

86. Antony Anderson, "Of Art and Artists," *Los Angeles Times*, June 21, 1925, p. 12.

87. See *Santa Barbara Morning Press*, March 11, 1927, courtesy of Michael Redmon.

88. According to numerous pieces of correspondence, Cooper made many unsuccessful attempts to have his work published.

89. Arthur Millier, "Of Art and Artists," *Los Angeles Times*, February 10, 1929, section 3, p. 14.

90. CCC diary, October 3, 1920, CCCFC.

91. Ibid., December 3, 1929.

92. Ibid., August 15, 1930.

93. Doris Drake, "Colin Campbell Cooper Tells of His Start and Experiences as an Artist," unidentified newspaper clipping, August 14, 1933, Santa Barbara Museum of Art artist file.

94. Colin Campbell Cooper, "The Open Mind," undated typescript, CCCFC.

95. Philip Ilsley to Cooper, October 20, 1932, in ibid.

96. John M. Gamble, "Fellow Artist in Tribute to Cooper," *Santa Barbara News-Press,* November 7, 1937.

97. See, for example, "Colin Cooper, Artist, Died," *Santa Barbara News-Press,* November 7, 1937, p. 1; "C.C. Cooper, Artist, Dead in West at 81," *The New York Times*, November 7, 1927, section II, p. 9; "Art Colony Dean Dies," *Los Angeles Times*, November 7, 1937.

98. Gamble.

99. "Colin Campbell Cooper, Artist, Died."

Catalogue of the Exhibition

1

Nude Male Study, c. 1880s
Oil on canvas
23½ × 14½ inches
Collection of Michael and Deborah McCormick
Photograph courtesy of Sullivan Goss–An American Gallery

2

The Brittany Coastline, 1890
Oil on canvas
20¼ × 29 inches
Courtesy of The Greenwich Gallery

3

The Pageant at Bruges, 1896
Oil on canvas
16 × 20 inches
Payton Family Collection

4

Dordrecht Harbor, c. 1898
Oil on canvas
43 × 32 inches
Payton Family Collection

5

Portrait of a Lady in a Green Dress, c. 1900
Oil on canvas
18 × 21 inches
Collection of Michael and Deborah McCormick
Photograph courtesy of Sullivan Goss–An American Gallery

6

Wells Cathedral, c. 1902
Oil on canvas
25 × 31 inches
Courtesy of Berry-Hill Galleries

7

Cliffs of Manhattan, 1903
Oil canvas
36 × 48 inches
Collection of the City of Santa Barbara
Photograph courtesy of Scott McClaine

8

Mountains of Manhattan, c. 1903
Oil on canvas
42 × 68 inches
Collection of the City of Santa Barbara
Photograph courtesy of Scott McClaine

9

Broad Street Cañon, New York, 1904
Oil on canvas
56 × 39 inches
Leonard N. Stern School of Business, New York University

10

Flat Iron Building, 1904
Casein on canvas
40 × 20 inches
Dallas Museum of Art, Dallas Art Association Purchase

11

Broad Street Station, Philadelphia, 1905
Oil on canvas
45 × 33 inches
Courtesy Payne Gallery of Moravian College
Bethlehem, Pennsylvania

12

St. Paul's Chapel, 1905
Oil on canvas
33 × 22 inches
Mongerson Galleries, Chicago

13

Fifth Avenue, New York City, 1906
Oil on burlap
39 × 27 inches
The New-York Historical Society, Museum Purchase
James B. Wilbur Fund, 1940.956

14

Old Grand Central Station, 1906
Oil on canvas
24¼ × 32 inches
Collection of the Montclair Art Museum, Montclair,
New Jersey, Gift of Mrs. Henry Lang, 1927.7

15
The Rush Hour, New York City, 1906
Oil on canvas
32 × 44 inches
The New-York Historical Society
Gift of George A. Zabriskie

16
The Rialto, 1907
Oil on canvas
53 × 36 inches
Private Collection

17
The Wall Street Ferry Slip (The Ferries, New York), 1907
Oil on canvas
34 × 50 inches
Collection of Greg and Sharon Roberts

18
The Financial District, c. 1908
Oil on canvas
32 × 19½ inches
Collection of Mr. and Mrs. Thomas B. Stiles II

19
Main Street Bridge, Rochester, 1908
Oil on canvas
26¼ × 35 inches
Memorial Art Gallery of the University of
Rochester, New York, Gift of Mr. Hiram W. Sibley
Photograph courtesy of James Via

20
Broadway near Wall St., N.Y., 1909
Oil on canvas
30⅜ × 23 inches
Courtesy of the Biggs Museum of American Art
Dover, Delaware

21
Broadway from the Post Office (Wall Street), c. 1909
Oil on canvas
51⅜ × 35⅜ inches
Collection of the City of Santa Barbara
Photograph courtesy of Scott McClaine

22
Columbus Circle, 1909
Oil on canvas
26 × 36 inches
Allentown Art Museum, Allentown, Pennsylvania
Purchase: J. I. and Anna Rodale Fund, 1945

23
Glass Train Shed, Broad Street Station, Philadelphia, c. 1910
Oil on canvas
24 × 30 inches
Collection of Lee and Barbara Maimon

24
West Front, Steps of the Capitol, c. 1910
Oil on canvas
36 × 22 inches
Bank of America Collection

25
New York Public Library, c. 1912
Oil with graphite on canvas laid on board
14 × 20 inches
Private Collection, St. Louis

26
Old Waterworks, Fairmount, 1913
Oil on canvas
35 × 45 inches
Philadelphia Museum of Art: Gift of the artist, 1936

27
Taj Mahal, Afternoon, c. 1913
Oil on canvas
29 × 36 inches
Private Collection
Photograph courtesy of Sullivan Goss–An American Gallery

28
Kanchenjunga, The Himalayas, 1914
Oil on canvas
24 × 32 inches
Collection of Harry and Cricket Wilson
Photograph courtesy of Sullivan Goss–An American Gallery

29
Palace Gate, Udaipur, India, 1914
Oil on canvas
36¼ × 46⅛ inches
Santa Barbara Museum of Art
Gift of the family of the artist
Photograph courtesy of Scott McClaine

30
Hunter College, c. 1915
Oil on canvas
40 × 25 inches
Courtesy of Sullivan Goss–An American Gallery

31
Panama-Pacific Exposition Building, c. 1915
Oil on canvas
36 × 54 inches
Collection of the City of Santa Barbara
Photograph courtesy of Scott McClaine

32
Shwe Dagon Pagoda, Burma, 1915
Oil on canvas
40½ × 27¾ inches
Courtesy of Edenhurst Gallery, Los Angeles and Palm Desert

33
Tower of Jewels, Panama-Pacific International Exposition, 1915
Oil on canvas
18 × 22 inches
Private Collection

34
An Afternoon Stroll (Pool and Canadian Building), 1916
Gouache on paper
17 × 20¾ inches
Redfern Gallery, Laguna Beach, California

35
Balboa Park, Varied Industries Building, 1916
Gouache on paper
17½ × 21¾ inches
Private Collection

36
California State Building, San Diego Exposition, 1916
Oil on canvas
26 × 20⅛ inches
Santa Barbara Museum of Art
Gift of the family of the artist
Photograph courtesy of Scott McClaine

37
Half Dome, Yosemite, 1916
Oil on canvas
20 × 26 inches
Collection of Paul and Kathleen Bagley

38
Japanese Tea Garden, c. 1916
Oil on board
10 × 14 inches
Private Collection

39
Lily Pond, Balboa Park, c. 1916
Gouache on canvas
37 × 55 inches
Collection of the City of Santa Barbara
Photograph courtesy of Scott McClaine

40
Mission Corridor, San Juan Capistrano, c. 1916
Oil on canvas
21½ × 17¾ inches
Collection of Peter and Gail Ochs

41
Mission Courtyard (San Juan Capistrano), c. 1916
Oil on board
17½ × 21½ inches
Private Collection, Courtesy of The Irvine Museum,
Irvine, California

42
Mission San Juan Capistrano, c. 1916
Gouache on canvas
36 × 46 inches
Collection of the City of Santa Barbara
Photograph courtesy of Scott McClaine

43
Palace of Fine Arts, San Francisco, 1916
Oil on canvas
40¼ × 50½ inches
Crocker Art Musueum, Sacramento, California, Gift of
Helene Seeley in memory of Mr. and Mrs. C. C. Cooper;
conserved with funds provided by Mr. Gerald D. Gordon
through the Gifts to Share program

44
Panama-Pacific Exposition, c. 1916
Oil on canvas
19 × 22 inches
Private Collection, Courtesy of The Irvine Museum
Irvine, California

45
*Panama-Pacific International Exposition (Court of the Four
Seasons)*, c. 1916
Oil on canvas
20 × 26 inches
Collection of Paul and Kathleen Bagley

46
Entrance to the Maharaja's Palace, Jaipur, 1917
Oil on canvas
22 × 18 inches
Private Collection

47
Lower Broadway in Wartime, 1917
Oil on canvas
57½ × 35¼ inches
Courtesy of the Pennsylvania Academy of the Fine Arts
Philadelphia, Joseph E. Temple Fund

48
Metropolitan Tower, New York City, 1917
Oil on canvas
28⅛ × 20⅛ inches
Private Collection

49
South Ferry, New York, 1917
Oil on canvas
29½ × 36¼ inches
The National Arts Club, New York

50
Two Women, c. 1917–18
Oil on board
24½ × 21½ inches
Private Collection, Courtesy of The Irvine Museum
Irvine, California

51
The Rustic Gate, c. 1918
Oil on canvas
46 × 36 inches
The Irvine Museum, Irvine, California

52
Chatham Square Station, New York City, 1919
Oil on canvas
40 × 50 inches
Guillaume Family Collection

53
Chatham Square, New York City, c. 1919
Watercolor, gouache, and pencil on paper
13¾ × 17¼ inches
Guillaume Family Collection

54
The Three Towers, c. 1919
Oil on canvas
43¾ × 29¼ inches
Private Collection

55
Hudson River Waterfront, c. 1921
Oil on canvas
36 × 29 inches
The New-York Historical Society, Gift of Miss Helene
F. Seeley, in memory of the artist and his wife, 1943.180

56
The Lotus Pool, El Encanto, Santa Barbara, c. 1921–22
Oil on canvas
36 × 29 inches
Courtesy of the Reading Public Museum
Reading, Pennsylvania

57
Chambers Street and the Municipal Building, N.Y.C., 1922
Oil on panel
30 × 24 inches
The New-York Historical Society, Museum Purchase
James B. Wilbur Fund, 1940.957

58
New York from Brooklyn, c. 1922
Oil on board
25 × 30 inches
Jersey City Museum, New Jersey, Gift of Nellie Wright Allen

59
Columbus Circle, c. 1923
Oil on canvas
25 × 30 inches
Norton Museum of Art, West Palm Beach, Florida
Gift of Elsie and Marvin Dekelboum, 2005.57

60
Pergola at Samarkand Hotel, Santa Barbara, c. 1923
Oil on canvas
29 × 36 inches
Private Collection, Courtesy of The Irvine Museum
Irvine, California

61
In a Garden, San Diego, 1924
Oil on canvas
18 × 24 inches
Private Collection

62
Palma de Majorca, c. 1924
Oil on canvas
30 × 50 inches
Collection of Harry Parashis

63
Segovia, Spain, 1924
Oil on canvas
36⅛ × 33⅛ inches
Santa Barbara Museum of Art
Gift of the family of the artist

64
Lily Pond, El Encanto, Santa Barbara, c. 1925
Oil on canvas
30 × 36 inches
Private Collection

65
A Santa Barbara Courtyard, c. 1925
Oil on canvas
15½ × 18 inches
Santa Barbara Historical Society
Gift of Helene F. Seeley, 1956.14

66
The Pool, Prince's Park, Aranjuez, c. 1925–30
Oil on canvas
36 × 40 inches
Collection of Paul and Kathleen Bagley

67
Beauvais Cathedral, 1926
Oil on canvas
45 × 33 inches
Courtesy of Sullivan Goss–An American Gallery

68
Greco-Roman Theater at Night, Taormina, Sicily, c. 1933
Oil on canvas
29 × 36 inches
Courtesy of Sullivan Goss–An American Gallery

Index